Jack B. Yeats: His Watercolours, Drawings and Pastels

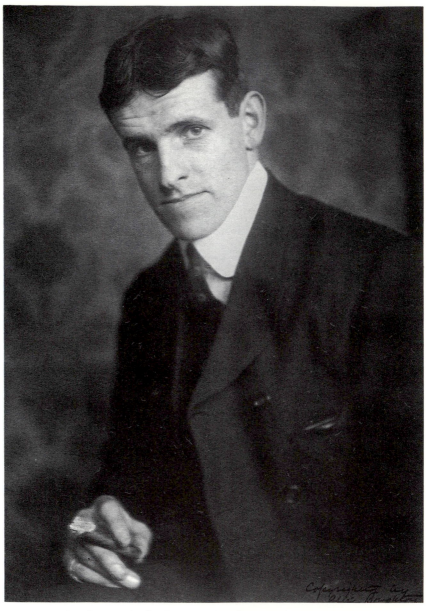

Studio photograph of Jack B. Yeats by Alice Broughton, March 1907

JACK B. YEATS

His Watercolours, Drawings and Pastels

HILARY PYLE

IRISH ACADEMIC PRESS

This book was set
in Adobe Garamond
by Seton Music Graphics, Bantry.
Published in Ireland by
IRISH ACADEMIC PRESS LTD
Kill Lane, Blackrock, Co. Dublin

and in the United States of America by
Irish Academic Press
International Specialized Book Services
5804 NE Hassalo St, Portland, OR 97213

A catalogue record for this title
is available from the British Library.

ISBN 0-7165-2477-5

Printed in Ireland
by Betaprint, Dublin

CONTENTS

PREFACE

MUCH OF THE RESEARCH for this catalogue of watercolours was undertaken when I was preparing my biography of Jack B. Yeats. I received hospitality and encouragement from many people: and the material which I perused while writing the biography helped me towards a better understanding of the artist's work.

I would like to thank all of the collectors of works by Jack B. Yeats, both private owners and curators of public collections, who freely offered their time and assistance. Not only have they allowed me to study their drawings and watercolours, but often they have had personal recollections or letters which they have permitted me to use.

I am also grateful to the librarians of the following libraries for their courteous co-operation, and for permission to use and quote from letters, newspaper reviews, and other published or manuscript material referred to in the catalogue: the National Gallery of Ireland; the National Library of Ireland; Trinity College, Dublin; University College, Dublin; Cork Public Library; University College, Cork; The British Library; the Victoria and Albert Museum; the Witt Library, Courtauld Institute of Art; the New York Public Library Berg Collection; the Archives of American Art.

One particularly valuable source of material has been the collection of prints, echtachromes and catalogues, belonging to the late Victor Waddington, which I consulted during his life time: and I thank Leslie Waddington and Sarah Tooley of Waddington Galleries Ltd., London, for making this archive available to me again. Leslie Waddington has been most generous in providing photographs for reproduction, as have the curators of the various public collections, and many private owners. Rex Roberts has photographed from the sketchbooks with sensitivity and enjoyment. Jim Eccles and Niall Moore have provided other necessary photographs. I have consulted further photographic and printed matter in the collections of Leslie Waddington, the late George Waddington, the late Leo Smith of the Dawson Gallery (Dublin), the National Gallery of Ireland, Pyms Gallery, Christie's and Sotheby's (London), James Gorry, Cynthia O'Connor Ltd., and the Adam Salerooms (Dublin). Leo Smith was always most supportive in introducing me to collectors, and in tracing the whereabouts of watercolours.

There are many others to whom I am grateful, among them members of my family, who have offered advice and encouragement. Rosemary Roberts and Seán O'Doherty assisted with typing and clerical matters in the early days: and more recently I have relied on Sorcha and Dúinseach Carey, most able assistants, and my husband Maurice.

Most rewarding of all, and this cannot be understated, has been the enthusiasm and co-operation of Anne Yeats, the artist's niece, who has been able to provide me

with first hand knowledge of the artist's method of working, as well as other invaluable information, making every aspect of his memorabilia available towards the writing of this book. My thanks are due to herself and to Michael Yeats for their generosity for allowing me to reproduce so much of Jack B. Yeats's work, and especially so many examples from his hitherto unpublished sketchbooks.

INTRODUCTION

IN RECENT YEARS it has been fashionable to extol Jack B. Yeats's late paintings, and to ignore his early work. Yeats himself would have approved this attitude in part. In his early fifties, when his painting was taking a revolutionary direction he dubbed himself 'the first living painter in the world';[1] and realised that he had suddenly released something within his being that would now make his painting great.

However, when he painted solely in watercolour, his approach to his art was no less serious than when he painted in oil. His consistent exploration of a single theme, and his gradual perfecting of the watercolour technique so as to attain an original and expressive manner, combined to make this first phase of his work important.

The curious thing is that at his latest, most celebrated, stage of development, from 1950 onward, his oil painting displays characteristics of freedom of expression that relate most closely to the drawings and watercolours of his first period. It is as though his work had completed a cycle of growth with the attainment of an original European style in the mid-twenties, and, during its second cycle, in the stylistic freedom of the final paintings, it carried the richness and depth of an early revelation re-experienced.

Taking Yeats's full career into account, it is impossible to consider the artist's late and internationally admired work without appreciating fully the body of water-colours, pastels and drawings that made up the exhibitions of his first ten years as a professional painter. Yeats did not regard his watercolours as secondary to oil. He was unusual among artists in that he painted in watercolour as his main medium until the age of forty: and only then, because of some experimentation in oil, felt confident to exhibit oil paintings. For this reason, a study of his watercolours is essential to the understanding of his stylistic development. Out of his watercolours—which come to an abrupt end in 1910—grew the roots of his late and ambiguous themes in oil.

The Sligo background

Jack B. Yeats's childhood and schooling in County Sligo laid the foundation for the theme of contemporary Irish life he would pursue in his watercolours. He was born in London of a Sligo mother, and an artist father whose grandfather had been rector of Drumcliff (north of Sligo town), dying at Drumcliff only twenty-five years before Jack was born; so family associations in Sligo were strong. Jack was fortunate that, because

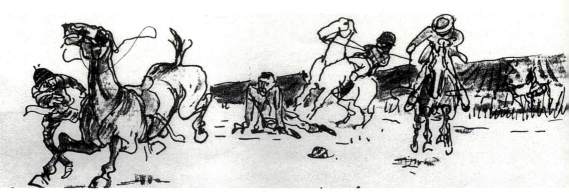

1 Detail from *The Letters of Dennis O'Grady (2)* 1888 (coll: NLI)

of the family's impecunious circumstances, he was brought up away from London, and from Dublin where the Yeatses moved for a time. His grandfather's business was shipping, and Yeats lived on the quays, among sailors, or followed his uncle, who was a horse trainer, into fields and fairs.

In later years, his friend John Masefield wrote about him, 'Nearly all of his best paintings commemorate someone vivid who has lived by his hands in a rough world . . . the very best of them are of scenes in the country life of the West of Ireland, where he lived as a boy.'[2] From the outset, and as long as he was painting in watercolour, Yeats would be primarily interested in reality. As he wrote to John Quinn in 1906,[3] 'the word "art" I don't care much for. I believe that all fine pictures . . . must have some of the living ginger of Life in them.'

Living in Sligo, gave him the opportunity to establish an artistic character of his own. Even as a child he discovered that he could draw. He created characters such as the Pasha and the Beast (no. 2), and Dennis O'Grady, West of Ireland correspondent (fig. 1)[4] for his sister Elizabeth. Even earlier, on holiday with his brother and sisters at Branscombe in Devon—Devon where his grandfather Pollexfen came from had further family associations—Jack's drawings, preserved by Lily with those of the other children,[5] show a preoccupation with incident (figs. 2–3). Willy and Lilly Yeats drew the church. Willy and Lolly drew the house they stayed in, with an old bent tree forming a half arch near the gate. While eight year old Jack, who was the youngest of the four, was interested less in the strong thrust of the tree, and more in the presence of cows, and of himself with pen and pencil in the foreground. He also drew a lively sketch of coastguards embarking in their boat from a beach. JBY, his father, noticed this, and wrote later, 'his drawings were never of one object, one person or one animal, but of groups engaged in some kind of drama.'[6]

Jack made a model farm as a boy; and in his thirties developed his interest in human drama through the model boats he and Masefield constructed and

10

demolished as they floated on the stream near his house in Devon. He painted the stream itself many times in watercolour, and the toy boats appear at a later period in the reminiscent oil paintings. The poet and the artist developed a whole private mythology through the cut-out pirates imaged by Jack and verbalised by them both; and Jack expanded the notion of cut-out drama in his miniature theatre, derived from the popular Victorian juvenile dramas of Redington, Pollock and Webb.[7] Yeats's early illustrated plays make use of the melodrama mould; but in words and theme they draw on actual life and the legends he heard during his Sligo youth.

Early art training and black-and white work

This instinctive love of narrative incident, in which an appreciation of reality mingles naturally with the more imaginative elements of the mind, may explain why Jack Yeats reacted against a formal training at art school. He left Sligo life at sixteen to join the family at Earl's Court in London, and in the autumn of 1887 entered the South Kensington Art School, later attending classes at Chiswick and Westminster: but he learned little other than how to control and stylise his already fluent line (fig. 5).

By April 1888 he was finding an opening for his pen and ink sketches and cartoons in the *Vegetarian*, and two years later began a profitable career as a black-and-white artist, working for illustrated papers such as the *Daily Graphic, Ariel* and *Paddock Life*. From this time on, one can see clearly that his artistic career divides itself roughly into three separate periods with different techniques:

1. 1888–1897 Black-and-white illustration, pen and ink

2. 1897–1909 Watercolour sketches and paintings

3. 1909–1955 Oil paintings

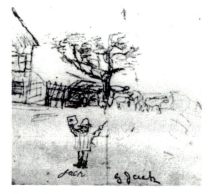 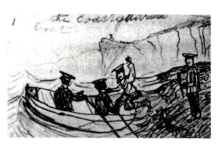

2 and 3 Sketches from family album, Devon, 1879 (coll: Michael B. Yeats)

The periods overlap a little. Yeats's first oil can be dated in style as early as the period when he began to work seriously in watercolour. He continued to paint in watercolour for a year or two after he had turned to oil. With regard to pen and ink illustration, after abandoning a career as a black-and white artist, he repeatedly made pen and ink illustrations, for the Cuala Press, and for books including his own, and for greetings cards, almost until the end of his life. During the thirties he made an important series of mixed media drawings, contained in seven manuscript volumes, entitled *Lives* (see pp 27ff).

But the areas outlined above are a ready guide to the artist's development, and indicate the periods at which a certain technique was his main preoccupation.

The first exhibition of watercolours

While a few watercolours survive from the earliest black-and-white period, it seems that Yeats was beginning to think seriously about concentrating on watercolour from 1894. In 1895 his *Strand Races, West of Ireland* was accepted by the Royal Hibernian Academy; and the following year he painted a few watercolour landscapes in Devon, while looking for a house where he could settle away from London. At the time, like many other Irish artists, he must have seen more opportunities for a career in art in England than in Ireland, and his Devon ancestry would have drawn him naturally to the area.

What interested him in Devon was people rather than landscape. He was fascinated by the farmers and the horse traders, by the local rivalries and the fair entertainments, by the contenders in races and boxing matches, and no less by the audience who were glued to the performances. He worked assiduously in an original style which consisted occasionally of watercolour alone, but mainly of pencil or

a

b

c

4 Jack B. Yeats signature: a. 1897; b. 1903; c. 1910

5 Old Quaritch (publisher) at book sale, London, 1890

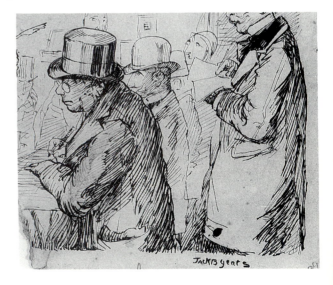

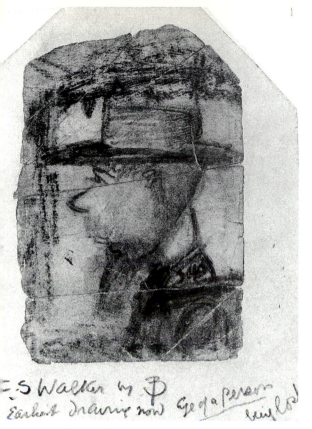

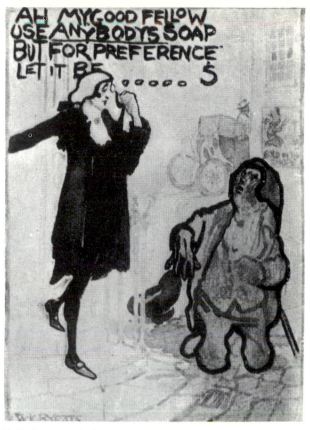

6 F. S. Walker (Yeats's earliest surviving drawing)

7 Early poster design (photo: Witt Library)

charcoal and crayon sketching, finished with a harmonious, sometimes vivid, wash. By November 1897 he had gathered together forty-three watercolour sketches for his first one-man exhibition at the Clifford Gallery in London's Haymarket.

Style was an obvious consideration by the artist in this first collection of watercolours, even to the affected nature of the signature. Used occasionally in his pen and ink period, and featuring a box shape on top of the 'J' (fig. 4), this form of signature disappeared before the end of the century, to be replaced by a bolder but plainer form of autograph, generally in capital letters.

Early influences

Yeats in these first works established a distinctive post-impressionist manner, most noticeable for its sketched, 'living' quality, and for the virtuoso use of empty space. In some examples this latter characteristic relates to the artist's mannered illustrations of the early nineties, and are an obvious response to the effects of Art Deco and Nabi innovations. Yeats himself had worked as a poster artist. A

13

photograph of an unidentified poster design by him in the Witt Library (which may never have been used; fig. 7) shows how he reacted to current taste, and the influence of Lautrec's widely circulated designs. Yeats, like Toulouse Lautrec, was a compulsive sketcher of popular entertainers and entertainments. But in the case of the watercolours it is more likely that he had seen some Degas drawings and pastels in London at the New English Art Club. The common interest of both artists in race meetings and stage entertainment, and Degas's powerful line, would have made the older artist instantly attractive to the younger. Yeats never commented on modern masters, other than in an irreverent dismissal of those who were idolised: but his eyes were always open to what was to be seen, and he tended to absorb what was available rather than to copy.

He had opportunities to see contemporary art. As a young man he visited Paris. Another trip took him through Belgium and Switzerland to Venice, stopping at Como; while on a further occasion he travelled on a steamer down the Rhine, stopping at towns on the way. He attended exhibitions and visited galleries in London and Dublin. Yet he was loath to offer an opinion on the work of other artists.

According to George Moore he looked bored in the National Gallery. Writing about J. M. Synge, Moore, who though cynical could be quite astute in his observations, compared playwright and artist with one another as being totally unacademic. 'Synge and Jack Yeats are like each other in this, neither takes the slightest interest in anything except life, and in their own deductions from life; educated men, both of them, but without aesthetics. . . . Synge did not read Racine oftener than Jack Yeats looks at Titian.'[8]

Yeats's sketchbooks, of which there are over one hundred and fifty during his watercolour period, reveal a knowledge of and an interest in all things visual as aspects of life: and the life of the common man, as he interpreted him, whether comic or tragic, was the subject of his watercolours.

Early characteristics

A remarkable feature of the watercolours of his first exhibition of November 1897 is the emphasis the artist laid on titles. Titles of course were important to Victorian watercolourists. With Yeats, however, they tend to extend the theme of the water-colour rather than to embellish or describe it. '*Hold Me Hat till I Tear 'Un!*' and others using local dialect not only show the artist's continual enjoyment of words, which later resulted in some resounding poetic titles, but indicate how he brought a human warmth to the rather spare imagery.

Some of the 1897 scenes are handled with less elegance than others, and some are slight. One forgets, seeing the works singly a century later, that Yeats was not only forming a personal style, but that he regarded each watercolour as only a part

of the whole collection, so that it did not matter how minimal it was physically so long as it contributed to the overall impression. The sketches were conceived in much the same way as the elements of a modern installation, which consists of wall pieces, and audio aids, only that with Yeats there are only wall pieces. Critics from twenty papers and more who visited the exhibition recognised this, and dubbed the exhibition *Life in the West Country*, even though he had chosen the rather modest title, *Watercolour Sketches*.

The critics commented on his ability to create movement and character, albeit by caricature. They noticed the thinness of his colour, and found a few sketches like *The Light on the Foam* and *Thistles* to be inanimate. But they showed great interest, as did the public. The sketches were priced between three and fifteen guineas, prices which remained constant as long as he painted in watercolour, the largest being as big as his small oils would be, or larger; and quite a few sold, one to Elkin Mathews, who not long afterwards became Yeats's publisher.

It was perhaps because of the criticism of his work that Yeats the following year was more adventurous with colour. He quickly reduced the sketch element in his work, and began to appreciate the flexibility and glowing translucence of the watercolour medium. *The Music* (no. 109) and *Singing—'The Big Turf Fire'* (no. 110) of 1898 revel in liquid tones; while the rich clear colours of the yacht paintings, *On the Broads* (nos. 130–2), pre-empt the joyous spectrum of the late oil paintings.

Second exhibition

Even so, his second exhibition—in 1899, again in London, but at the Walker Art Gallery in New Bond Street, which was to be the venue for his subsequent water-colour shows—earned some criticism for an occasional muddiness of colour when he used gouache. The critics, though, were agreed that he had a real talent for drawing, not with absolute accuracy, but with a gift for catching character—with a caricaturist's spice of malice—and for suggesting the weather and lighting of landscape. The *World* likened '*The Big Turf Fire*' to Daumier, and felt the young artist fulfilled the promise of his first exhibition; while the *Artist* added, 'Many of the pictures shown were merely hurried notes, but none the worse for that'. R.A.M. Stevenson, writing in the *Pall Mall Gazette*, noticed Yeats's tendency to blend fact and fancy, and felt he had 'an intuitive feeling for the consistency of an imagined compact between nature and human emotions.' *Le Moniteur des Arts* declared that he would seduce the Parisians!

'Life in the West of Ireland'

Yeats seems to have seduced the London critics from the start through what the *Artist* called his 'remarkable sense and power of conveying unconscious Irish

humour'—something that would not always appeal to Irish critics, who suspected an element of the stage Irish in his approach. His second London collection was very different from the 1897 exhibition in that he had now deliberately announced his theme, perhaps losing any diffidence after his impression of 'Life in the West Country' had been accepted seriously. Henceforward his theme was 'Life in the West of Ireland'.

The conversion to the Irish theme came during a visit to Donegal (fig. 39) and Sligo, planned for the summer of 1898, because of the success of his first exhibition.[9] The Irish visit coincided with the centenary celebrations of the Rising of 1798 (figs. 8, 39). Yeats was carried away by the figure dressed as Robert Emmet carrying the Tubbercurry flag (fig. 9), to see the possibilities of a grand *oeuvre* exploring the various aspects, high and low, political and social, of contemporary life in the part of Ireland he had known intimately since boyhood.

The first Dublin exhibition

His first Dublin exhibition, again with the title *Sketches of Life in the West of Ireland*, opened at the Leinster Hall in Molesworth Street, in May 1899, showing most of the pictures that had appeared in London. Now the major critics and collectors came from a background of literary Dublin. Synge, Hyde, Maud Gonne and Susan Mitchell were at the opening reception hosted by Lady Gregory. George Moore and Max Beerbohm were there. Horace Plunkett, Yeats's Uncle George (Pollexfen), and Edward Martyn, who collected continental works and promoted Irish artists, all came to buy.

The *Dublin Independent* placed Jack Yeats 'in the first rank of the school of modern impressionists', while other papers tended to see him offering in a visual way what Carleton and Lever did in literature. AE alone looked more deeply, summing up the overall effect of the exhibition as 'strange and somewhat grotesque'. Writing in the *Dublin Express* he described the 'almost poetical excess of energy in the conception'.

His comment is interesting, coming in the same week as the row about W. B. Yeats's play, *The Countess Cathleen*. 'The sombre Yeats has his poem-play enacted in the Antient Concert Rooms, and the sunny Yeats has his pictures on exhibition at the Lecture Hall', commented the *Independent*. But WB's play was attacked during the performance; and later some university students complained about its being 'unIrish'.

There was no question about Jack Yeats's Irishness, which appealed to those Irish people who identified with its original form of nationalism. There was still the very human humour that had characterised his Devon drawings, and the bonhomie was still conveyed in stylish caricature images, with striking titles such

as '*It's the largest firrm in all Ireland—eleventeen acres, not wan less*'. Yeats delighted in local idiom and idiosyncrasy, and could make use of ballads which he loved (cf. nos. 195, 198). Perhaps the best work on show was the large image of a pugilist, *Not Pretty But Useful* (no. 203)—a Devon subject which he did not feel was ready to be exhibited until 1899: but it fitted into the general scheme. Edward Martyn recognised its merit and purchased it, and it is now in the Hugh Lane Municipal Gallery, Dublin.

Yeats's method

Having adopted a permanent theme, Yeats now established a method for watercolour making. He had for some years been making sketches wherever he went, at first on odd pieces of paper, or in stray notebooks together with cuttings of interest. He used Rowney Ringback sketchbooks for the first time on his trip to Como and Venice in 1898, and afterwards used these small sketchbooks (listed at the end of this volume) for the most part as visual diaries, making comments and noting dates and places (figs 40, 41). In some one can see the day's events unfold as each page is turned. He referred to these pencil and wash sketches, even when he had abandoned watercolour for oil, throughout the rest of his life.

His habit, from 1898, became to visit Dublin and the West of Ireland generally during the summer to study landscape, local characters (fig. 10) and events, and make sketches. These he worked into large watercolours when he returned to his studio at Cashlauna Shelmiddy, near Strete, in Devon (fig. 26). The works were exhibited when ready, at first in London and then Dublin, but increasingly in Dublin where, with the growing strength of the Irish Literary Revival, he opened up new attitudes to visual creativity in Ireland because of his original approach.

Just as his brother, observing Russian and continental advances in drama, determined to reform Irish theatre by rejecting established conventions, Jack Yeats in his first watercolour sketches indicated his response to contemporary European art, aiming to image what he saw in a living impression, at the same time as developing the emotional and social resonances of his images. Viewers found his works untidy and mysterious, but exciting because of their originality. He was adopted by the literary movement, his Dublin openings usually coinciding with opening nights of the Irish Literary Theatre. Yet he remained independent. Living in Devon enabled him to avoid being absorbed into the general cultural movement. He had time to develop his original manner in a leisurely way, and to maintain complete objectivity about his Irish subject-matter as he painted.

His nationalism

Irish critics were puzzled rather than enthusiastic, even though Jack Yeats's belief—

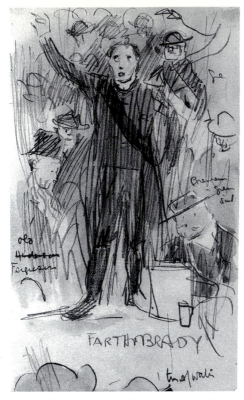

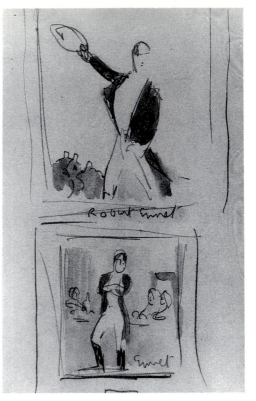

8 Father Brady at Carricknagat, 1898 (Skb. 12)

9 Robert Emmet banners, Carricknagat procession, 1898 (Skb. 12)

that the best way to create a distinctive Irish school of art was to stimulate young artists to find their own mode of expression in painting their own country and their own people[10]—was in the best spirit of nationalism of the day.

Opinions about him differed. *An Claidheamh Soluis* in August 1902 called him 'Seághan de Ghéats: fear aisteach' ('strange man'). Though the *Art Journal*[11] might think him 'the most distinctively Irish painter' of all the artists showing in Lane's London Guildhall Exhibition of Irish art, Robert Elliott, writing about the current renaissance in painting and sculpture in the *Nationist* in 1905,[12] wondered 'whether Ireland contains him or not. . . . Probably not. . . . My impression of Mr. Jack Yeats's work is that it is more English than kindred English work itself. It is as nineteenth century English in its way as Mr. Orpen's painting is "New English" in its own way.' Whereas *Sinn Féin* seems to have accepted his idiosyncrasies, and, reviewing his exhibition in 1906, thought that his landscapes, compared with those of AE, were without poetry: and that he was best when painting men or women, or some fantastic circumstance.

His mid-period watercolour style

The *Freeman's Journal* analysed his work seriously in 1905 (19 September).

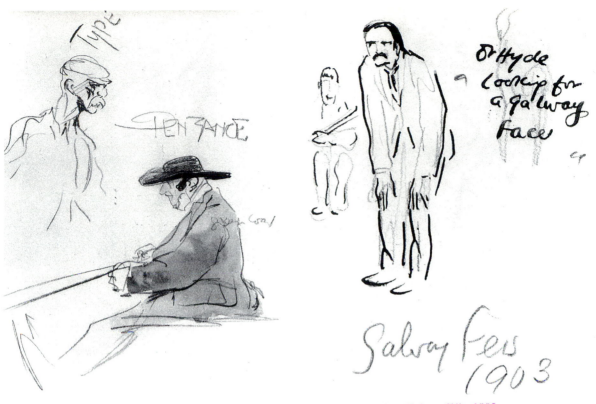

10 Types at fair, Penzance, 1898 (Skb. 7)

11 Douglas Hyde at Galway Féis, 1903

It is perfectly true that there are some of the pictures which record an 'impression' that may remain on the mind as a truthful indication of a passing episode. But the majority of them leave altogether too much to the imagination. Everybody appreciates their bold and fearless style, especially in watercolours, but there should be no need for putting a black, and in some cases, presumably, a purposeless black outline and filling the intervals up with a weak medium that gives no help whatever to the object or purpose in view. Mr. Jack B. Yeats would seem to think otherwise. If one were to judge by this exhibition, one would say that the artist's notion is that of 'suggesting' everything, and by making all things as gloomy and vague as possible the spectator is to arrive at some great and marvellous conclusion. The sooner Mr. Jack B. Yeats gets rid of that idea the better, if he desires to relieve himself from the position of occupying what has been described as a 'fool's paradise'.

At the same time, the reviewer praised the pictures which were more than mere sketches, and recommended the exhibition as 'good and rugged art' to any one who took an interest in the arts.

The work Yeats showed at his exhibitions in the first years of the century was of

19

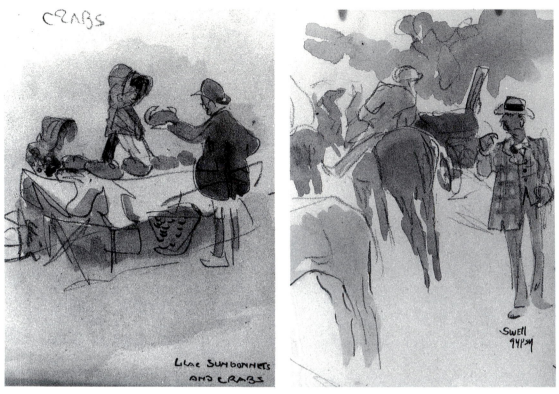

12 Kingsbridge Fair, 1899 (Skb. 22)

13 Swell Gypsy, Kingsbridge Fair, 1899 (Skb. 22)

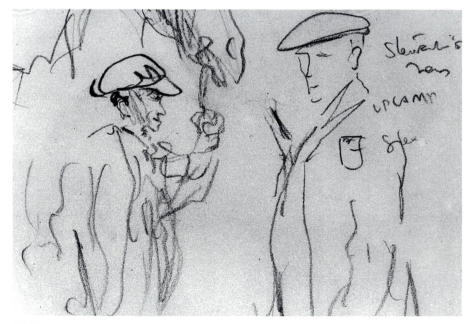

14 Two men at Camp Races, 1913 (Skb. 180)

15 On board the Celtic (Skb. 84)

16 'Gingerheaded Puller' (Skb. 84)

17 John Quinn, 1904 (Skb. 83)

21

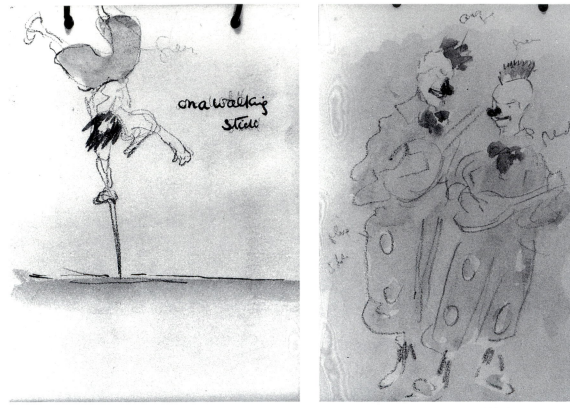

18 On a walking stick, Tivoli, Dublin, 1903 (Skb. 71) **19** Circus at Gort (two clowns), 1899 (Skb. 19)

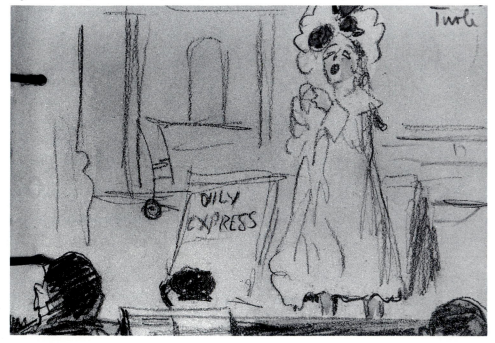

20 Dublin Tivoli, 1905 (Skb. 106)

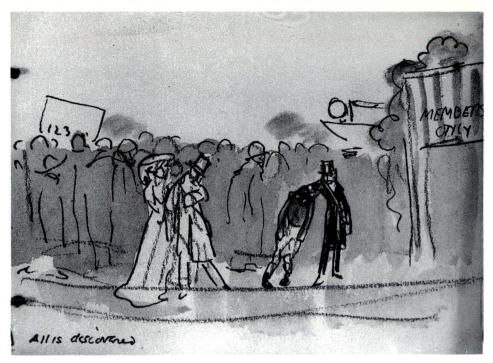

21 Melodrama—"All is discovered" (Skb. 60)

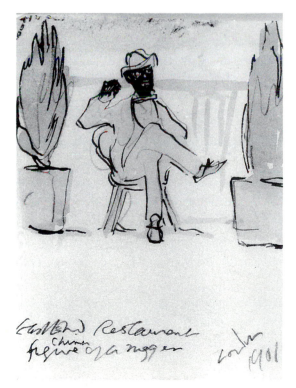

22 East End restaurant, London 1901 (Skb. 44)

23 In Chinatown, New York (from memory), 1905 (Skb. 103)

course uneven. He was constantly experimenting with new ideas. After 1900 he was caught up in contemporary cultural movements on both sides of the Irish sea. In Devon he was writing plays for his toy theatre, putting on performances for the local children, and for any visitors to his house: and Elkin Mathews, who collected his work, and was interested in the fusion of the arts, published several of these in London, as well as Yeats's monthly *Broadsheet*, a collection of poems and ballads illustrated by Yeats and Pamela Colman Smith, which came out during 1902 and 1903.

This venture led to an invitation, through Edward Martyn and Evelyn Gleeson of Dun Emer Industries, to design banners for the new cathedral in Loughrea, County Galway (nos. 447ff). Later Yeats illustrated and gathered material for the series of *Broadsides* which were published at the Dun Emer and Cuala Presses by his sister Elizabeth in Dublin, from 1908 for seven years.

As well as this, he was constantly experimenting with style, moving after 1900, in his middle period watercolours, from transparent tones to more solidly imaged paintings in gouache, with firm outlines. This was due in part to a slight change in attitude towards his work. While he still believed in creating an impression of 'the living ginger of Life' in his watercolours, Yeats had become conscious of the importance of memory as a tool for his craft, training his visual memory in his sketchbooks (fig. 55) as well as sketching from life (figs. 52, 53). Memory became a theme in *Memory Harbour* (no. 206), painted in 1900, and thereafter his watercolours become more weighty, perhaps affected by some contact with the symbolist movement, which affected his brother as well as himself.[13]

The lack of transparency of colour caused Dublin spectators probably viewing them in inadequate light in the Leinster Hall and elsewhere—to describe them as 'gloomy and vague'. Yet Yeats certainly knew how to use colour when he wanted to: and there is no doubt that his choice of bright or restrained colour has much to do with the emotion and atmosphere of the paintings. Colour for him has more to do with symbolism than realism, and he tended to use complementary tones as a result of post-impressionist influence (in this paralleling his father's work of the period in portraiture, where a harmonious combination of colours in each painting sets the mood for the portrait).

The firming of style was also a way of making his watercolours more enduring. For some reason Yeats was slow to take to oil. He painted and exhibited two figurative oils in 1902, one of them in a cloisonné manner, but did not use oil again for four years, when he gradually began training himself in its use by painting landscape. However, he developed a modern equivalent of the Victorian watercolour described as 'the poor man's oil', using solidly outlined images, made of layers of opaque colour, to build up the visual narrative which came naturally to him.

Not all of his mature watercolours are solid of course; but there is generally a definite outline. The outline derives partly from the artist's interest in stencil-making (figs. 44–7). He made portrait stencils as well as stencils of characterful shapes (for example, nos. 336ff): and form in itself interested him, as did the shadows cast by form (this is true also of his oils at all periods).

His use of outline was also influenced by his interest in the primitive block illustration on traditional balladsheets, which he imitated in his own *Broadsheet* and *Broadside* drawings. Nevertheless the tendency to outline was instinctive in an artist whose natural instrument for expression was line. Another natural influence was the West of Ireland landscape with its low horizon. Figures walking on the bohereens, lined with small stone walls, punctuated by scattered single storey cottages, were outlined against a vastness of sky.

Yeats was open to more modern influences too. The current fashion for Japanese prints led him to quite successful plagiarism (nos. 367–8a). He presumably knew the work of Hiroshige and Kunisada, who were widely collected: but his two pastiches resemble more the battle prints of Yoshitoshi (1839–92) in their warlike spirit. Yeats hides one of his own pirates in a Japanese disguise which is quite difficult to penetrate, and he obviously satisfied his own sense of humour, while experimenting with the oriental technique.

Not all his work of this middle period is experimental. He painted many confident watercolours, such as the *Valley Wood* series of landscapes (nos. 207ff), and studies of characters varying from the finely observed returned American (no. 281) to the sensitive portrait of John Masefield (no. 519; figs 36, 37) as well as vivid and humorous or tragic episodes of the western life he studied so intimately.

Collectors

Yeats had a steady, if moderate, flow of patrons at his exhibitions on both sides of the Irish Sea, particularly writers and artists, or collectors in sympathy with the literary renaissance. He attracted important buyers like Sir Hugh Lane, Sir Horace Plunkett, Lady Cadogan, and John Quinn (fig. 17), the American connoisseur, who collected a great number of his watercolours, and who organised his first exhibition in New York in 1904 (fig. 30).

His personal catalogue for the exhibition in 1902 at the Wells Central Hall, Westmoreland Street, in Dublin, is covered with sums, and has a note, 'I believe I have added it wrong, I am tired, but isn't it good! gate money paid, rent & printer'. His total earnings for the exhibition came to £106. 9s. His watercolours have continued to appeal to a wide range of pockets and tastes, being generally more modestly priced than the oils, and relating to a theme which in his own day was of current urgency, Irish life.

From the beginning of 1903, Hugh Lane was thinking seriously of establishing a gallery of modern art in Dublin;[14] and he set about approaching artists and friends who might be persuaded to present works to form the nucleus of a collection. Jack B. Yeats gave three watercolours, *The Rogue* (no. 465), *The Melodeon Player* (no. 476) and *The Day of the Sports* (no. 509), and these were exhibited, with the rest of the collection for the proposed gallery, at the Royal Hibernian Galleries in November 1904, with the object of convincing the Corporation and all of Dublin that such a gallery should be supported. The original Dublin Municipal Gallery of Modern Art (now the Hugh Lane Municipal Gallery of Modern Art) opened three years later on 20 January 1908, at 17 Harcourt Street, Dublin.

Jack Yeats gave of what he considered his most up-to-date important work—character studies of contemporary Irishmen of the West. Since then his drawings and watercolours have found their way into most of the galleries in Ireland, either by purchase or donation, the most important collections being in Sligo and Dublin. They may be found in England, where his watercolours have tended to be more popular than his oils, in public collections such as the Victoria and Albert Museum, and the Cecil Higgins Art Gallery in Bedford; and in America—in Boston and New York among other places. His watercolours are in private collections all over the world.

The late watercolours

From about 1906, when Yeats was painting a little more in oil, a new spirit is noticeable in his watercolours. The images and manner are much the same as before, but they are treated more seriously, often isolated pictorially in space; and the themes generate a greater breadth of purpose. Synge's friendship had made the artist see his Western Irish imagery in a wider context, so that landscapes and figures plumb more deeply from the particular to the universal.

Having embarked originally on his theme from a distance, developing artistically the visual reporting he had done in black-and-white in the nineties, Yeats now found his emotions were becoming involved in his own country, and he was instinctively distancing himself from Devon, where he had been living for a decade. 'I don't think a great lot of a great many of the Sinn Féiners', he told his American patron, John Quinn, 'but I believe in the Sinn Féin "idea". I think its a good thing for its full of living ginger.' He had no illusions that Ireland was better than any other place, but it was his own country. 'It is a nation ready to start at any time though I know that if we had Home Rule tomorrow, for many years there would be many queer things done, as there would be among any people who had had no hand in governing themselves since modern ways of governing became necessary.'

He continued to paint Irish characters, such as the pig buyer (no. 635), the country

rake (no. 637), and the circus clown (nos. 645, 681). He was making pictures now rather than sketches. He first called an exhibition *Pictures of Life in the West of Ireland* in 1905, and continued the practice from 1907 on. The smooth relaxed style of the period was adopted for the oils he was attempting to master concurrently with the final watercolours; and, judging from the way oils and watercolours are reproduced together in his book of illustrations, *Life in the West of Ireland* (1912), for the moment his attitude to both techniques of painting was similar. He did not differentiate between watercolour and oil stylistically, or seek different effects. Instead subject-matter was the prime concern. In his last watercolours, exhibited in 1910, there is a visionary quality on occasion, as in *The Look Out* (no. 692), achieved through an understanding of colour and form, which he had not at that date reached in his oil painting.

After 1910, when he settled permanently in Ireland, Yeats painted consistently in oil, and the final entries in this catalogue are of sporadic drawings and pastels made when these media had assumed a secondary importance for him. The pastels of Ballycastle, Co. Mayo (nos. 714–18), are important in that they look forward to the sketch-like impressions of landscape in pure colour in late oils such as *And Grania Saw This Sun Sink* and *Queen Maeve Walked Upon This Strand*, painted in 1950. The late drawings, especially nos. 715, 717–8, are integral to understanding Yeats's development as a painter, showing how he explored the implications of memory and increased subjectivity, and essayed a more personalised style in pencil long before he did so in oil.

It is worth observing that these compositions were still independent works, and were not sketches or studies for his oil paintings.

Lives

During the 1930s Yeats demonstrated how he still regarded his work in other media as being totally independent of his oil paintings. About 1939, he finished the final volume of seven books worked in pencil, wax crayon and ink which he called *Lives*.[15]

Lives parallels his contemporary output in prose and plays, which was a major preoccupation during the 1930s,[16] as well as his painting of some extraordinarily imaginative but deeply human fantasy oils dealing with mythological themes, such as *A Race in Hy Brazil* and *Helen*. It is difficult to say whether the seven books of *Lives*, describing various aspects of active, meditative, melodramatic and visionary life, by superimposing monochrome or coloured images over and around each other, were executed at one time. They may have been worked at intervals over a fairly long period; though judging by Yeats's speed of working it is more likely that the span of creativity was more like a matter of months.

The effect of the volumes, as one turns the pages, is to create an instant illusion of the complex layers of human life at physical and metaphysical levels, the whole

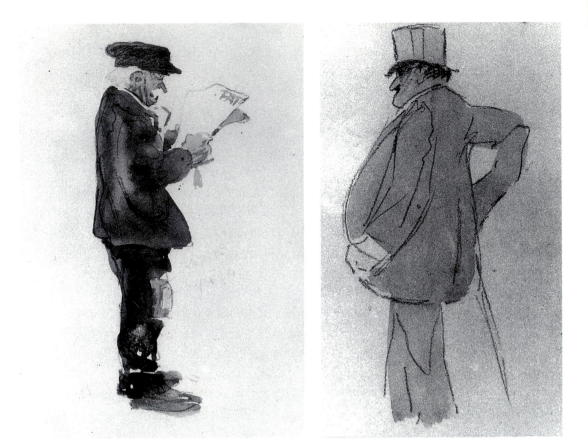

24 Workman reading, Paris 1899 (Skb. 21) 25 Man with top hat, Paris 1899 (Skb. 21)

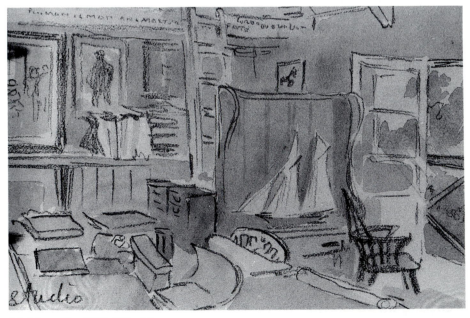

26 My studio, 1899 (Skb. 24)

27 Snails Castle, 1897 (Skb. 3)

28 Group of four, Paris, 1899 (Skb. 21)

29 Our luggage, Rotterdam, 1907 (Skb. 127)

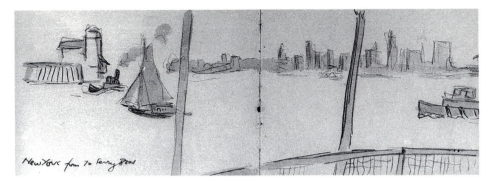

30 New York from ferryboat, 1904 (Skb. 83)

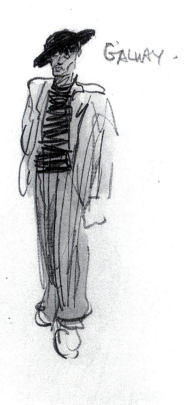

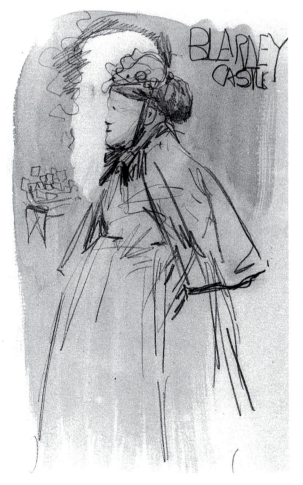

31 Galway 1898 (Skb. 9) **32** Blarney Castle, 1898 (Skb. 9)

expressed with a superb and irrepressible vitality. While certain characters recur, no individual dominates the whole; and Yeats's aim, it seems, is to visualise the abundance of human life and thought that exists and has existed both physically and in the imagination at any one moment. There is a great deal of drama, a good deal of pure description, and always an underlying *expressivo* musicality of emotion.

Individual drawings may show an emphasis on pencil, or coloured crayon, or on heightened pen work. The handling of the linear colour may be compared with Oskar Kokoschka's portraits of the forties where the crayon lines change from blue to green, yellow or red, as he draws, thus catching in variations of mood or changing the artistic emphasis.

The large volumes of *Lives* may appear to have little in common with the small sketchbooks that Yeats had carried around with him from his earliest years, to enable him to note on the spot what he saw. They came as an astonishing interlude during a particularly fecund period of original writing and painting. However, on reflection, the link is strong. Not only do the volumes underline for the student of Yeats the degree of importance he put on the lighter media which he used in his early sketchbooks, such as pencil, crayon and watercolour, but they also pick up the theme of 'Life' which Yeats explored in those sketchbooks, and use similar means to do so.

Yeats had trained himself from the start in the use of pencil and colour, and through the exercise discovered the value of 'Life' as a subject. Out of this revelation grew his whole watercolour *oeuvre*, which formed the foundation of his work as an oil painter. Then during the thirties he developed his theme of 'Life' into these volumes of *Lives*, making visual a broader view of the ephemeral reality and complex fantasy of the human life, inextricably woven in and out of the lives of others. *Lives* in a way bridges the artist's move from the comparatively few and important individual paintings of the late thirties to the numerous panels and canvases of the forties, with their curious levels of reality and fantasy knit together in colourful complexity.

The importance of the watercolours and drawings

In his work as a watercolourist as well as his work as an illustrator, Yeats valued the power of style: and he imitated and experimented with various manners, suitable to the occasion for which he fashioned them. His watercolours are interesting in themselves for their variety, the breadth of the subject-matter and for their inventiveness. Over the ten years when he worked primarily in watercolour, his style changed as often as it would in the oil paintings he painted for forty years after that. So did the sizes and shapes of his watercolours, which vary enormously, from the minute or the elongated panorama shape to a size only smaller than the largest oil he ever painted.

But in watercolour, unlike illustration, he was seeking for self-expression. The experimenting in watercolour laid the ground for his painting in oil. The oils

continue the theme, *Pictures of Life in the West of Ireland*: and during the first period differ little in style from the opaque watercolours except that the oil medium is more capable of subtleties of expression. Subsequently his oil manner developed in its own way, becoming a truly expressive instrument.

Yeats continued to look back to the themes of his watercolours when painting his late oils, where memory played a major part in his conceptions. Simple images are repeated after an interval of forty years, *The Street Juggler* (no. 603) of 1906 for example reappearing in metaphorical guise as *The Street Performer* in 1947. Tinkers, tramps, and pirates, the rather sinister personnel of the *Life in the West of Ireland* days, seem to have been an emotional outlet for the darker side of the artist's personality as well as a vehicle for fantasy. They people Yeats's canvases of the forties, their energy and colour contributing to the colour and fire of the late oils, their more vulnerable aspect being explored as they are revealed on occasion as Everyman. Similarly the circus clown, who is an entertainer caught at different moments in the watercolours, and epitomised in the personality of the legendary Johnny Patterson in 1899 (no. 198) and the oil of 1928, is transformed later in eloquent metaphor as the virtuoso *Clown of Ocean*, 1945, and and the deeply human *Glory*, 1946.

Yeats's experiences with Synge, on their now historic trip through the congested districts of Connemara in June 1905 (figs 33, 35), yielded many watercolours and pen drawings, and were the source for many oil paintings as well, which drew on the original watercolours.[17] Two important late oils in particular may be cited. *A Silence* benefits from the portraits Yeats made of Synge in 1905, translating memory into a metaphysical act of meditation, while *Many Ferries* remembers a particular incident, and transforms it in a mood of fantasy into a lyrical vision of bygone life. Landscapes, likewise, studied for mood and topographical aspects in the drawings of the artist's watercolour phase, because of the familiarity he gained in such close acquaintance, became the instrument through which he reached his most profound poetic images late in life.

Dating the watercolours

Dates of watercolours and drawings in this catalogue refer to the year when Yeats considered his work finished and ready to be exhibited. In late life he kept a list of paintings as he completed them. After painting, he would put a picture with its face to the wall, and take it out six months later. If he was satisfied, he then marked a seagull beside its entry in the list, showing it was ready to fly.[18]

His procedure with his watercolours was probably similar, though not so organised. He merely recorded the watercolours as he exhibited and sold them. As

I have said earlier, Yeats sketched during his visits to London and other places during the year, and to Ireland (to Sligo and Dublin in particular) each summer. He worked up his notes into compositions during the autumn and winter, and the following spring considered his watercolours ready for exhibition. So that the date given for a work in this catalogue is generally the date when it was first exhibited. Very occasionally a work was not shown for some years: but where I have seen it, and its style appears earlier than work of the year when it was first exhibited, I have placed and dated it according to style.

When Yeats's watercolours and early oils began to be exhibited in the early sixties after his death, dating was often noticeably wide of the mark (for example, no. 484). Some of the dates were first pencilled on the back forty or fifty years after the watercolour was executed. Yeats—who was in his seventies when Waddington became his dealer—dated them approximately; and since his style had not been assessed properly, not enough was known about them to date them accurately. It was believed at that time that Yeats had started painting and exhibiting watercolours much earlier than he did. In his records he sometimes—in the forties or later—entered as an 'early' watercolour one which is really from the final watercolour period—for example, 1910: so that 'early' is an ambiguous term.

By studying watercolours which are dated, or whose date is known from the artist's records and catalogues of his exhibitions, it has been possible to trace Yeats's chronological development, and so to provide a probable dating for works about which there has been uncertainty.

The same problem has pertained to titles in some cases. Titles in the catalogue marked with an asterisk do not appear in Yeats's records, probably because he never exhibited them. When Victor Waddington became Yeats's agent in 1943, and afterwards his executor, he evidently received various portfolios of watercolours and drawings most of which had no titles or dates. He would have shown those received during Yeats's lifetime to the artist, perhaps during a meeting at his Dublin gallery. The artist no doubt supplied alternative titles, not remembering the original names (they had been painted forty years before).

After the artist's death, Victor Waddington provided some titles himself, and essayed dates for some of the works shown in his London exhibitions of the sixties and seventies. This has been the case with some early landscapes of Devon and Dublin, which when I saw them unframed at Victor Waddington's Gallery in London in the mid-sixties had no dates or titles, and have acquired them, and sometimes a stamped monogram, in the meantime. Where I have identified the original title, both titles are entered in the catalogue and index, with the correct date.

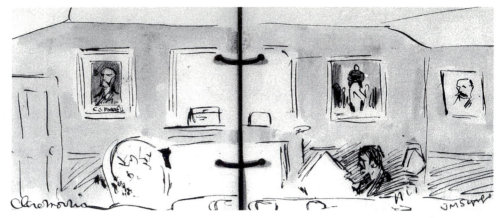

33 Synge at Claremorris, 1905 (Skb. 103)

34 J. M. Synge, 1905 (Skb. 103)

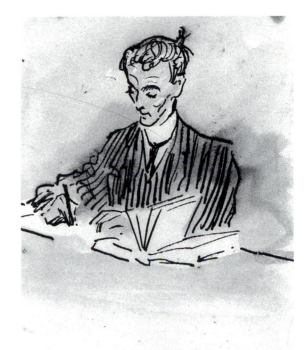

35 Mrs. Jordan, Belrnullet, 1905

36 Masefield writing, 1903 (Skb. 66)

37 Masefield and Moby
Dick, 1903 (Skb. 66)

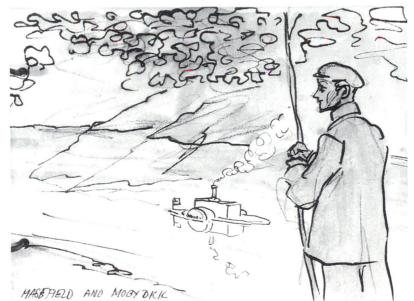

MASEFIELD AND MOBY DICK

38 Fife and drum band, 1898 (Skb. 12)

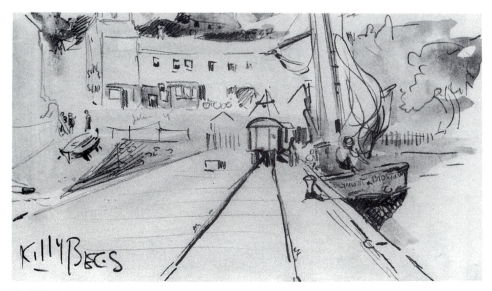

39 Killybegs, 1898 (Skb. 10)

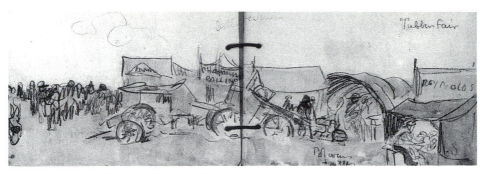

40 Tubber Fair, Galway, 1906 (Skb. 116)

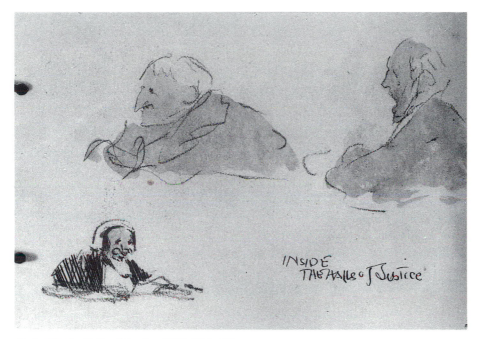

41 Inside the Halls of Justice, 1899 (Skb. 18)

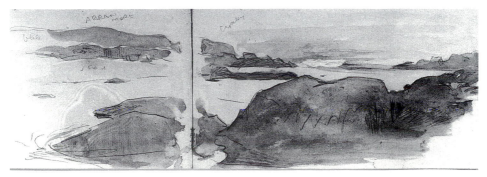

42 Arranmore, 1898 (Skb. 11)

When Yeats showed his first watercolour sketches in 1897, there is little doubt, judging from his emphasis on style apart from content, that he saw himself as part of a modern movement. His initial influences had been from Irish 19th century painting, through his father John Butler Yeats, with a background of English illustrators of childhood stories such as Cruikshank and Leech. Working with Furniss and Phil May in London as a black-and-white artist gave him a professional expertise with his pen and a flexibility of manner and outlook.

The spontaneity and choice of subject-matter of his first watercolour sketches suggest that he had seen the drawings of Lautrec and Degas and other contemporary masters, and was also sensitive to the effects of Impressionism. His inadequate formal training was responsible for a rawness of technique, which nevertheless contributed a great part of the authenticity and sense of immediacy to his work.

Subsequently Yeats dedicated himself to creating an Irish theme and original style which, as a result of the influences of post-impressionism, found its individual idiom through close study of the landscape he knew in Sligo and Connemara. This individual and unacademic approach isolated him from other Irish artists, who with the exception of O'Conor and W. J. Leech, who had removed to the Continent, tended to be conservative, working within the shadow of the Academy. He deliberately maintained an aloofness from other artists, particularly during his watercolour period, and therefore it is difficult to judge him satisfactorily in a purely artistic context.

In addition, after 1900, he did not exhibit in the Royal Hibernian Academy, and, with the exception of Hugh Lane's Guildhall and Dublin exhibitions of 1904, he showed rarely in group shows.[19] He depended on his regular one-man shows for bringing his work to the public: and only when he turned full time to oil did he begin offering paintings regularly to group exhibitions at home and abroad.

His watercolours therefore—apart from the fact that they form the main corpus of his artistic output and thus must be considered differently from those which are the minor works of a master—do not fit satisfactorily into the existing context of the Irish School. This was led by Orpen at the time, who was slightly Yeats's junior and the guiding light of young academicians. Yeats's watercolours at a certain point are closest perhaps to the domestic scenes of Walter Osborne, who, though a distinguished academician, just before his early death in 1903 was painting in watercolour, in particular, under the influence of impressionism.

Other original watercolourists like Mildred Anne Butler and Rose Barton, the latter painting contemporary city scenes, never broke completely from their academic training. When Yeats's watercolours were exhibited at the opening of the

Municipal Gallery of Modern Art, in Harcourt Street, Dublin, in 1908, alongside Lane's collection of continental, English and Irish drawings and watercolours, it was not to Beerbohm's polished caricatures and Conder's decorative fantasy that he related, despite his obviously English antecedents. Instead his raw live manner, his ironic yet compassionate approach, and his absorption in everyday events unfolding before his eyes, comes closest to Daumier and Legros.

During these early years, when he was working both superb watercolours and more experimental drawings of uneven quality, the Dublin spectators found it difficult to accept Yeats. Though his singular power and original viewpoint were acknowledged, what he painted disturbed viewers. One contemporary commentator wrote, 'It is as if he had determined to make visible for himself and us the wasteage, and wreckage and human debris of a great race, passing, or near passed. He has done this, though I am not sure that it is not an ill thing well done.

The general effect is sinister. These strange, strong, cunning faces seem somehow to belong, not so much to the wasted or gone astray, as to the damned.[20]

In this sentiment the writer was merely echoing the observations of AE, a fellow painter, who had found Yeats's first exhibition in Dublin 'strange and somewhat grotesque'. But AE had noticed also—prophetically—the 'almost poetical excess of energy in the conception'.

1 Jack B. Yeats to W. B. Yeats, 31 October 1925.
2 *Dublin Magazine,* vol. 1, no. 1 (August 1923), 3.
3 7 September 1906. New York Public Library Manuscript Collection.
4 Private collection and National Library of Ireland. These appear in the catalogue of Jack B. Yeats's black-and-white illustration which is yet to be published.
5 Illustrated in W. Murphy, *Prodigal Father* (1978, 1979), 119.
6 *Christian Science Monitor* (Boston, 2 November 1920), 'The education of Jack B. Yeats' by John Butler Yeats.
7 Pyle, H. (1970, 1989), 60-7.
8 *Vale* (1933), 140-1.
9 See Pyle, H. (1970, 1989), 42. Jack told his brother at the 1897 exhibition that if it did well he intended to go to the West of Ireland to draw.
10 *Irish Independent* (11 May 1909).
11 1904, p. 236.
12 28 September 1905, p. 33.
13 See T. R. Henn on W. B. Yeats, 'Painter and Poet' in *The Lonely Tower* (1965), 238–71, among other references.
14 See also Lady Gregory, *Hugh Lane's Life and Achievement* (1921), 32 etc. and Thomas Bodkin, *Hugh Lane and his Pictures* (1956), 7.
15 Private collection. Being in book form, these volumes technically fall outside the scope of this catalogue of individual watercolours and drawings; but they are worth considering in the overall context of Yeats's graphic *oeuvre*, and, like the sketchbooks listed on pp. 183ff, play a vital role in the understanding of the growth of Yeats's oil style. Examples are reproduced in plates 21–23. The individual volumes are described in more detail in Pyle, H. (1970, 1989), 147–8.

16 Pyle, H. (1970, 1989), 147–8, etc. J. W. Purser, *The Literary Works of Jack B. Yeats* (1991), 18–24.
17 See Pyle, H., 'Many Ferries—J. M. Synge and realism' in *Éire-Ireland* (Summer 1983).
18 Anne Yeats in conversation, also in lecture on her uncle, *James Joyce Seminar* organised by the Princess Grace Library, Principality of Monaco (12 June 1990).
19 He contributed to exhibitions organised by the Irish Literary Society, the Gaelic League, the Oireachtas and the Dublin Aonach. Other group exhibitions of the period in which he showed are listed on p. 176ff.
20 *All Ireland Review* (30 September 1905), 360.

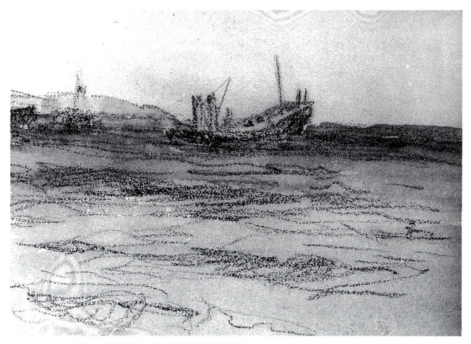

43 Boat seen from Haul Sands, 1899 (Skb. 24)

CHRONOLOGY
OF THE LIFE OF JACK B. YEATS

1871 Jack Butler Yeats, third son and youngest surviving child of John Butler Yeats, and Susan Pollexfen of Sligo, born at 23 Fitzroy Road, Regent's Park, London, on 29 August.

1879–86 Lived mainly with his grandparents, William and Elizabeth Pollexfen at Merville, and then Rathedmond, Sligo; sometimes visiting his family in Dublin, while his father was painting portraits there. Drawing continually from an early age. First known watercolours, of *Beauty and the Beast*, given to his sister, Elizabeth Corbet Yeats, July 1885.

1887 Joined his family who had moved to 58 Eardley Crescent, Earls Court, in London. Attended art classes at the South Kensington School of Art, at the Chiswick School of Art, and at the Westminster School of Art. Season ticket for the American Exhibition at Earls Court, starring Buffalo Bill.

1888 The Yeats family moved to 3 Blenheim Road, Bedford Park. Jack Yeats started work as a black-and-white artist for *The Vegetarian*. Later he illustrated for *Ariel* and *Paddock Life*, and did book illustrations.

1892 Designing posters for David Allen & Sons in Manchester.

1894 Staff artist on *Lika Joko*. Married Mary Cottenham White (Cottie) on 23 August, at the Emmanuel Church, Gunnersbury, Middlesex. Their first home was at the Chestnuts, Eastworth, Chertsey in Surrey, where Yeats began compiling his first sketchbooks the following year.

1895 *The Strand Races, West of Ireland*, a watercolour, exhibited at the Royal Hibernian Academy in Dublin.

1897 The Yeatses moved to Strete, Devon, to live at Snail's Castle (Cashlauna Shelmiddy). Yeats working consistently in watercolour for his first one-man show in November, at the Clifford Gallery, Haymarket, London: and continued to work mainly in watercolour for the next ten years.

1898 Visited Venice. Present at the '98 Celebrations in Sligo at Carricknagat.

1899 First exhibition devoted to Irish subject-matter in London in February. The exhibition, consisting of watercolours and drawings, moved to Dublin in May, being his first one-man show there. Visited Coole at the invitation of the playwright, Lady Gregory, and visited Aran. Visited Paris in June.

1900 Death of his mother, Susan Pollexfen Yeats. Painted *Memory Harbour*. After 1900, he ceased to exhibit with the Royal Hibernian Academy until 1911. He continued to show his watercolours at the Dublin Aonach and Oireachtas exhibitions.

First showing of miniature plays in his miniature theatre at Cashlauna Shelmiddy.

1901 Published first miniature play, *James Flaunty*. Made many watercolour stencils, including *Pannerramarama of the Coronation*.

1902 Edited *A Broadsheet* for Elkin Mathews, with Pamela Colman Smith. Painted the Mechanics Theatre, which later became the Abbey Theatre.

1903 Gouache cartoons for banners in Loughrea Cathedral. Edited *A Broadsheet* alone until the final number in December. Visit of John Masefield, the poet, to Strete (Cashlauna Shelmiddy).

1904 To New York for his exhibition at the Clausen Galleries. Contributed three watercolours to Hugh Lane's exhibition of Irish art at the Guildhall in London.

1905 To the Whistler exhibition in London. Masefield in Strete. Toured South Connemara with the dramatist, J. M. Synge, to prepare illustrated articles for the *Manchester Guardian*; and later painted *The Man from Aranmore* and *The Causeway Bridge*, as well as portraits of Masefield, in watercolour, and Synge in indian ink stencil.

1906 Illustrated Synge's book, *The Aran Islands*. Painted his first landscape in oil, and began to paint more regularly in oil, while continuing to exhibit watercolours. Painted *A Warning Against Book Borrowers* in watercolour for John Quinn.

1907 Holiday on the Rhine.

1908 Yeats's father, the portrait painter J. B. Yeats, visited New York, and settled there permanently. First issue of *A Broadside* selected and illustrated by Jack B. Yeats.

1910 Yeats sold his house in Devon, Cashlauna Shelmiddy, and went to live in Greystones, County Wicklow, at Red Ford House. Last visit to Sligo for many years, for the funeral of his uncle, George Pollexfen.

He showed watercolours for the last time at his December exhibition at the Leinster Hall, in Dublin; and from now on painted in oil, or made drawings in pencil or coloured crayon.

1911 Began to contribute to Royal Hibernian Academy for the first time since 1900, showing oil paintings. Watercolours to Dublin Aonach and Oireachtas exhibitions.

1912 Published *Life in the West of Ireland*, including reproductions of watercolours and new oil paintings along with line drawings.

1914 Elected ARHA. Included a few watercolours for the last time in a one-man show at his exhibition in the Walker Art Gallery, London, in June.

1915	Elected RHA.
1922	Lecture on Irish Art to the Irish Race Congress in Paris.
1943	First exhibition with Victor Waddington, Dublin. Exhibited at inaugural show of the Irish Exhibition of Living Art.
1945	Eleven watercolours in the *Jack B. Yeats National Loan Exhibition* held in Dublin. They included *Useful*; *Singing—The Big Turf Fire'*; and, from the collection of Samuel Beckett, *Corner Boys*.
1946	D. Litt. Dublin University.
1947	Death of Mary Cottenham Yeats.
1948	Major retrospective at the Tate Gallery, London, organised by the Arts Council of Great Britain.
1950	Invested Officer of the Legion of Honour at the French Embassy in Dublin.
1951	Began to spend winters in the Portobello Nursing Home.
1955	Last paintings. Went to live permanently at Portobello House.
1957	Died on 28 March. Buried at Mount Jerome Cemetery, Dublin.
1961	First exhibitions of watercolours since 1910, in London at the Waddington Galleries, in Dublin at the Dawson Gallery.
1965	James N. Healy Bequest to Sligo County Library and Museum, in memory of his parents, which includes major watercolours from the collection of John Quinn.
1967	Purchase of *On the Broads, The Man from Aranmore* and *The Circus Chariot* for the National Gallery of Ireland permanent collection.

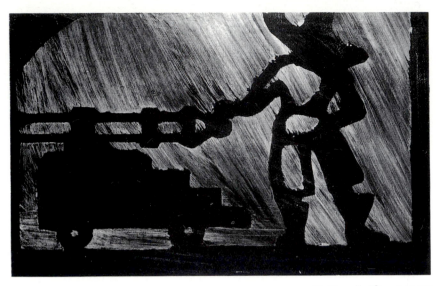

44 Stencil: 'Our men are full of rum.'

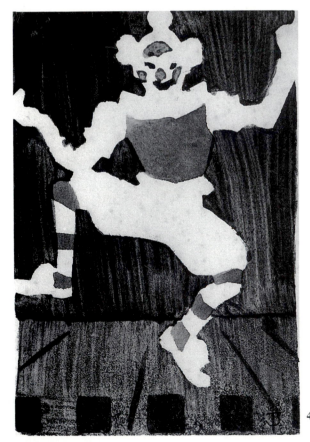

45 Stencil: 'Wishing you a happy Christmas', 1901

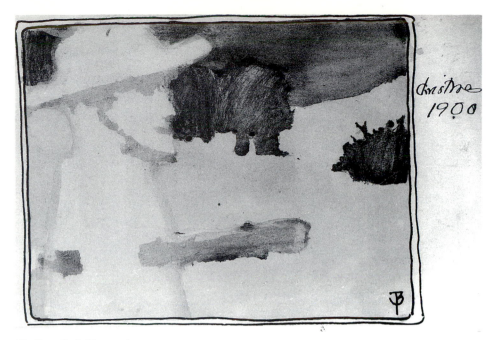

46 Stencil: Self-portrait
with baton and hat,
Christmas 1900

47 Stencil: Violinist on chair

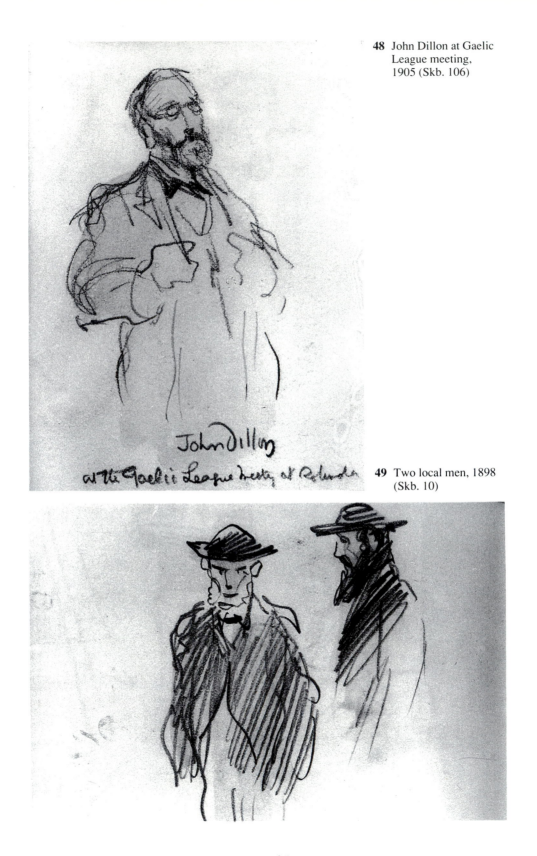

48 John Dillon at Gaelic
League meeting,
1905 (Skb. 106)

49 Two local men, 1898
(Skb. 10)

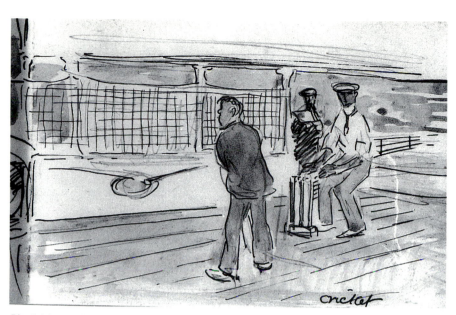

50 Cricket on board
the Celtic, May
1904 (Skb. 84)

51 Jeway Smith,
1903 (Skb. 65)

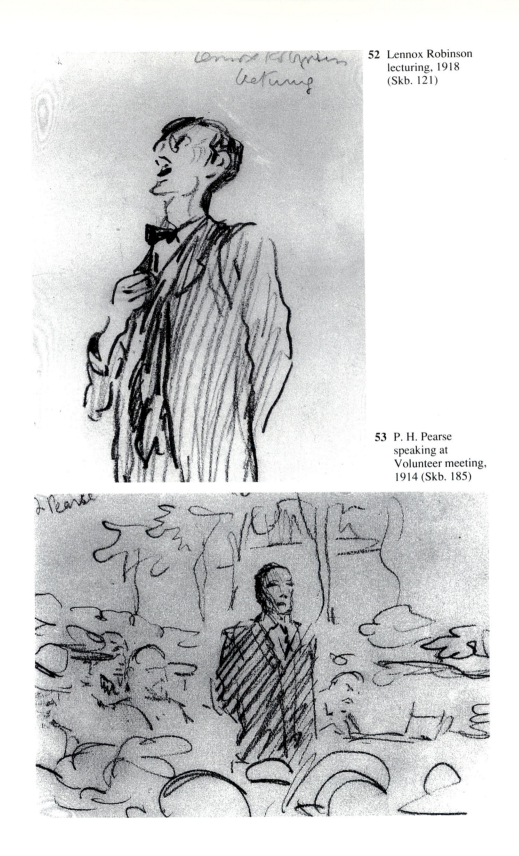

52 Lennox Robinson
lecturing, 1918
(Skb. 121)

53 P. H. Pearse
speaking at
Volunteer meeting,
1914 (Skb. 185)

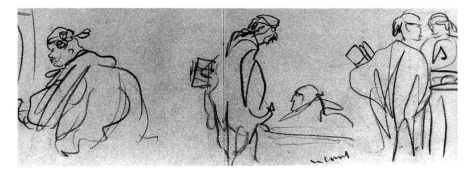

54 In Court, 1926 (Skb. 216)

55 WBY from memory, 1948
(Skb. 229)

THE CATALOGUE

CATALOGUE NOTE

Records kept by Jack B. Yeats

Jack B. Yeats's own records have been of great assistance in compiling this catalogue of watercolours. With their help it has been possible to study the development of his style chronologically: and so dating of works is believed to be generally accurate.

While the artist's records have made the listing of his watercolours and oil paintings fairly simple, there can be confusion due to the fact that he rarely noted down the medium in which a work was executed. Early exhibitions, up to about 1909, according to newspaper reviews, and to other references, consisted mainly of watercolours. His inclusion of two oils, *Simon the Cyrenian*, and *Willie Reilly*, listed among works known to be watercolours shown at these exhibitions, makes one wonder if any of the unknown works were also in oil. However, unless a work is known to be in oil, it is included in this watercolour catalogue until it is known for certain that it is not in watercolour.

Yeats of course did many watercolours that were not exhibited. When he sold one himself, he noted down the transaction. Since his death more have been sold from his studio portfolios and his drawing-books, and some of his sketchbooks have been broken up, and the sketches sold singly. Where I have been able to locate them, these sketches have been noted in the catalogue. Those watercolours and sketches which are not mentioned in the artist's personal records are distinguished from those that are in the records by an asterisk, since there is the possibility that some of the finished watercolours—now known under new names—may already be in the catalogue under the original titles Yeats used, if they were included in the early exhibitions.

The records that Yeats kept are as follows:

1. *Workbook 1897–1918*
 Inscribed: 'Pictures painted by me, where exhibited and sold, and any of the particulars'.
2. *Exhibition catalogues 1897–1946*
 A bound book containing catalogues of one-man exhibitions, which supplement the information in 1 and 3.
3. *Index 1*
 An index, started in 1919, to works painted and works exhibited from that date on. It is continued in

4. *Index 2*

 Works here were painted and/or exhibited mainly in the 1940s and 1950s. Some of the last paintings are included.

5. *Index 3*

 Carries on from Index 1 and 2. Mainly devoted to the 1950s, and includes some of the last paintings. Indexes 1-3 overlap to some extent as regards date. Works before 1919, too, are included if they were exhibited after 1919.

6. *Large Workbook*

 Kept late in life, and noting the date of release of each painting, when it was completed and the oil dry.

7. *Typelist (i)*

 Headed 'Black Workbook labelled Pictures (3)'. It is a typelist of Index 3.

8. *Typelist (ii)*

 A typed copy of item 6.

9. *Sketchbooks 1896–1953*

 There are over 200 of these, which give a detailed record of the artist's activities for the first twenty years of his career, and useful information applying to the later years. They are an invaluable source for dating, and contain first thoughts for watercolours and works painted sometimes many years after a sketch was first made. Those that I have located are listed on pp 183ff. There are others extant, given as gifts by the artist to friends, that have not been located. Some have been cut up and individual leaves are listed (when located) among the watercolours.

10. *Photographs, newspaper cuttings etc.*

 Collected by Yeats, and preserved among his papers.

Catalogue details

Watercolours are generally executed on paper. When it is known that the support is other than paper, this is indicated.

There is a separate entry for each work. Each is numbered. In the rare case of a work which is one of a series, such as one of a group of sketches taken from a sketchbook, it is catalogued with the other sketches of the group, but each sketch has an individual number.

Works are arranged in chronological order as far as possible. The date in the right margin represents when Yeats considered a watercolour ready for exhibition: but if it is thought to have been completed at an earlier date the work is entered at the earlier date. An effort has been made to group watercolours of similar subject, such as landscapes, or pub scenes, together: though this cannot be absolutely accurate since the content of many unlocated watercolours is uncertain.

All the works listed in the records kept by the artist are included. In the case of a few, about which nothing is known, the entry occupies a position close to that in the original records, thus allowing an approximate dating, and an indication that the work had been completed by that date.

Yeats sometimes changed his mind about titles, or exhibited a work with a slight variation in the title. Where I have identified a watercolour with a title not used by Yeats to be a watercolour exhibited under an original title, I have included both versions of the title, with for the more recent title in square brackets. I have also included title variations made by Yeats himself.

Measurements are given in centimetres, height preceding width.

Information about exhibitions is given in an abbreviated form which states the date of the exhibition, the place where it was held, and the number of the work in the exhibition. Entries entirely in roman type refer to one-man exhibitions; those in italics refer to the group shows to which Yeats contributed: and full details of the exhibitions are supplied in lists at the back of the book.

With the recent interest in Yeats, pictures are tending to change hands rapidly, and collectors and dealers are less willing to reveal ownership. For this reason it has possible to give only limited information about the present whereabouts of the watercolours.

Abbreviations

*	indicates that the work is not listed in the artist's records.
Sgd.	indicates that the work is signed in full 'Jack B. Yeats'.
Sgd. with monogram	indicates that the artist has used the monogram of his initials which he devised '𝒥'.
Stamped with monogram	indicates that the watercolour is stamped with a replica of the artist's monogram devised by Victor Waddington about 1967.
Insc.	Inscribed by the artist.
Exh.	Exhibited. Details of exhibitions are given in lists at the end of the catalogue. Dates, places of exhibition and catalogue number are given with each work: and those in roman type may be referred to the list of one-man exhibitions, those in italics to the list of group shows.
Coll.	Collections in which the work has been.
Lit.	Literary references.

'1897 London (2)' References to exhibitions are given in abbreviated form. Those in roman type refer to the Jack B. Yeats one-man shows listed on pp. 173ff: those in italics refer to group shows in which he exhibited, listed on pp. 176ff.

(repro) Reproduced in the catalogue or work specified.

■ indicates that the work is reproduced in full colour in the colour section of this book.

☐ indicates that the picture shown alongside is a reference picture, not the work itself. Where it is not clear from the catalogue note which reference picture is shown, a further indication is given.

There is no entry no. 696. Illustrations at catalogue entry nos. 201, 469, 540 and 640 were unavailable at time of going to press.

Abbreviations of literary references

MacGreevy, T. (1945)	T. MacGreevy, *Jack B. Yeats: an appreciation and an interpretation.* Dublin, 1945.
Murphy, W.M. (1978, 1979)	W.M. Murphy, *Prodigal father: the life of John Butler Yeats (1839–1922)*, Ithaca and London, 1978, reprinted 1979.
NGI (1986)	H. Pyle, *Jack B. Yeats in The National Gallery of Ireland.* Dublin, 1986.
Pyle, H. (1970, 1989)	H. Pyle, *Jack B. Yeats: a biography.* London, 1970, revised 1989.
Rosenthal, T. G. (1966)	T.G. Rosenthal, *Jack B. Yeats, 1871–1957.* London, 1966.

A NOTE ON YEATS'S ATTITUDE TO REPRODUCTION

Jack B. Yeats, for a large part of his career, actively objected to his pictures being reproduced, and it is only since his death that this has been done on a large scale. He did recognise that it was necessary for a student of art to have some visual record of a painting. In a letter of 4 August 1945 to Con McLoughlin about Thomas MacGreevy's monograph, he said, 'I myself liked best the idea of small reproductions of pictures, which recall the picture, as against larger reproductions, which, the bigger they are, the more they become like a featureless ghost staggering in front of a picnic party sheltering on a rainy day in a ruined home of other years.' An attempt has been made here to include as many small reproductions as possible, 'which recall the picture'.

1 Childhood Drawing of Horses* 1879–81

Insc. Mama from her loving son Jack
Pen and ink on an envelope, 9.5 x 19.5
Exh. 1965 *Greater Victoria (B.C.)* (453)
Coll. Dr. A. Saddlemyer, University of Toronto

The envelope was found in a copy of George
Clausen's *Six Lectures on Painting* (1904), orig-
inally owned by John Butler Yeats. One sketch
shows a galloping horse, the other the upper
half of a horse in harness.

2 The Beauty and the Beast* 1885

Insc. By Jack Yeats July 1885 g
iven to his sister Lollie July 14th 1885
Pencil, watercolour and some ink on 4 sheets
of drawing paper, 24 x 24, bent over and
fastened together with sewing thread to form
a small book
Coll. National Library of Ireland (Ms. 4595)

There are six scenes (in addition to front and
back cover drawings): 1. The Pasha departs;
2. The Pasha and the Beast; 3. Beauty goes to
the Beast; 4. The Prince; 5. The Pasha in the
days of prosperity; 6. The Pasha gives his two
daughters the sack.

**3 The Glorious, Pious and Immortal
Memory of King William*** *c.*1890

Sgd. bottom right
Pen, ink and watercolour, 17 x 19.5
Exh. 1989 Sligo (1)
Coll. Sligo County Library and Museum (SC38)

A vignette of an 18th century carousal, in
Yeats's Cruikshankian style, no doubt contem-
porary with the bicentenary celebrations of the
Battle of the Boyne which took place in 1690.
There is a hunting party, with a small boy, on
the verso.

4 Brixham* 1894

Insc. Brixham Aug. 94
Watercolour, 18 x 26
Coll. Victor Waddington, London; Waddington
Galleries

A sketch in soft colours of the sea town.
Brixham is on the south coast of Devon, and
Yeats may have visited there after his mar-
riage in August 1894.

5 The Three Hats* ?1894

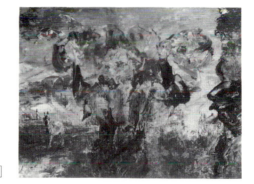

Sgd. bottom right '94 (?)
Watercolour, 27.5 x 22 (sight)
Exh. 1961 London (12) (repro); 1964
Derry/Belfast (12)
Coll. N. Bernstein, Dublin

The theme of a clown in a circus ring, bal-
ancing three hats on his head, is repeated in
the oil of 1954, *The Clown of Hats*.

5a Bronco Rider, Wild West Show* ?1894

Sgd. bottom right
Watercolour and pencil, 17 x 19.5
Coll. Victor Waddington, London

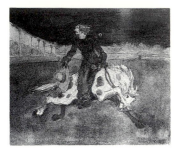

Dated by Victor Waddington to 1894, the style is similar to that of a few years later, when Yeats was concentrating on Devon scenes for his first London show of November 1897.

6 The Metal Man* *c.*1895

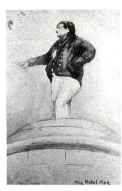

Sgd. bottom left
Insc. with title
Watercolour, 25.5 x 16.5
Exh. 1971–2 Sligo/Dublin (1); 1989 Sligo (2)
Coll. Private collection; Dawson Gallery, Dublin, 1966; Sligo County Library and Museum (SC1)

Probably the earliest version of the Metal Man in Sligo Bay by the artist. The absence of outline suggests that Yeats was planning one of the watercolour stencils he made slightly later. This wash sketch is now very faded.

7 The Strand Races, West of Ireland 1895
Sgd. bottom left
Watercolour, 11.5 x 68.5 (sight)
Exh. 1895 *Dublin* RHA (249)
Coll. Sold to Dr. Van Ingen, 1902; bought by Dr.

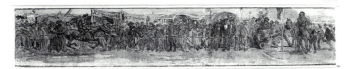

Coen of Athlone at a later date; T. Egan, Athlone, who sold it in 1969 to a private collector

This has been called *The Races at Laytown*, Laytown being a small sea resort to the south of Drogheda: but it is a Sligo scene with a strong sense of comedy. There is little doubt that it is *The Strand Races, West of Ireland*, the first work that Yeats showed in the Royal Hibernian Academy annual exhibition.

8 Strand Races* *c.*1895

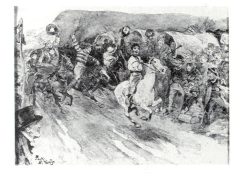

Sgd. bottom left
Stamped verso: Jack B. Yeats, The Chestnuts, Eastworth, Chertsey, Surrey
Pencil and watercolour on card, 15 x 20.5
Exh. 1988 *Dublin* (25) (col. repro)
Coll. George Pollexfen, Thornhill, Sligo; bought by the parents of Moira Woodgate when they purchased Thornhill *c.*1910; Moira Woodgate, Kent; Gorry Gallery, Dublin; private collection

Lit. Yeats, Jack B., *Life in the West of Ireland* (1912) 67

The style relates to Yeats's drawings in illustrated papers such as *Paddock Life* and *Judy* for which he worked during the eighteen nineties. The scene is Drumcliff Strand in Co. Sligo, with Ben Bulben occupying the background. The jockey coming in first on his dappled horse, with deep melancholy eyes and hollow jawline, becomes a type for *The Winner* in *Life in the West of Ireland* (1912), etc. Behind him is massed the crowd of stock characters Yeats would develop elsewhere, including farmer, shawlie and balladsinger: and the gentleman in the left foreground, leaning into the picture, appears in his pugilist drawings of the time.

9 Luckham Farm* 1896

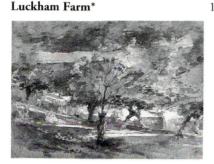

Stamped with monogram *c.*1968
Insc. Luckham Farm, June 15, 1896 (verso)
 Watercolour, 18.5 x 25.5
Coll. The artist's estate; Victor Waddington; Mrs. John C. West

10 Untitled* 1896

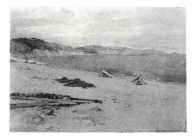

Sgd. monogram bottom right
Insc. Aug. 1896 (verso)
 Watercolour, 25 x 34
Exh. 1961 London (16) (repro)
Coll. The artist's estate; Victor Waddington, London; private collection, London

The strand is probably in South Devon.

11 The Little House* 1896

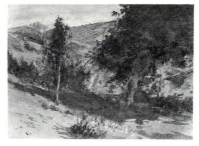

Sgd. monogram lower right
Insc. The little house Aug 14 1896 (verso)
 Watercolour, 25.5 x 34.5
Exh. 1962 Dublin (24); 1964 Derry/Belfast (15)
Coll. Dawson Gallery, Dublin; Mrs. Gladys E. McConnell

The view down a hillside to a small grey house in the woody valley below is in the runny greens and blue of the period.

12 Snail's Castle* 1896

Stamped with monogram *c.*1968
Insc. Snail's Castle Aug 21st 96
 Watercolour, 25 x 35
Coll. Victor Waddington, London

An interior, with the table laid for tea. In 1897

Yeats and his wife took up residence at Snail's Castle (where Yeats made many sketches: see *sketchbook 3*), at Strete in Devon, renaming it Cashlauna Shelmiddy, using the Irish translation for the original name.

13 'Arrah, How's Every Inch of Yez' 1896

Exh. 1896 *Dublin RHA* (372)

14 Bungay 1896. The Tippler Rush* 1896

Sgd.
Insc. with title
Watercolour, 30.5 x 20
Coll. J. C. Miles; Mrs. G. Miles, Yarmouth

Yeats used to sail with J. C. Miles at Great Yarmouth; and presumably combined this with a visit to Bungay, on the border between Norfolk and Suffolk, in 1896.

15 'Mullaghmore Races' – A Popular Win
1896

Exh. 1896 *Dublin RHA* (193)

Mullaghmore Strand in the north of County Sligo was the scene of local races in Yeats's youth.

15a Hooley (1)* 1896

Stamped with monogram bottom right
*c.*1968
Insc. Hooley Dec 2nd 96
Pencil and watercolour
Coll. Waddington Galleries, London

Jack Yeats's dog, Hooligan, asleep with his head upright against a pillow.

15b Hooley (2)* 1896

Stamped with monogram bottom right,
*c.*1968
Insc. Hooley Dec 2nd 96
Pencil and watercolour
Coll. Waddington Galleries, London

See *15a*. Hooley has slipped down a little, and opens an eye.

16 The Light on the Foam 1897

Exh. 1897 London (19)
Coll. Sold to Elkin Mathews

17 In the Marshes 1897

Exh. 1897 London (13)
Coll. Sold later to R. Hodgson

18 Thistles 1897

Exh. 1897 London (18)

19 Untitled* 1897

Sgd. bottom right 97
Watercolour, 16.5 x 23.5
Coll. Victor Waddington, London

A sketch of farm buildings.

20 A Farm on the Coast 1897

Exh. 1897 London (24)

21 The Auction* 1897

![](black square marker)

Sgd. lower left 97
Watercolour and gouache, 24 x 34
Exh. 1960 Sligo (2)
Coll. Sold by the artist to Terence de Vere White, 1950; James Adam (Dublin) sale, 14 Nov. 1978; Straffan House sale (Christie's), 28 Feb. 1990, lot 282 (repro); Dr. Michael Smurfit, Dublin

A Devonshire scene in a livestock ring, in Yeats's graphic style modified with runny colour, which is typical of this period. This may be *22* with a later title.

22 'What! No Advance on Thirteen Pound Ten? Now, Doan'te Miss 'Un!' 1897

Exh. 1897 London (16)

23 A Fair in Devon* 1897

Sgd. bottom right 97
Watercolour and pencil, 25 x 33.5
Exh. 1961 London (18) (repro); 1964 Derry/Belfast (17)
Coll. Victor Waddington, London; T. A. Gilbert

24 Talk of the Fair (Devonshire)* 1897

Sgd. bottom left 97
Watercolour and pencil, 46 x 34
Exh. 1961 London (24) (repro); 1967 London (58) (repro); 1969 Montreal (26)
Coll. Mark Brocklehurst, 1961; Sotheby's 20 July 1966, lot 110; Victor Waddington, London

25 The Farmers' Ordinary [Fair Day Dinner, Devonshire]* 1897

Sgd. lower left 97
Pencil and watercolour, with gouache, 25.5 x 35.5

Exh. 1897 London (28); 1985 *London* 'Celtic Splendour' (14)(repro)
Coll. Waddington Galleries, London; Mr. and Mrs. S. Grabner; Pyms Gallery, London; private collection

26 The Cattle Drover [His Thoughts to Himself*] 1897

Sgd bottom right 97
Watercolour and pencil, 66 x 47
Exh. 1897 London (32); 1961 London (29) (repro)
Coll. Mr. and Mrs. H. Merkin, New York

A study of a man resting on a bench in an inn, his empty glass beside him, exhibited in 1897 as *The Cattle Drover*.

27 For the Farmers 1897

Exh. 1897 London (25)
Coll. Victor Waddington Galleries 1945; private collection

'An ancient rustic servitor, who goes up the stairs at an inn, carrying a tray well fitted with rummers of spirits "For the Farmers"' (*Morning Post*, undated review, November 1897, artist's estate).

28 Cider in Devonshire* 1897

Sgd. bottom left 97
Watercolour, 33.5 x 24

Exh. 1897 London (17), as *Cider*
Coll. Victor Waddington, London

The *Western Morning News* (undated notice, the artist's estate) in its review of the 1897 exhibition notes that 'Each of the two pictures of 'Cider' is representative of the West Country, in the one the burly squire calling for cider at the open bar in the field, and in the other the labourer taking a swig of cider from the cask'. This is probably the second of the two pictures mentioned, though the man wears riding breeches and there is a pack of hounds down the lane behind him. The *Morning Leader* (undated notice, the artist's estate) describes what is probably the first of the two pictures, 'A scene at a bar, with a sheep fold where they are sheep-shearing in the distance. Superior countryman drinking cider', see *29*.

29 Cider 1897

Exh. 1897 London (14)

See *28*.

30 Greetings in the Market Place 1897

Exh. 1897 London (2)

31 'Hold Me Hat Till I Tear 'Un!' ['Let me at Him'] 1897

Sgd. bottom right 97
Watercolour, 30.5 x 48

Exh. 1897 London (8); exhibited as *The Combat**
in 1988 *London* Royal College of Art
Coll. Victor Waddington, London

32 The Irish Dealer—'There's the Little Harse to Make a Farmer Grand and a Nobleman Go Clean aff his Head, Squire!' 1897

Exh. 1897 London (31)
Coll. Sold to H. D. Law, 1897

33 'Howd'jer Like One o' Them?' 1897

Exh. 1897 London (35)

33a The New Hat*

Sgd. bottom left
Watercolour and pencil, 32.5 x 23
Coll. James Adam (Dublin) sale, 22 Nov. 1972; private collection

Perhaps *33*. Two young girls admire a wide-brimmed hat which the taller of the two is wearing.

34 'They Say He can Jump a Hurdle with his Legs Tied' 1897

Exh. 1897 London (6)

35 A Tussle with a Moor Pony 1897

Exh. 1897 London (12)
Coll. Sold to a private collector

36 A Runaway 1897

Sgd. lower right 97
Watercolour, gouache and pencil, 34 × 24.5
Exh. 1905 Dublin (22); 1969 Montreal (30); 1990 *Dublin* (55) (col. repro)
Coll. Given as a wedding present to Mr. and Mrs. Onions by Sir Paul and Lady Harvey in 1907; the Misses Onions, Oxford; Sotheby's (London) sale, 1 May 1968, lot 32; Victor Waddington, London; Simon McCormick; Gorry Gallery, Dublin, March 1990

The watercolour, though dated 1897, does not appear to have been exhibited until 1905. It is an unusually virtuoso watercolour for Yeats, owing something to Degas and the post impressionists in the dramatic use of empty space. The blankness of the wall of the building in the left upper portion of the drawing acts as a foil to the rushing void of the unpaved road in the near foreground. A horse in the wall's shadow bolts away with a figure clinging to its back, causing the farmer holding its bridle to fall flat on his back towards the spectator. The village where the fair is going on, in the right background, is in sunshine, and part of the drama of the image lies in the way the farmer's head is lit up as he falls.

37 The New Purchase 1897

Exh. 1897 London (3)
Coll. Sold at the exhibition to a private collector

'A horse which, harnessed to a gig, has mounted a hilly road at high speed. The vehicle with its passengers is boldly relieved against a sky flushed with sunset hue' (*Morning Post*, undated review, 1897; artist's estate).

38 A Story about a Horse 1897

Exh. 1897 London (22)

39 Sunday 1897

Exh. 1897 London (43)
Coll. Sold to Mrs. Corscadden at the exhibition

A painting of horses, according to the artist's workbook.

40 The Old Ram Changes Hands 1897

Sgd. bottom right 97
 Watercolour and pencil
Exh. 1897 London (11)
Coll. Waddington Galleries, London

A farmer and some lads push a large ram on to a cart, while a small boy looks on. A gas light featured here appears in some oil paintings many years later.

41 A Veteran 1897

Exh. 1897 London (41)

42 Otter Hunting – 'Where be 'e Teu?' 1897

Exh. 1897 London (36)

43 Fish-hawkers Racing 1897

Exh. 1897 London (37)
Coll. Sold to Mrs. Corscadden at the exhibition; perhaps *Two Carts**, signed 97, 24 x 34.5, Sotheby's (London) sale, 3 Nov. 1982, lot 20

This may be the watercolour sold in 1982 at Sotheby's under the title *Two Carts**, showing two rivals glaring at one another as they race their carts along the sea's edge.

44 Through the Woods* 1897

Sgd. bottom left 97
 Watercolour, 39.5 x 26.5 (sight)
Coll. Private collection, Ireland

A tall man in breeches, leggings and hunting jacket, examines the bark of a tree in a sunlit glade.

45 Untitled* 1897

Sgd. bottom right 97
 Black chalk and watercolour, 16.5 x 23
Coll. H. Harrod, bequeathed to the Victoria and Albert Museum 1948

Two men, with a game bag and a dog, sit by the side of a road. See *46–7*. This may be one of those two watercolours: or it may have been sold by the artist without any record of the sale.

46–7 When Ferrets lie up and when rabbits are plentiful [plenty] 1897

Exh. 1897 London (26)
Coll. Sold at the exhibition 'to a man with copyright, and reproduced in colour'

Described in the artist's records as 'a pair'. The reproductions and collector have not been traced.

48 The Rib-binder 1897

Exh. 1897 London (10)

49 The Three Card Man Meets his Match
 ?1897

Sgd. bottom left ?97
 Watercolour, 25 x 12

Exh. 1899 London (40); 1899 Dublin (34)
Coll. Purchased at the Waddington Galleries by a private collector

A race course sharper confronted by a large angry labourer who feels he has been cheated.

50 'Hi! Hi! Hi! Hi!' [probably the watercolour known as **Devonshire Horse Fair**]* 1897

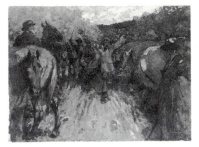

Sgd. bottom right 97
Watercolour and pencil, 25 x 35.5
Exh. 1897 London (30)
Coll. Victor Waddington, London

51 'They'll Take a Lot of Catching!' 1897

Sgd. bottom left 97
Watercolour and pencil
Exh. 1897 London (5)
Coll. Victor Waddington, London

52 Mixed Field in Devon* 1897

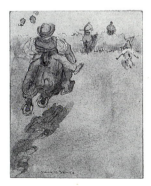

Sgd. bottom left
Watercolour with pencil, 10.5 x 8.5
Exh. 1961 London (15) (repro)
Coll. Major and Mrs. D. H. Daly, London

Perhaps a sketch for *51*.

53 Jumping at the Horse Show 1897

Exh. 1897 London (33)

54 Watching the Jumping at the Horse Show 1897

Exh. 1897 London (27)

55 At a Small Race Meeting* 1897

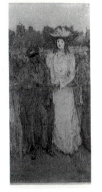

Sgd. bottom left 97
Watercolour and pencil, 32 x 14.5
Exh. 1961 London (19) (repro)
Coll. Mr. and Mrs. H. Abrahams, London

A tall willowy girl, wearing a hat decorated with flowers, standing with a small jockey at a country race meeting or horse show. This is probably *54*.

56 'What They Don't Know isn't [wasn't] Worth Knowing' 1897

Exh. 1897 London (23)

According to a contemporary review (*Morning Post*, undated notice; artist's estate), a jockey and a sporting gentleman are 'engaged in confabulation'. See *57*.

57 Before the Start* 1897

Sgd. bottom right 97
Watercolour with some pencil, 46.5 × 30
Exh. 1961 London (21) (repro); 1967 London (20) (repro); 1971–2 Dublin/New York (9)(repro)
Coll. Peter Katz; Victor Waddington, London

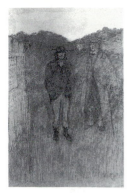

A jockey and a horse owner in a caped coat confer outside a country race meeting. See 56.

58 Waiting* 1897

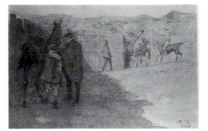

Sgd. bottom right 97
 Watercolour, 30 x 47.5
Exh. 1961 London (20) (repro); 1964
 Derry/Belfast (18); 1967 London (61)
 (repro)
Coll. Mabel Waddington, London; Mr. and Mrs.
 P. B. Brotchie
Lit. *NGI* (1986) xv (fig. 8)

59 Totnes Races 1897

Exh. 1897 London (39)
Coll. Sold at exhibition to a private collector

60 After Them* 1897

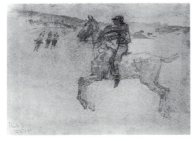

Sgd. bottom left 97
 Watercolour and pencil, 17.5 x 25.9

Exh. 1961 London (28) (repro)
Coll. P. J. Goldberg, London; private collection

A sketch of a horse and jockey pursuing three distant horses on a strand. Perhaps a pair with *61*. Yeats painted the same subject with the same title in a medium-sized oil of 1948.

61 The Last Bank* 1897

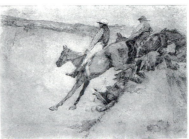

Sgd. bottom right
 Watercolour and pencil, 18 x 25.5
Exh. 1961 London (27) (repro)
Coll. Victor Waddington, London; P. J. Goldberg,
 London; private collection

62 A Popular Win [Brent Race] 1897

Exh. 1897 London
Coll. Given by the artist as a wedding present to
 Muriel Pollexfen 1907

This watercolour was first exhibited in November 1897. The artist was also at Brent Races in Devon on 25 May 1898, where he sketched steeplechases.

63 The Ring Boy* 1897

Sgd. bottom left 97
 Watercolour and pencil, 34.5 x 24
Exh. 1961 London (26) (repro)
Coll. Dr. Graham McCarthy, Stockholm

A side-show competition at a race meeting.

64 The Pride of the West 1897

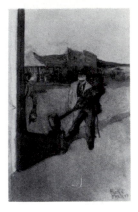

Sgd. bottom right 97
 Watercolour, 35.5 x 19.5
Exh. 1897 London (42); 1962 London (6); 1967
 London (18) (repro); 1969 Montreal
 (28)(repro)
Coll. Victor Waddington, London

A farmer trying his strength in a hammer com-
petition at a Devonshire race meeting.

65 The Man on the Merry-Go-Round 1897

 Watercolour
Exh. 1897 London (29)

This watercolour received high praise from
contemporary critics, who admired its 'vivid
suggestion of a rapid whirl'. Judging by the
price, 15 guineas, the highest charge in the
1897 exhibition, it was fairly large.

**66 'Now's yer Time ter be Took – You'll
 Never be Younger!' [Now's the Time –
 You'll Never be Younger] 1897**

Sgd.
 Watercolour, 35 x 25
Exh. 1897 London (38)
Coll. Victor Waddington, London

Outside a photographer's booth.

67 A Cigar for a Kick 1897

Sgd. bottom left 97
 Watercolour, 34 x 25
Exh. 1897 London (4); 1971–2 Dublin/New York
 (10)(repro)
Coll. Cecil Higgins Art Gallery, Bedford
Lit. Pyle, H. (1970, 1989), plate 1

This has also been known as *At a Small Race
Meeting*.

68 An East End Athlete 1897
Exh. 1897 *Dublin* RHA (200)

69 The Champion* *c.*1897

Sgd. bottom right
 Gouache and watercolour on card, 48.5 x 29
Coll. David Clegham-Thomson, London; private
 collection, U.S.A.; Victor Waddington,
 London

An athlete, stripped to the waist, with scarf
around neck and pink trousers, starts forward,
watched by two burly men. In style and form
of signature this dates to *c.*1897. See *415*.

70 The Boxing Booth 1897
Exh. 1897 London (34)

**71 Local and Travelling Champions,
 Devonshire** 1897

Sgd. bottom left 97
 Watercolour and pencil, 35.5 x 25.5
Exh. 1897 London (15); 1961 London (23) (repro)
Coll. Mr. and Mrs. F. Hess, London

72 Down and Up Again 1897

Exh. 1897 London (21)

73 The Onlookers* 1897

Sgd. bottom left 97
 Watercolour and pencil, 11.5 x 15
Exh. 1961 London (22)(repro)
Coll. Major D. R. Daly, London
Lit. Rosenthal, T. G. (1966), plate Ib (col.)

A man in top hat, with cigar, with a compan-
ion, watches a pugilist who has been felled to
the ground forcing himself to his feet. This
may be *72*.

74 Ringsiders* *c.*1897

Stamped with monogram bottom right in
1967
Insc. with title
 Pencil and watercolour, 12.5 x 35
Exh. 1967 London (13)(repro)
Coll. Private collection, Ireland
Lit. Yeats, Jack B., *And To You Also* (1944)19,
 22; *Illustrated London News* (30 September
 1967) 26–7: A. Causey, 'Jack B. Yeats: artist
 of Ireland and the Irish.'

75 Out* ?1897

Sgd. top right 97 (or 99)
 Watercolour and pastel, 51 x 68
Exh. 1961 London (4)(repro); 1962 Dublin (14);
 1964
 Derry/Belfast (6); 1971 *Cork* (133)
Coll. Dawson Gallery, Dublin

The date beside the signature is faint, and has
previously been read as '91'. But the style
suggests either '97' or '99', and probably the
former.

**76 The Pugilist in the Boxing Booth Meets a
Hard Nut that Takes a Lot of [Some]
Cracking** 1897

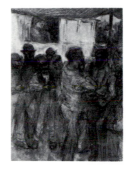

Sgd. bottom right 97
 Watercolour and pencil, 34.5 x 24.5
Exh. 1897 London (1); 1961 London (25) (repro)
Coll. Presented by the artist to London &
 Westminster Bank Skittle Alley, 1902; Victor
 Waddington, London

**77 A Madhi of the Circus ('There is no God but
God; an' Mahomet am 'um Prophet')** 1897

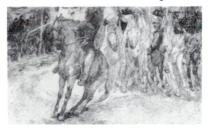

Sgd. bottom right 97
 Watercolour, 31 x 50.5
Exh. 1900 Dublin (39); 1901 London (41); 1967
 London (14)(repro)
Coll. George Waddington, Montreal; M.
 Weissberg, London; Christie's (London) sale,
 19 May 1972, lot 130

An armed and mounted hero of the circus
looks back, urging on his followers. On the

verso is a watercolour sketch of a woman seated at a table, looking up at a man with scythe who has entered the room.

78 Men-o'-War (s) Men in Fancy Dress [Costume] also known as **Blue Jackets in Fancy Dress** 1897

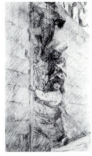

Sgd. bottom left 97
Watercolour, black chalk and pencil, 35.5 x 19
Exh. 1897 London (7); 1961 London (17)(repro)
Coll. Waddington Galleries; Mrs. S. Levy, London; private collection, Belfast

A spontaneous drawing of sailors at Dartmouth climbing up the ladder on to a quay.

79 The Messenger* ?1897

Sgd. bottom left

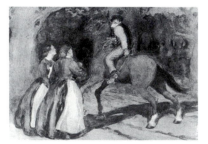

Watercolour, 26.5 x 36
Exh. 1962 Dublin (27)
Coll. Mrs. H. L. Egan, Tullamore

Dated 1897 in the 1962 catalogue, it appears slightly later according to its style, and may be *The Mailer*, first exhibited in 1901, *333*.

80 The Glow-Worm 1897

Exh. 1897 London (9)
Coll. Sold to Mrs. Corscadden, 1897

'Painted practically in monotone, in a soft neutral tint, hesitating between blue and purple A country road in the gloaming, and a little lad descending the hill with a blithe, swinging

tread. The little shining creature in his cap gleams with lifelike tenderness through the misty twilight which envelops the painting' (undated review in *Madame*, November 1897; the artist's estate.)

81 The Gipsy and the Aesthete – 'Why, We Both Wears the Same Colour o' Necktie!' 1897

Sgd. bottom left 97
Watercolour, 35.5 x 25.5
Exh. 1897 London (40)
Coll. Victor Waddington, London; purchased by a private collector

82 In a Devonshire Lane* 1898

Sgd. bottom right
Watercolour, 24.5 x 34.5
Exh. 1961 London (30) (repro)
Coll. Waddington Galleries; Michael Broom

83 Aran More 1898

Exh. 1899 Dublin (ex catalogue)
Coll. Sold to Isaac Yeats at the exhibition

Described in the artist's records as 'small landscape'. Yeats did a sketch of Aran More, off the coast of Donegal, from a point on the Dungloe Road in August 1898 (*sketchbook 11*); and this is doubtless a larger version of it.

84–97 Fourteen Watercolours from a Sketchbook inscribed on cover 'Finished at Burton Port 1898'* 1898

Stamped in 1967 with monogram, except *96* and *97*. *96* is signed bottom right
Watercolour, each 9 x 13
Exh. 1967 London (21–34) (repro)
Coll. Private collection, *84* and *93*; Miss Evelyn Hardy *91* and *92*, sold at Sotheby's, 22 Nov. 1972 to J. Manning Gallery; Victor Waddington, London, the rest

84 Boglands; *85* Small pasture; *86* Strand;

87 Shore; *88* Shore; *89* Shore, looking towards Ben Bulben; *90* Landscape; *91* Cottages; *92* Shore; *93* Ben Bulben; *94* Road; *95* Road; *96* Inlet; *97* Little Lake.

Yeats was in Burtonport, on the West Coast of Donegal, in August 1898. The sketchbook was one of the many in which he recorded views and incidents which he would work up into watercolours when he returned home. In later life, the sketchbooks reminded him of amusing or arresting events, which he transformed through 'half-memory' into the elusive metaphors of his richly coloured oil canvases. Breaking up some of the sketchbooks has meant that some of the small sketches are now seen out context, and some have no reference, date, or identity. The monogram stamp was devised by Victor Waddington in 1967 as a substitution for a signature, to authenticate these loose sketches, but was used only for a short while.

85

86

88

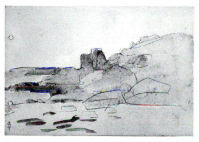
89

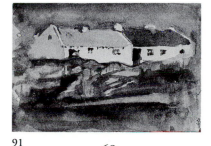
91

92

93

94

95

96

97

98 Small Sketch, Donegal 1898

☐

Exh. 1899 Dublin (ex catalogue)
Coll. Sold to Lady Devas at the exhibition

AE writing in the *Express*, 19 May 1899, described this as a 'sketch of mountain, heather and lakes'. Yeats was sketching in Donegal in August 1898 (see *sketchbook 10*).

**99–103 Five Watercolours from a Sketchbook
dated 1898***

Watercolour, 9 x 13
Coll. The sketchbook was given by the artist to Mrs. Beatrix M. Craig in May 1945, and later sold to the Waddington Galleries; *102* purchased by J. Bryson, Oxford, from Waddington Galleries, London, 1961; *103* purchased from Waddington Galleries by Patrick Hall

99–101 Sea and land.
102 Sandy beach with rocks and figure.
103 Landscape.

104 A Sunday Morning in Sligo* 1898

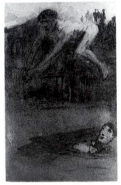

Sgd. bottom right 98
Watercolour 44.5 x 28
Exh. 1963 Sligo (not in catalogue); 1971–2 Sligo/ Dublin (3); 1989 Sligo (4)
Coll. Victor Waddington, presented in 1963 to Sligo County Library and Museum (SC3)
Lit. *New Alliance* (April 1940) 3–4: Jack B. Yeats, 'The Too Early Bathers'.

This may be *The Bathers*, first exhibited in

1899, *141*. The boyhood experience of bathing at Rosses Point, in Sligo, made a profound impression on Yeats, who later remarked in *The Too Early Bathers*, 'Almost every year of my boyhood some friend, or myself stepped too soon into the creaming edge of the Atlantic. But now I recall that moment of perishing, it was seldom a creeping up of numbness which would come from the lacey edges of waves on a flat shore. It was a moving into deep water, the dash was made in general from the spring board, or the steps beside it, down at the Dead Man's Point.'

This sketch describes with singular immediacy the shock and excitement of the first dip of the year. Late paintings such as *The Old Bathing Place* (1943), *The Spring Board* (1952), etc., etc. indicate what a lasting effect such a ritual had on him.

105 Donkey Races 1898

Sgd. bottom right ?98
 Watercolour, 29.5 x 45.5
Exh. 1899 London (14); 1899 Dublin (13); 1904 New York (56)
Coll. Sold at the New York exhibition to John Quinn; listed in the Quinn inventory, and in the catalogue of the Quinn collection, 1926; American Art Galleries (New York) sale of John Quinn collection, 11 Feb. 1927, lot 421; bought by F.J. Deordan; Mrs. Eleanor B. Reid, San Francisco; private collection.

Three boys mounted on donkeys race along the beach. Yeats in later years honoured the donkey in poetic canvases such as *Of Ancient Lineage* (1950).

106 The Grain Ship* 1898

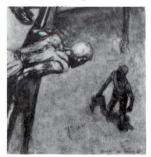

Sgd . bottom right 98
 Watercolour, 28 x 24
Exh. 1961 London (32) (repro)
Coll. Victor Waddington, London; Michael Demarest; private collection, Canada
Lit. Rosenthal, T. G. (1966), plate IIb

One of Yeats's most striking early watercolours, where he contrives a view of the hold of a ship from above. The feet, in one case, and the head and torso in the other, of two men looking down at a dusty workman below standing in the middle of the cargo of golden grain, create an uncanny angle into the picture plane. It is one indication of the effect of post-impressionism on the artist, perhaps at this stage mainly through posters. The tonal washes of grey and yellow pre-empt oils of the twenties such as *The Ball Alley* (1927) (Hugh Lane Municipal Gallery of Modern Art, Dublin, 1337), as does the ghostly figure of the man in the foreground of the watercolour, half-in, half-out, drawing the spectator into the picture.

107 A Push Halfpenny Champion* *c.*1898

Sgd. bottom right
 Inscribed with title bottom left
 Watercolour stencil, 28.5 x 21
Exh. 1973 London Waddington Galleries III (3)

The artist made a black-and-white illustration of a push halfpenny match in 1898. The stencil perhaps dates from the same year, though Yeats was working regularly in watercolour stencil around 1900.

108 Robert Emmet (in 1898) 1898

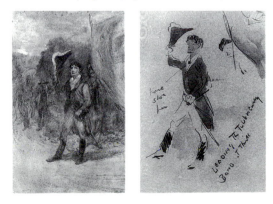

71

Sgd. bottom right 98
Watercolour with pencil and some pastel, 44 x 28
Exh. 1899 London (5); 1899 Dublin (5); 1904 New York (37); 1966 *Dublin* (170); 1971–2 Dublin/New York (11)(repro)
Coll. Dr. E. MacCarvill, Dublin; private collection
Lit. Pyle, H. (1970, 1989)53–4

A procession at Carricknagat in County Sligo, on 4 September, 1898. The centenary celebrations held in honour of Bartholomew Teeling, who distinguished himself at the Battle of Carricknagat in 1798, had such a profound effect on Yeats that he went back to Devon determined to paint an Irish subject-matter from then on. Above the figure dressed as Robert Emmet flies the Tubbercurry flag, decorated with a harp and figure of Wolfe Tone. Yeats made an initial sketch for this watercolour in *sketchbook 12.*

109 The Music* 1898

Sgd. bottom right, also signed bottom left 98
Watercolour (47 x 30)
Exh. 1961 London (33)(repro); 1967 London (64) (repro)
Coll. Mark Brocklehurst, 1961; Sotheby's sale, 20 July 1966, lot 111, bought by Victor Waddington, London
Lit. Yeats, Jack B., *Life in the West of Ireland* (1912) 33

Three men with fiddles playing in a street, rendered in the soft liquid colours found in Yeats at this period. 'The music' is an Irish term used to describe the traditional musician: and is the title of one of the line illustrations in his book, *Life in the West of Ireland* (1912). There is a sketch of a single fiddler in Killybegs made in August 1898 in *sketchbook 10.*

**110 Singing – 'The Big Turf Fire,
And the Tare-Rare-Rare
And the Big Turf Fire'** 1898

Sgd. bottom right 98
Watercolour and pencil, 28 x 37.5
Exh. 1899 London (11); 1899 Dublin (10); 1904 London (24); 1945 Dublin National Loan (171)
Coll. Given by the artist to Brenda Gogarty on her marriage to D. J. Williams April 1945; James Adam (Dublin) sale, 14 July 1983, lot 67 (repro)
Lit. MacGreevy, T. (1945) 23

One of the many similar compositions, showing a ballad singer on the road, singing in the driving rain, his hands in his pockets. Small bonfires may be seen lighting in the distance. The watercolour is painted in the soft runny browns typical of this period.

111 The Sporting West of Ireland *c.*1898

Exh. *1898 Dublin RHA (397)*

112 The Hard Stuff 1898

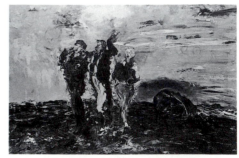

Sgd. bottom right 98
Watercolour and pencil, 35 x 17
Exh. 1899 London (18); 1899 Dublin (16); 1904 New York (19); 1961 London (31) (repro)
Coll. Victor Waddington, London

A local man regaling himself in a race-course tent in the West of Ireland. The whiskey tent was to appear in a more symbolic way in the late oil landscapes, such as *Shouting* (1950)

113–114 Two Pages from a Sketchbook of 1899 entitled 'On the Broads'*

Sgd. with monogram
Watercolour, *113* with pencil (verso watercolour sketch), *114* with crayon, each 9 x13

Coll. Dan McInerney,Dublin; Christie's (Dublin) sale Carrickmines House, Co. Dublin, 10 Feb. 1986, lots 362–3

115–128 Fourteen Watercolours from a Sketchbook inscribed on cover 'Yarmouth the Human Tragedy 1899'*

Stamped in 1967 with monogram
Watercolour, except for *122–124*, which are watercolour and crayon; each 9 x 13, except for *115* (2 sketches together), which is 9 x 26

Exh. 1967 London (35–54) (repro except 124 verso)

Coll. Victor Waddington, London

115–16 Yarmouth (2 separate watercolours together making a single scene) *and* Harbour (verso of left-hand side of *115*); *117* Approaching Horning (inscribed with title); *118* The Broads, Morning *and* Cottages and windmill (verso); *119* On Hickling Broad (inscribed with title); *120* On Hickling Broad *and* Inn on Hickling Broad (verso, inscribed with title); *121* Fishing Competition Returning: Horning Ferry (inscribed with title); *122* On the Broads; *123* Pottington (inscribed with title) *and* Fishing boat and sketches of flags (verso, with notes); *124* A Fisherman *and* Sketch of boat (verso); *125* Morning *and* Pottington (verso, inscribed with title); *126* On the Broads *and* On the Broads (verso); *127* On the Broads *and* On the Broads (verso); *128* On Hickling Broad

These are watercolour sketches taken from one of Yeats's sketchbooks recording his visit to Yarmouth and the Norfolk Broads in July 1899.

115–16

115v

117

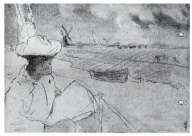

118

118v

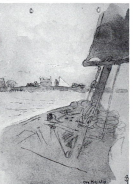

119

120

120v

121

122

123

123v

124

124v

125

125v

126

126v

127

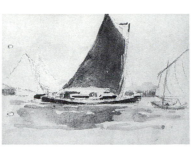

127v

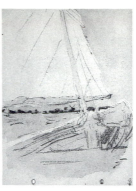

128

128a 'Towards the Broads' *c.*1899

Sgd. Stamped with monogram
Watercolour and pencil, 9 x 13
Coll. Privately owned

A leaf taken from a sketchbook, dating from
*c.*1899. Sandhills with masts of ships seen
beyond, the colouring pale blues and green.

**129 J. C. Miles Looking into Cabin on Wherry
in Broads** 1899

Sgd. lower edge
Insc. For Miss ——— Miles. This drawing of her
great grandfather by her great grand
Godfather, Jack B. Yeats
Watercolour, 18 x 25.5
Coll. Given to Sarah Jane Miles as a christening
present December 1942; Mrs. G. Miles,
Great Yarmouth

Jack B. Yeats and J. C. Miles were close friends
during the late eighteen nineties, and in July
1899 Yeats and his wife spent a holiday with
Miles on the Norfolk Broads. In a letter to his
friend accompanying this drawing on 5 Dec-
ember 1942 (coll: Mrs. G. Miles), the artist
asked for the Christian name of his god-
daughter to be filled in, adding, 'I searched and
found a watercolour of yourself, done on the
broads, when we were both young men.'

130 On the Broads (1)* 1899

Insc. on verso with title
Watercolour, 35.5 x 17
Exh. 1961 London (57)(repro); 1967 London
(55) (repro); 1971-2 Dublin/New York
(13)(repro); 1986 Dublin (1)(col. repro)
Coll. Victor Waddington, London, purchased by
the National Gallery of Ireland in 1967 (6318)
Lit. *NGI* (1986) 2, plate 1

See *129*. The first of three
companion watercolours
(*130–132*) (which may
have been painted on site as
they were worked on a
drawing block), in which
Yeats studies various aspects
of the yacht in which he and
J. C. Miles sailed. Here the
vessel is under sail, heeling
over in a fresh wind. The
watercolour is used in a liq-
uid flexible way, with a
dominant colour tone back-
ed up by touches of rich
complementary colours.

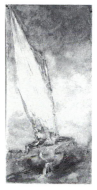

131 On the Broads (2): On Deck* 1899

Lit. *NGI* (1986) 4, plate 2

See *130*. Yeats, in this brief indication of the
lower mast and billowing sail, and the up-
heave of the yacht's prow, creates the sense of
human presence, enjoying the physical near-
ness of the boat speeding on the water, and
the view of the low shore growing clearer as
the vessel advances.

Watercolour, 17 x 35.5
Exh. 1961 London (55) (repro); 1967 London
(56) (repro); 1971–2 Dublin/New York (14)
(repro); 1986 Dublin (2) (col. repro)
Coll. Victor Waddington, London, purchased by
the National Gallery of Ireland in 1967 (6319)

132 On the Broads (3): Below Deck* 1899

Watercolour, 17 x 35.5
Exh. 1961 London (56) (repro); 1967 London
(57)(repro); 1971–2 Dublin, New York (15)
(repro); 1986 Dublin (3) (col. repro)
Coll. Victor Waddington, London, purchased by
the National Gallery of Ireland in 1967 (6320)

See *130*. The interior of J. C. Miles's yacht,
with a view of the coastline through the win-
dow.

133 Near Ballycastle, 1899*

Sgd. monogram bottom left
Insc. on verso with title
Watercolour, 25 x 33.5
Exh. 1981 London (5)
Coll. Victor Waddington; Theo Waddington,
London; Senator Moynihan 1986

A sketch of low tide on a beach of rocks and
sand, with channels of blue water. Presumably
Yeats travelled up through Mayo on his way
from Coole to Sligo in the Spring of 1899,
though he did not record the journey in his
sketchbooks. He painted landscape in water-
colour and oil at Ballycastle, Co. Mayo, in
1909, see *651–2*.

134 Near Ballycastle, County Mayo* c.1899

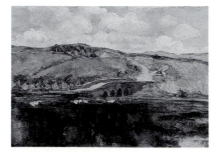

Stamped c.1970 with monogram
Watercolour, 25 x 33.5
Exh. 1973 London Waddington III (7)
Coll. Victor Waddington, London

A view of water, bridge and road under a
cloudy sky, in free runny paint. See *133*.

135 In the County of Mayo 1899

Exh. 1899 London (20)

136 Morning* 1899

Sgd. bottom left
Watercolour with pencil, 8.5 x 11
Exh. 1961 London (37) (repro)
Coll. Private collection

A page from a sketchbook.

137 Untitled, from a sketchbook* 1899

Sgd. bottom right
Watercolour with pencil, 8 x 12
Exh. 1961 London (38) (repro)
Coll. Charles Aukin, England

A sketch of cliffs and sea.

138 Untitled* 1899

Sgd. monogram bottom right
Insc. on verso July 99
Watercolour, 18 x 25.5
Coll. Waddington Fine Art, Montreal

A beach scene with a boat in mellow light
colouring. Yeats was at Strete, and in Norfolk
in July 1899.

139 Untitled* late 1890s

Watercolour, 35 x 25.5
Coll. Victor Waddington, London

Garden plots on each side of a winding path, leading to a hill.

140 Captain Sillers, Rosses Point* *c.*1899

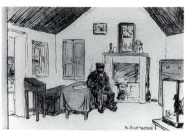

Watercolour, 25.5 x 18
Coll. Victor Waddington, London

Interior showing hall and staircase, with a view of Rosses Point and the sea through the open door. Yeats made a series of studies of 'Rooms' in 1899 while in Sligo and Rosses Point (*sketchbook 20*), and this is presumably one of them.

141 The Bathers

Exh. 1899 London (15); 1899 Dublin (14)

At the end of a sketchbook taken to Sligo and Killybegs in August 1898 (*sketchbook 10*), Yeats made a note of 'Bathers Dead Man's Point' (Rosses Point) as a subject, probably with a watercolour in mind. See *104*.

142 The Bather—Sketch* *c.*1899

Insc. recto, with title verso: W. B. Yeats bathing in the lake at Coole by Jack perhaps – Lily Yeats
Ink and blue wash, 8 x 12
Coll. Anne Yeats; Colin Smythe, London

143 Apples in our Orchard* 1899

Insc. with title Nov. 3rd 99
Watercolour, 12.5 x 17.5
Coll. Victor Waddington, London

A small tapestry of the shapes and mellow colours of an orchard scene.

144–156 Thirteen Sketches from a Sketchbook*
1899–1909

Insc. on verso with notes

Pencil, pen and watercolour, 13 x 9
Coll. The artist's estate; private collection

The sketches include a portrait of Cottie Yeats, and drawings of Clifden in 1907 and Bally-castle in 1909.

157 Small Landscape Sketch *c.*1899

Exh. 1899 Dublin [not in printed catalogue]
Coll. 'Sold to Geoghegan at Dublin exhibition for £3–3–0'

158 On the Gara River* 1899–1900

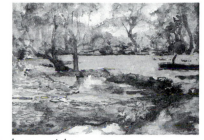

Sgd. bottom right
Watercolour, 25.5 x 35.5
Coll. Victor Waddington, London; private collection

A bend in the stream which ran near Yeats's house in Devon. The mood is relaxed, the light and reflections dappled. This may be *384*, though in style it appears to have been painted about 1899 to 1900.

159 The Little Donkeys* 1899

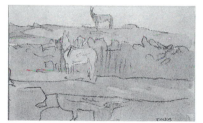

Sgd. bottom right
Watercolour and pencil, 8 x 12
Exh. 1961 London (39) (repro)
Coll. Victor Waddington, London; Willis Heal, England

A sketch taken from a sketchbook.

160 The Rolling Donkey 1899

Sgd. bottom right
Watercolour, 28 x 43

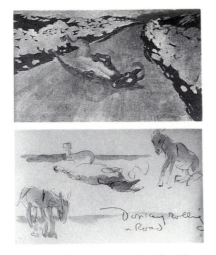

Exh. 1899 London (7); 1899 Dublin (7); 1904
London (243)

Coll. Sold to Robert Gregory at the Dublin
exhibition; private collection, England

Lit. Gregory, A., *Me and Nu; Childhood at Coole*
(1970) 87–8; *The Artist* (London) 25 (1899)
148 (repro)

A donkey rolling on a dusty road, bounded by
a stone wall and rocky field, in grey-lilac
colouring. There is a sketch, perhaps for this,
in *sketchbook 11*, completed in Donegal and
Sligo in August 1898. Robert Gregory thought
the scene might be in County Clare.

161 A Long Team 1899

Sgd. bottom right
Brown chalk and watercolour heightened
with body colour, 17.5 x 28.5

Exh. 1899 London (22); 1899 Dublin (not in
catalogue)

Coll. Sold to Mrs. Bradbury, probably at the
London exhibition; Dr. J. V. Farmon;
Sotheby's (London) sale, 9 July 1969, lot 66,
bought by Spink; Sir John Galvin; private
collection, Dublin

Lit. *The Artist* (London) 25 (1899) 148 (repro)

A team of donkeys drawing a cart emerge from
between two cottages to gallop back up a coun-
try road. There is a touch of caricature in the
lightly handled, freely hatched drawing. This
has also been called *An Irish Team* and *The
Donkey Team*, but not by Yeats.

**162 After the Next Race I'll be Giving Away a
Gold Watch*** 1899–1900

Sgd. with monogram bottom right
Watercolour and gouache, 27 x 23

Exh. 1969 Montreal (34)

Coll. Victor Waddington, London

A portrait of a fat bookie.

**163 In the Hibbidy-Hubbadies [The Hibbidy
Hubbidy's]** 1899

Exh. 1899 London (19); 1899 Dublin (17); 1904
New York (62)

'Little boys are very fond of getting in the wash
of a steamboat to feel the boat pitch in the
small waves.' (note by Yeats, *Gaelic American*, 5
April 1904)

164 Porpoises 1899

Exh. 1899 London (6); 1899 Dublin (6)

Coll. Sold at the London exhibition to York
Powell and exhibited in Dublin on loan

165 Sea Poppies*

Sgd. bottom right '99
Watercolour, 13.5 x 25

166 Catching the Young One 1899

Sgd. bottom right
Watercolour on paper, 22 x 28.5
Exh. 1899 London (39); 1899 Dublin (33); 1904
New York (32); 1961 London (36) (repro);
1964 Derry/Belfast (27); 1967 London
(60)(repro)
Coll. Private collection

Two young boys press themselves against the
side post of a shed door, watching a man
bridling a restive mare in the darkness of the
interior, and waiting expectantly for the colt
racing by the water in the left background to be
enticed into the shed.

167 Selling a Horse 1899

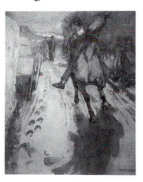

Sgd. bottom right
Watercolour, 60 x 27
Exh. 1899 London (21); 1899 Dublin (18); 1945
Dublin National Loan (170)
Coll. Sold at the Dublin exhibition in 1899 to
Edward Martyn, who presented it to George
Coffey; Mr. and Mrs. Diarmuid Coffey;
private collection

A farmer puts his horse through its paces for a
possible purchaser. A vivid and impressive
scene, the galloping horse and mount throwing
a dramatic shadow, cf. 36.

168 Midsummer's Eve 1899

Exh. 1899 London (27); 1899 Dublin (22); 1904
New York (63)
Coll. Sold to John Quinn at the New York
exhibition; listed in Quinn inventory, 1924.

Described in the artist's records as 'the Bonfire
one (small)'.

169 A Mother of the Rosses 1899

Sgd. bottom left
Watercolour, 43 x 28
Exh. 1899 London (2); 1899 Dublin (2)
Coll. Sold to Louis Purser at the Dublin
exhibition; private collection, Dublin; James
Adam (Dublin) sale, 16 July 1968, lot 260;
private collection

A mother travelling with her infant in a boat at
evening, the luminous sky and water and the
vague light cast on the boatman contributing a
poetry to the simple Donegal scene. Æ thought
highly of the picture, writing in the *Daily
Express* (10 Oct. 1899): 'The sketch called "A
Mother of the Rosses" is by far the best thing
on the walls . . . It is one of those scenes
which, though seen but for a moment as they
pass by, are long remembered after.'

170 The Cow Doctor 1899

Exh. 1899 London (38)
Coll. Sold to Dr. Sidney Hall at the exhibition

171 The Returned American 1899

Exh. 1899 London (43)
Coll. Sold to an unknown collector at the exhibition

'A man smoking a cigar at evening on a coast
road, with a village ingeniously packed in
between his shoulders and his hat' (*Pall Mall
Gazette*, 24 Feb. 1899). From the reviewer's
description, it would appear that this as yet
untraced drawing was a first thought for *206*.

172 The Bag Man 1899

Exh. 1899 London (42); 1899 Dublin (36)
Coll. Sold to Horace Plunkett in 1899
Lit. Yeats, Jack B., *Sligo* (1930) 9

The 'bag man' or commercial traveller, as a
travelling man, was an intriguing subject for
Yeats. See *173*.

173 Untitled* c.1899–1900

Sgd. bottom left
Watercolour on card, 31 x 51
Coll. Red Cross Sale, Dublin, 1944, bought by

Dr. Patrick McCartan; P. McCartan, Greystones; Christie's (Dublin) sale, 23 Oct. 1989, lot 51 (col. repro)

Two men on a side-car move quickly over a strand, drawn by a tandem. The bowler-hatted passenger sits on the far side, his luggage piled up on the bridge; the jarvey on the near side lights his pipe. The predominant colour is a lilac shade. This may be *172*.

174 The Dark Man 1899

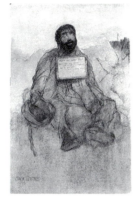

Sgd. bottom left 99
 Pencil and watercolour
Exh. 1899 London (25); 1899 Dublin (21); 1904 New York (41)
Coll. Private collection, U.S.A.
Lit. Rosenthal, T. G. (1966) 3, 5 (repro fig. 2)

'A blind beggar. The beggars are the only fat people in Ireland' (note by Yeats, *Gaelic American*, 5 April 1904). Yeats gives a graphic picture of the blind man, sitting with his hat outstretched, his stick laid on the ground beside him. It seems that the words on the card hanging from the man's neck appealed to him as much as did the image of the professional-looking plaintiff:

'PITY THE DARK MAN
CHRISTIANS YOUR CHARITY ON THE
DARK MAN BESTOW
THAT HIS AFFLICTION YOU MAY NEVER KNOW.'

From this, the watercolour has become known as *Pity the Dark Man* (Rosenthal p. 5).

175 The Dispensary Doctor 1899

Exh. 1899 London (32); 1899 Dublin (27)
Coll. Sold at the Dublin exhibition to an unknown collector

176 The Squireen* 1899

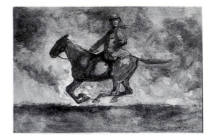

Sgd. bottom right 1899
 Watercolour, 35 x 51.5
Exh. 1961 London (34)(repro); 1964 Derry/Belfast (28)
Coll. Waddington Galleries, London, 1961; N. Bernstein, Dublin

A petty squire, of a type well known in Ireland at the time, flying past jauntily on the back of a galloping pony. He and his mount are silhouetted against the tossed sky. The landscape lies beneath them. See *330*.

177 The Emigrant 1899

Exh. 1899 London (3); 1899 Dublin (3)
Coll. Sold at the Dublin exhibition to an unknown collector

Yeats did a pencil sketch of a crowd watching a side car speeding away along a rocky road, when visiting Dungloe in August 1898 (*sketchbook 11*), adding the caption 'To America'. It may have been the basis for the fuller composition. A sketch of *The Emigrant*, under the title *Off to America*, and signed by Yeats, was published in the *Dublin Independent,* 19 May 1899.

178 The Street Juggler 1899

Sgd. bottom right
 Watercolour, 26.5 x 18
Exh. 1899 London (36); 1899 Dublin (31); 1961 Dublin (23); 1964 *New York*
Coll. The Directors, Arthur Guinness & Co., Dublin

A man walking down the street is throwing one bottle of stout in the air with his right hand, and catching another in his left, watched by a country woman in a shawl.

179 The German Who Played 'O'Donnell Aboo' in the Rosses 1899

Sgd. bottom right
Exh. 1899 London (33); 1899 Dublin (28); 1904 New York (ex catalogue)
Coll. Victor Waddington, London

'He . . . forces his great brass instrument to give out the strains of 'O'Donnell Aboo' to the deaf rocks' (*Dublin Express*, 10 May 1899). Yeats noticed this incident in Donegal, on the road to Bundoran, in August 1898 (*sketchbook 10*). See *180*.

180 'Must have been an Allegory' 1899

Sgd. lower right
Watercolour with pencil, 9 x 15
Exh. 1899 London (31); 1899 Dublin (26); 1904 New York (25), as '*It Must have been an Allegory*'
Coll. Sold to John Quinn at the New York exhibition; listed in the Quinn inventory; American Art Galleries (New York) sale of John Quinn collection, 10 Feb. 1927, lot 276A; bought by J. M. Kerrigan

This is another version of *179*; and shows the German playing his French horn in front of a deserted cottage. A horse's skull lies outside the boarded-up window. To this description in the *Gaelic American*, 5 April 1904, Yeats added, 'The German must have thought the skull was an inn sign'. There is a sketch for the watercolour in *sketchbook 10* (1898), though here the cottage is referred to as 'the house of the donkey's skull'.

181 'It's the Largest fir-rm in all Ireland – Eleventeen Acres, Not Wan Less' 1899

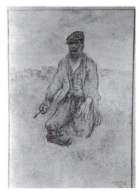

Sgd. bottom right 99
Watercolour, 35 x 24
Exh. 1899 London (23); 1899 Dublin (ex catalogue); 1961 Dublin (18)
Coll. Gerald Goldberg, Cork

182 'O Where's the Anti-Gambling League' 1899

Exh. 1899 London (1); 1899 Dublin (1)
'Red-headed sybil . . .' (*Pall Mall Gazette*, 24 February 1899).

183 'An Old Dog For a Hard Road; A Young Pup for a Tow Path' 1899

Exh. 1899 London (10); 1899 Dublin (9)
Coll. Sold to Edward Martyn for T. P. Gill at the Dublin exhibition

184 Political 1899

Sgd. bottom left
Watercolour with pencil, 44 x 27.5
Exh. 1899 London (35); 1899 Dublin (30); 1904
New York (36)
Coll. T.C.R. Pulvertaft, Denmark

A priest on a rearing horse, dressed in tailed coat
and top hat, with a green sash over his right
shoulder, raises his right hand as he wheels
round towards the spectator. In the background
is a procession with a green banner, led by a
man with a large drum. See *108*.

185 The Jew's Harp 1899

Exh. 1899 London (24); 1899 Dublin (20)
Coll. Sold to Edith Johnson at the exhibition in
Dublin

**186 The Yankee Table Cloth [The American
Table Cloth]** 1899

Sgd. lower right
Watercolour, 29 x 44
Exh. 1899 London (12); 1899 Dublin (11); 1904
New York (43)
Coll. Sold to John Quinn at the New York
exhibition; listed in the Quinn inventory;
American Art Galleries (New York) sale of
the John Quinn Collection, 9 Feb. 1927, lot
43 bought by Samuel J. Lustgarten

'Two men sit [over] . . . a brightly coloured
oil cloth with the eagle and American flag in
the centre and compartments about labelled
with the names of our States' (*New York Times*,
5 April 1904).

187 Looking Back 1899

Exh. 1899 London (44); 1899 Dublin (37)

188 The Green Above the Red 1899

Exh. 1899 *Dublin* (157); 1903 Dublin (29)

Coll. Sold at the exhibition in 1903 to Tom Kelly,
U.S.A.

189 The Indian Corn 1899

Exh. 1899 London (17); 1899 Dublin (15)

190 In the Sporting West 1899

Exh. 1899 London (13); 1899 Dublin (12)
Coll. Sold to George T. Pollexfen at the Dublin
exhibition

191 Going to the Races 1899

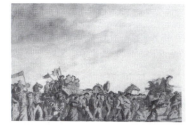

Sgd. lower right
Watercolour and gouache, 24.5 x 34.5
Exh. 1899 London (41)
Coll. Sold at the exhibition to an unknown
collector; Christie's (London) sale, 9 Mar.
1990, lot 262 (col. repro); Thomas Agnew,
London, April 1990

This is a long panoramic picture, showing peo-
ple on foot and in conveyances going to the
races. The different characters appear in other
panoramic scenes of the period, or are some-
times treated individually in other watercolours.

191a A Game of Skill at Galway Races 1899

Exh. 1899 Dublin (19)

192 Untitled: Strand Races* 1899

Sgd. bottom right 99
Watercolour, 12 x17
Coll. Victor Waddington Galleries, presented by
Victor and Mabel Waddington to Mr. and
Mrs. M. Lederman, New York

A chestnut horse lands on the sand after leaping a grass hedge. Figures are seen in the right background, under a tossed blue and white sky.

193 The Festival of St. Stephen's 1899

Exh. 1899 London (4); 1899 Dublin (4)
Coll. Sold before the Dublin exhibition to an unknown collector and exhibited on loan

According to descriptions in newspaper reviews, this is the annual steeplechase on a country race course.

194 Inside the Whisky Tent 1899

Exh. 1899 London (29); 1899 Dublin (24)

The whiskey tent, low and barrel topped, a feature of race meetings in the West of Ireland during Yeats's youth, appears in several very late paintings, such as *Shouting*, painted in 1950. See *604*.

**195 'In the Foot-Race Competition there are many to compete,
But the Brave Muldoon, will very soon, our spirits elevate' – *Race Ballad*** 1899

Exh. 1899 Dublin (34); 1899 Dublin (29)
Coll. Given to Lady Gregory after the Dublin exhibition

The quotation forming the title is taken from the ballad, 'Drumcliffe Races 1889' by Martin Waters, collected by the artist. The ballad extols the virtues of the champion Sligo jockey, who, with his horse, Rattlesnake, is depicted in *376*.

196 'Let Me See Wan Fight' 1899

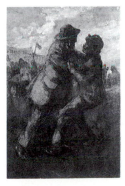

Sgd. bottom right
Watercolour, 41 x 27
Exh. 1899 London (9); 1899 Dublin (8); 1904 New York (40); 1961 London (50) (repro)
Coll. Mr. and Mrs. M. Lederman, New York
Lit. *Illustrated London News* (8 April 1961) 593 (repro)

An incident at the Galway Races on 3 August, 1898, which Yeats later described as 'A farmer trying to keep his son out of a race-course scrap' (*Gaelic American*, 5 April 1904). A sketch for the watercolour, entitled 'Lemme see wan fight', is in *sketchbook 9*.

197 The Losing Crew going Home 1899

Exh. 1899 London (8)
Coll. Sold to Mr. Coulter at the exhibition

198 Johnny Patterson Singing 'Bridget Donoghue' 1899

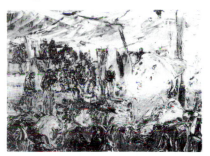

Exh. 1899 London (26)
Coll. Sold at the London exhibition to an unknown collector

Johnny Patterson is the subject of some of Yeats's finest oil paintings, among them *The Singing Clown* (1928; above), *The Clown among the People* (1932) and *Glory* (1946). He was born in Belfast, and joined the circus, working as a trapeze artist and a bare back rider, at the age of twelve. After a successful trip to New York in 1879, he returned to Ireland with his own circus, 'Patterson's Great United States Circus', afterwards merged with Keely's Circus. He was most famous as a clown, and for his renderings of his own compositions, 'Bridget Donoghue' and 'Daddy's Letter', which he accompanied on the accordion. He died during a performance in 1899.

199 Sketches for 'The Countess Cathleen' by W. B. Yeats* inserted in Lady Gregory's copy of *Beltaine 1* (May 1899) 1899

Pasted inside front cover: Dorothy Paget; The Peelers in the Gallery; John O'Leary; George Moore. Further sketches inserted throughout the volume include: First Demon (7 sketches); Second Demon (2 sketches); One of the Soul Sellers; Gill; Gardener; Aleel (3 sketches); Servant (2 sketches); Countess Cathleen (2 sketches) etc. etc. Herdsman; Maud Gonne; The Man with a Crack in his Soul; The Merchant's Soul with the Crack in it (a scene); Grace; A Soul Seller; Oona (2 sketches); George Moore: Buying the Souls; Sheeogue; The Woman with the Soul to Sell

Pencil and watercolour, some measure 9 x 13 and are removed from a Rowney sketchbook; others are on roughly edged pieces of paper of different sizes cut from larger sheets

Coll. New York Public Library, Berg Collection

W. B. Yeats's controversial play, *The Countess Cathleen*, was published in its first version in 1892. It describes how the people of Ireland were persuaded to sell their souls during a time of famine; and its performance in Dublin in April 1899 was received with hostility. These drawings were made during rehearsals.

200 **'Howld up Owld [Ould] Stock'** 1899

Exh. 1899 London (30); 1899 Dublin (25)

201 **The Old Champion*** *c.*1899

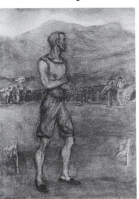

Sgd. bottom left
Watercolour and crayon, 36 x 27
Exh. 1962 Dublin (35); 1962 London (8); 1964 Derry/Belfast (29)
Coll. Dawson Gallery, Dublin, sold to Rosie Black in 1962; Dan McInerney, Dublin; Christie's (Dublin) sale, Carrickmines House, Co. Dublin, 10 Feb. 1986, lot 351 (repro); James Adam, Dublin; Leslie Waddington, London

An aging athlete, featured at a country race

meeting, which forms a background behind him.

202 **Hurley** 1899

Exh. 1899 London (28); 1899 Dublin (23)

203 **Not Pretty But Useful [Useful]** 1897–99

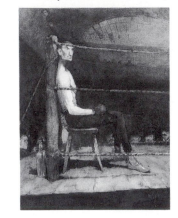

Sgd. bottom right 97 (or 99)
Watercolour, 71 x 56
Exh. 1899 London (16); 1899 Dublin (38); 1945 Dublin National Loan (169); *1988 Dublin (19)*; 1990 Monaco (2)
Coll. Sold to Edward Martyn in 1899; Edward Martyn Bequest to the Municipal Gallery of Modern Art (later the Hugh Lane Municipal Gallery of Modern Art), 1924; on loan to the Hon. Martyn Hemphill, Tulira Castle, from 1928, and lent to the National Loan Exhibition by Lady Hemphill; returned in 1982 to the Hugh Lane Municipal Gallery, Dublin (591)

Yeats would have heard the comments 'Not pretty but useful', and 'Useful', at the boxing matches he sketched as a black-and-white illustrator during the eighteen nineties. He exhibited the work under both these titles. The post-impressionist performer theme relates to his open and experimental approach with his subject-matter before he became committed to the portrayal of *Life in the West of Ireland*. The inscribed date is obscure, but the signature is of the stylised kind he used in the mid-nineties, until 1897. However the fact that he exhibited the watercolour for the first time in 1899 suggests that he continued to work at it until 1898 or 1899.

204 **Arran Island** ? 1900

Exh. 1900 Dublin (30); 1901 London (33)
Though this watercolour, and *205*, were not

exhibited until 1900, they may have been executed at an earlier date. Yeats did an evening sketch of Aran Island, off the north west coast of Donegal, from the Dungloe Road when he was visiting those parts in August 1898; see *83*.

205 From Arran Island ? 1900

Exh. 1900 Dublin (27); 1900 Oxford.

See 204.

206 Memory Harbour early 1900

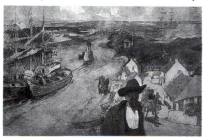

Sgd. bottom right 1900
Watercolour and crayon on card, 31 x 47
Exh. 1900 Dublin (25); 1901 London (31); 1971–2 Dublin New York (18)(repro); 1989 Sligo (5); 1990 Monaco/Dublin (3) (col. repro)
Coll. Presented by the artist to W. B. Yeats: Mrs. W. B. Yeats; private collection
Lit. Yeats, W. B., *Reveries over Childhood and Youth* (1915) (repro); (1916) ix (repro frontis.); Pyle, H. (1970, 1989) 17, 46, 128; *Connoisseur* 181 (September 1972) 57

Memory Harbour, a view of Rosses Point in Sligo where Yeats spent his summer holidays as a youth, is a seminal work, gathering together images on which the artist was to draw during the rest of his career, as well as establishing the conscious source of his stylistic development as the memory. 'No one creates', he told his brother's biographer, Joseph Hone more than twenty years later, 'The artist assembles memories' (7 March 1922. University of Kansas Libraries Special Collections).

The view in the watercolour can no longer be seen. The new promenade leading to the Point, recently built over the shoreline, has forced the road that runs through the village of Rosses Point inland, though features of the channel and of the headland, such as the Metal Man, and the shells of the old pilot house and the Middletons' house are still extant. The artist presented the watercolour to his brother, the poet, W. B. Yeats, who used it to illustrate *Reveries over Childhood and Youth*, published by

Cuala (1915) and Macmillan (1916). 'In half the pictures he paints today I recognize faces that I have met at Rosses or the Sligo Quays', WB wrote in *Autobiographies*; and in *Reveries* he pointed out aspects of the harbour which appealed particularly to himself and his brother: 'The man on the pedestal in the middle of the river is "the metal man", and he points to where the water is deep enough for ships. The coffin, cross-bones, skull and loaf at the point of the headland are to remind one of the sailor who was buried by a ship's crew in a hurry not to miss the tide. As they were not sure if he was really dead they buried him with a loaf as the story runs.'

Deadman's Point is one of Jack Yeats's illustrations in *A Broadsheet*, August 1903: and other separate elements of the watercolour led to *The Sea Captain's Car*, the oil of 1922 (see *407*), *The Metal Man* of *Life in the West of Ireland*, 1912 (see above), which Yeats also painted in oil, *From the Old Pilot House* (1945; see below)), and other compositions.

Jack Yeats's mother had died suddenly early in 1900, on 3 January: and, though she had been a total invalid almost as long as he had known her, the reminiscent mood of the watercolour probably owes much to this event. The figure in the right foreground is a typical 'returned American', an emigrant who has come back to his birthplace, see also *281*. His

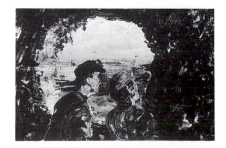

face is dark with emotion as he turns his back on the scene of the pastimes of his childhood, his eye alone lit up. In later life, when Yeats developed the idea of memory with greater elaboration he substituted himself for the returned American of the watercolours, as in *The Showground Revisited* (1950): and he created a similar contemplative character, Mr. No Matter, the philosophical traveller of his book *The Charmed Life*, whose deep thoughts 'were communing with his inner ear'.

Stylistically the watercolour is sophisticated, striking a balance between illustrative narrative and a symbolism grounded in the artist's personal experience. After the initial pencil work and the application of the fluid watercolour, the artist has outlined the figures and scene with a clear brown crayon line, the line shortly becoming the most dominant feature of his watercolours and early oils.

207 The Valley Wood, Dublin* *c.*1900

Watercolour on card, 9 x 13
Coll. Victor Waddington, London; Tim Vignoles, Surrey

Probably dating from Spring 1900, when Yeats was in Dublin, and did much sketching in the area of the Rocky Valley, on the border of County Wicklow, between Bray and Enniskerry.

207a The Valley Wood, Dublin* *c.*1900

Sgd. bottom right
Stamped with monogram
Watercolour, 13 x 9
Coll. Dawson Gallery, Dublin; Mr. and Mrs. P. J. Murphy, Dublin

A small watercolour view, the same dimensions as a sketchbook drawing, of the woodland, with some withered branches in the foreground.

208 The Edge of the Valley Wood, Dublin*
 1900

Sgd. bottom right
Watercolour, 36.5 x 25
Exh. 1962 Dublin (63); 1964 Derry/Belfast (49); 1971–2 Dublin, New York (19)(repro)
Coll. Dawson Gallery, Dublin; Sir Robert and Lady Mayer; private collection
Lit. Joyce, W. St. J., *The Neighbourhood of Dublin* (1921) 101-2

The Valley Wood is at the entrance to the Rocky Valley, which rises to the Great Sugar Loaf beyond Enniskerry. The view is of fields and hedges on the hillside above the wood, beneath a cloudy sky.

209 The Valley Wood* 1900

Sgd. bottom right
Watercolour, 37.5 x 25
Exh. 1961 London (43) (repro)
Coll. Victor Waddington, London

The interior of the wood, mainly the foliage.

210 The Valley Wood, Dublin* 1900

Sgd. monogram 1900 bottom right
Watercolour, 37.5 x 25

Exh. 1961 London (41)(repro); 1967 London
(70)(repro)

Coll. Mr. and Mrs. W. C. K. Wilmers, Switzerland

This may be *The Valley Woods, 389,* first
exhibited in 1902. The trees, of mauve tone
against a runny rich green, open up to a view
of hill fields beyond.

211 Below the Valley Wood, Dublin* 1900

Gregory's house at Gort in County Galway,
in soft blending shades.

212a At Coole* 1900

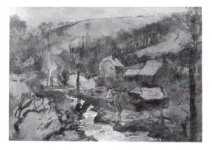

Sgd. monogram bottom right

Insc. on verso with title, April 25, 1900
Watercolour, 25 x 36

Coll. Cecil Higgins Art Gallery, Bedford

A little stream runs in the foreground, past a
house with outbuildings. Very freely painted
with a view up to the wood and the hills.

212 At Coole* 1900

Sgd. monogram bottom right

Insc. on verso with title April 30th 1900
Watercolour 36 x 25

Exh. 1962 London (9); 1967 London (67)(repro);
1973 London Waddington III (5)(repro)

Coll. Victor Waddington, London; private
collection

View from the verandah window of Lady

Sgd. monogram 1900 bottom left
Watercolour, 25 x 35.5

Coll. Waddington Galleries, London
See *212.* The verandah runs along the left
side of the picture, with a view of Coole Park
beyond it.

213 At Coole* *c.*1900

Sgd. bottom right
Pencil and watercolour, 9 x 13

Coll. C. P. Curran, Dublin; Mrs J. Solterer, U.S.A.

A landscape sketch of Coole Park taken from
one of the sketchbooks.

214 At Coole* *c.*1900

Stamped with monogram bottom left
Watercolour, 23 x 33

Exh. 1975 *Rosc Chorcaí* (148)

Coll. Dr. Michael O'Shea, Cork; James Adam
(Dublin) sale 10 Dec. 1987, lot 68 (repro)

A view of trees and meadow, with grey sky.

215 The Lake [On the Lake, Coole] *c.*1900

Sgd. bottom left
Watercolour, 9 x 13

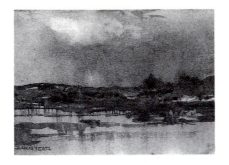

Exh. 1901 Dublin (30); *1965 Dublin* (85); 1988 Dublin (20)

Coll. Sold to Hugh Percy Lane at the exhibition in 1901, who presented it to the Dublin Municipal Gallery, later the Hugh Lane Municipal Gallery of Modern Art, Dublin (198)

Lit. Gregory, A., *Hugh Lane's Life and Achievement* (1921) 282

An impression of Coole Lake on a cloudy day, painted in a sketchbook during a visit to Lady Gregory's home in Co. Galway in the summer of 1900. The uninterrupted flow of colour, sustaining uneasy light, the threat of rain and the tranquil glow of the damp shore, is typical of Yeats's non-figurative landscapes around 1900.

216 The Lake, Coole* 1900

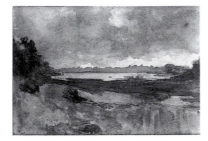

Sgd. with monogram bottom left 1900 Watercolour, 24.5 x 35.5

Exh. 1961 London (42)(repro)

Coll. Iris Winthrop, U.S.A.

The lake on a cloudy day, seen in mid distance, with the stream and shore occupying the foreground. See *386, 436*.

217 Coole Lake* c.1900

Stamped with monogram bottom right Watercolour, 17 x 35

Exh. 1973 Waddington III (8), as 1909

Coll. Waddington Galleries

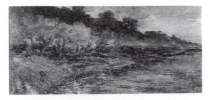

A view of the wood taken from the water, in the style of *212*.

218 Untitled: The Woods at Coole (?)* c.1900

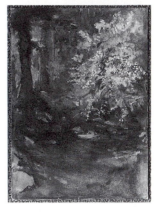

Stamped with monogram bottom right Watercolour, 35 x 25.5

Coll. Victor Waddington, London

A study of the light and shade of woodland, in soft warm colouring, with a May tree in flower in the near distance, other trees in a row beyond.

219 A Wet Day at Coole, August 1900*

Sgd. bottom left Watercolour, 25 x 35.5

Exh. 1961 Dublin (20)

Coll. Karl Mullen, Dublin; private collection

Lake in the foreground, with stones on the bank, then the path which leads to the water, with grass on either side, and — beyond again — the woods, beneath a strip of cloudy sky.

219a Watching Cricket* 1900

Insc. with title
 Pencil and wash, 9 x 13
Exh. 1982 London Fine Art Society 'Bank
 Holiday' (15291)
Coll. Mr. and Mrs. P. J. Murphy, Dublin

From a Romney Ringback sketchbook dated
1900.

219b In the Outfield* 1900

 Pencil and watercolour, 9 x 13
Exh. 1982 London Fine Art Society 'Bank
 Holiday' (15299)
Coll. Mr. and Mrs. P. J. Murphy, Dublin

From a Rowney Ringback sketchbook dated
1900, one of a group of sketches of Kiltartan
v. The County at Athenry.

220 Aran* 1900

Sgd. bottom right
 Pencil and watercolour, 11.5 x 9

Exh. 1961 London (40) (repro)
Coll. Anthony Ran, England

A sketch from one of the sketchbooks of an
arrival at the island, carrying a heavy load of
strapped baggage on his back, past a briefly
indicated cottage.

221 Stormy Day

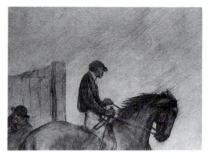

Sgd. bottom left
Exh. 1934 *London*
Coll. Sold through Victor Waddington Galleries
 to John Burke, 1947; James Adam (Dublin)
 sale, 15 Nov. 1983, lot 126a (repro)

Described as an 'early watercolour' in the
artist's workbook, which has a sketch note of
a building, trees and rain.

222 Untitled (A): Study of Branches* *c.*1900

Sgd. bottom right
 Watercolour, 13 x 9
Coll. Victor Waddington, London

From a sketchbook, a pair with *223*. Bare
branches are silhouetted against leaves and
other trees, and a strip of gold sky.

223 Untitled (B): Study of Branches* *c.*1900

Sgd. bottom left
 Watercolour, 13 x 9
Coll. Victor Waddington, London

See *222*. Blue branches in a wood, with a
glimpse of gold coloured sky.

224 Untitled: Cattle among Trees* *c.*1900

Sgd. monogram bottom left
Watercolour and pencil, 25.5 x 36
Exh. 1989 *Dublin* (18) (col. repro)
Coll. Victor Waddington, London; James Adam (Dublin) sale, 12 Feb. 1981, lot 67; James Gorry, Dublin

There is an emphasis on the heavy atmosphere of a corner of the field behind the trees where the young cattle congregate, rather than on an identified location. The row of knotted tree trunks in the foreground, with their loose veil of foliage and dark intricate shadows, and shapes of cattle behind them, opens to a low shoreline, with a calm sea.

225 Untitled: Landscape* *c.*1900

Watercolour, 25 x 33.5
Coll. Victor Waddington, London

A view of distant woods and landscape under a rainy sky.

226 Untitled: Seascape & Sailing Vessel* *c.*1900

Sgd. bottom right
Watercolour, 14.5 x 35
Coll. Victor Waddington, London

227 Untitled: Strand with Boat* *c.*1900

Watercolour, 25 x 33.5
Coll. Victor Waddington, London

228 Untitled Sketch* *c.*1900

Pencil and watercolour, 13 x 18
Coll. Victor Waddington, London

Seascape lightly treated, showing the sail of a boat and a view of the land.

229 The Round Tower

Exh. 1900 Dublin (31)

230 Bathers (II)

Exh. 1900 Dublin (10); 1900 Oxford; 1901 London (6); 1904 New York (12)

231 Untitled: A Donkey *c.*1900

Sgd. bottom right
Watercolour on light brown paper, 15 x 19
Coll. Victor Waddington, London

232 The Donkey (Jumping) [The Jumping Donkey] 1900

Sgd. bottom right
Watercolour, 30.5 x 46

Exh. 1900 Dublin (21)
Coll. Given to Mrs. White after the exhibition; Mrs. Vincent O'Brien, Cashel

233 Harnessing the Long Team 1900

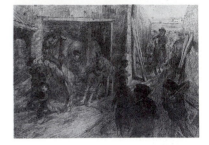

Sgd. bottom left
Watercolour with pastel, 25.5 x 35
Exh. 1900 Dublin (15); 1900 Oxford; 1901 London (12); 1904 New York (2); 1961 Dublin (12); 1964 Derry/Belfast (16)
Coll. Dawson Gallery, Dublin, sold to Rosie Black c.1965; Dan McInerney, Dublin; Christie's sale Carrickmines House, Co. Dublin, 10 Feb. 1986, lot 341 (col. repro); Thomas Agnew, London

A farmyard scene, with youths and small boys at work harnessing a donkey team, while others watch. A boy riding up a laneway towards them is framed against the West of Ireland landscape. Yeats described it at his exhibition in the Clausen Galleries, New York, in 1904, as 'Little boys collecting donkeys to drive, and presently they will start off with three donkeys in a row' (*Gaelic American* , 5 April 1904).

234 The Old Harness Cart* *c.*1900

Sgd. lower right
Watercolour, 18 x 29
Coll. Waddington Galleries, Montreal; Mrs. J. C. Douglas, Montreal

Sketch of a group of men around a harness cart.

235 The Red Cow Inn, London* *c.*1900

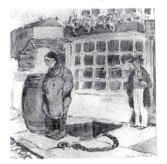

Sgd. bottom right
Pencil and watercolour, 23 x 18.5
Coll. Victor Waddington, London

236 The Little Gara River* *c.*1900

Sgd. bottom left
Watercolour, 28 x 44
Exh. 1961 Dublin 1964 Derry/Belfast (31)
Coll. R. A. French, Dublin
Lit. A Broadside, August 1913: 'The Little Gara
River' by Wolfe T MacGowan

The river, which ran at the bottom of Yeats's
garden at Cashlauna Shelmiddy, in Devon,
seen at a slant, with light falling through a gap
in the trees on the far bank, see *384*. Here Yeats
and Masefield sailed their boats in the early
nineteen hundreds. Yeats published a poem
about the Gara river in *A Broadside* in 1913,
under his pseudonym, Wolfe T. MacGowan.

237 Devonshire Coast* *c.*1900

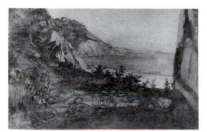

Sgd. monogram bottom left
Watercolour, 28 x 42
Coll. Victor Waddington, London

A sandy grassy foreground, with a frame of
cliffs, looming towards a blue hazy sea, des-
cribed in warm colours.

**238–252 Totnes October Fair 1900 (15
Sketches)***

Pencil and watercolour, on lined paper from
a notebook with rounded corners and gilt
edge, each 11 x 6.5
Coll. The artist's estate; private collection

Notes of gypsies selling horses, and of other
characters seen at the Totnes Fair. The sketches
are in an envelope marked in the artist's hand,
'Totnes Oct Fair 1900'.

253 Thinking about Horses *c.*1900

Exh. 1900 Dublin (17); 1901 London (11)
Coll. Sold to 'Mrs. Rhys's friend' at the London
exhibition

Lit. *Daily Express* (20 Feb. 1900) 6; a sketch of
this is reproduced in the *Weekly Independent*
(Dublin) (3 March 1900)

An ex-jockey or ex-coach driver, attired in an
immense waterproof, his hands sunk deep in
his pockets, leaning against a wall and pensively
eyeing the street gutters, according to the *Daily
Express* correspondent. 'Mr. Yeats overheard
someone asking this individual what he was
meditating on: — "I do be thinking of horses"
was the reply.' See *254*.

253

254 Waiting (for Opening Time)* *c.*1900

Sgd. bottom right
Watercolour, 46.5 x 31
Coll. From a private collection; purchased at
Sotheby's sale, 13 July 1961 by Riley; N.
Bernstein
A man in a great coat leans against a shop wall,
probably *253*.

255 Untitled: Talk at the Fair* *c.*1900

Stamped with monogram in 1967 bottom
right
Pencil on card, 19 x 26.5
Exh. 1967 London (59) (repro)
Coll. Victor Waddington, London

Pencil sketch of a fair, in a hilly setting. A man
with a stick, and his companion, talk with a
man on horseback who has stopped to greet
them.

256 'He's the Finest [Best] Horse from the Rosses to Rathmullen' 1900

Exh. 1900 Dublin (29); 1900 Oxford
Coll. Sold to J. Geoghegan in 1900

257 'Playing Thimselves [Themselves]' 1900

Sgd. bottom right
Watercolour, 30.5 x 46
Exh. 1900 Dublin (26); 1900 Oxford; 1901 London (32); 1961 London (60)(repro)
Coll. The Lady Albery

Two horses racing on a Sligo strand.

258 'The Long-Tailed Filly and the Big Black Hoss' 1900

Exh. 1900 Dublin (33)
Coll. Sold to Lady Gregory at the exhibition

259 Portrait of John Butler Yeats* 1900

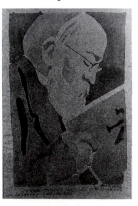

Sgd. bottom right
Watercolour, 33 x 21.5
Insc. J.B.Yeats, Snails Castle North Mills in the Coomberies of Devon Nov 16th 1900
Exh. 1962 Dublin (42); 1964 Derry/Belfast (32); 1971–2 Sligo/Dublin (6); 1989 Sligo (7)
Coll. Purchased from the Dawson Gallery, in 1964, by Sligo County Library and Museum (SC6)
Lit. Pyle, H. (1970, 1989) 59

A stencil portrait, right profile, made while J. B. Yeats was staying with his son at Cashlauna Shelmiddy (Snails Castle) in November 1900, probably his only visit there. Yeats was experimenting with stencils at this period, and made other important stencil portraits, see *260–1, 522–3*. His mastery of the stencil contributed in some part to the flexible economy of his final period oils.

260 Portrait of John Butler Yeats* *c.*1900

Sgd. monogram bottom left
Watercolour stencil, 26 x 20
Coll. The artist's estate; private collection

Right profile of the artist's father, his head bowed. See *259*.

261 Untitled* *c.*1900

Watercolour stencil on brown paper, 18 x 15
Coll. J. C. Miles; Mrs. G. Miles, Yarmouth

A stencil silhouette of a man's head.

262 Dan Leno* *c.*1900

☐ *Skb. 44*

Watercolour and pencil, 10.5 x 8.5
Coll. Niall Montgomery, Dublin; private collection
Lit. Wood, J.H., *Dan Leno* (1905)

A drawing of Dan Leno clog dancing at the Tivoli Music Hall in Dublin, taken from a sketchbook. Leno made his last appearance at Drury Lane, in 1903. See also sketch of Dan Leno in *sketchbook 44* (1901).

263 The Ballad Singer* *c.*1900

Sgd. monogram bottom right
Insc. with title
Pencil and watercolour, 9 x 13
Coll. C. P. Curran, Dublin; Mrs. Solterer, U.S.A.

A single figure sketched lightly, taken from a sketchbook.

264 A Country Jockey 1900–03

Tinted pencil sketch

Coll. Given by the artist to Miss Atkinson 1924 who gave it to Alan Duncan

265 The [A] Connemara Innkeeper 1900

Sgd. bottom right
Exh. 1900 Dublin (12); 1900 Oxford; 1901 London (8); 1904 *London* (220)
Crayon and watercolour, 35 x 13
Coll. Egan Galleries, Dublin; bought as a present for P. F. O'Brien of the Long Hall Bar, Dublin, *c.*1920; sold by auction Jury's Hotel, Dublin, 14 Mar. 1972; private collection, Dublin

The scene relates to emigration, which is one constant aspect of Yeats's watercolour theme of *Life in the West of Ireland.*

266 The Harvest Man Returning 1900

Exh. 1900 Dublin (19); 1900 Oxford
Coll. Sold to Robert Gregory in 1900
Lit. A rough sketch of this work was reproduced in the *Weekly Independent* (Dublin) (3 March 1900)

Described by contemporary reviewers as 'a typical Connaught labourer just arriving home from across the Channel after slaving amongst the unsympathetic Saxons', who stands on the deck of a hooker, looking towards the land.

267 A Young Man's Troubles 1900

Sgd. lower right
Crayon, 14 x 47
Exh. 1900 Dublin (11); 1900 Oxford; 1901 London (7); 1904 New York (3)
Coll. Sold in New York to John Quinn; Quinn Inventory as *The Bar*, American Art Galleries (New York) sale of John Quinn collection, 10 Feb. 1927, lot 268; bought by W.C. Murphy

'A shop interior in a Connaught town; a sad-faced young man stands brooding at one side of a broad board or counter; behind him pasted on the wall are a row of emigration notices; in front of him, at the far side of the counter, two elderly men stand drinking, and they watch with kindly distant disinterest the working of his thoughts' (*All Ireland Review* , 10 March 1900, p.5).

268 The Gentleman Rider 1900

Exh. 1900 Dublin (35); 1900 Oxford; 1901 London (36)

269 A Gentleman Walking* *c.*1900

Sgd. bottom right
Pencil and watercolour, 25 x 17
Exh. 1967 London (68)(repro)
Coll. Sotheby's sale 14 Dec.1966, lot 268; Victor

Waddington, London; Sotheby Parke Bernet (New York), 9 Oct. 1976, lot 3902

Sketch of an old-fashioned gentleman, dressed in a cut away coat and top hat, walking on the strand. It is probably earlier than the date of 1904 given in the 1967 London catalogue.

270 Portrait Figure of an Irish Gentleman*

1900–05

Sgd. bottom right
 Watercolour, 35.5 x 25.5
Coll. James A. Healy, New York; presented to Sligo County Library and Museum in 1965 (SC7)
Exh. 1971–2 Sligo/Dublin (7); 1989 Sligo(9)
Lit. *A Broadsheet* (February 1903)

Probably the 'Head and shoulders of man with landscape' listed in the inventory of John Quinn's collection, 1924. The composition may be compared with *369* and *370*, for the method of introducing an introspective element into Irish landscape,

also with *Meditation*, the oil painting of 1950. In *A Broadsheeet* of February 1903, Yeats illustrated Lady Gregory's translation of 'It's my grief that I am of the race of poets . . .' with the head and shoulders of a man with a wide hat, and landscape background. Meditation became a constant theme in his late painting.

271 The Gypsy Glance

1900

Sgd. bottom right
 Watercolour, 47 x 32
Exh. 1900 Dublin (37); 1900 Oxford; 1901 London (38)
Coll. Sold through Victor Waddington Galleries November 1945 to Mr. and Mrs. Frank Butler, Minnesota

Painted in browny pinks with a blue background and a light peach sky. The gypsy looks over his shoulder with a wild confident expression to where the hand of a horseman greets him.

272 The Big Pedlar

1900

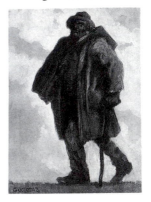

Sgd. bottom left
 Gouache on board, 56 x 40
Exh. *1900 Dublin* (156); 1901 Dublin (14); 1902 *Cork*; 1903 London (13)
Coll. Sold to John Quinn in 1903; listed in the Quinn inventory as *The Travelling Man;* American Art Galleries (New York) sale of John Quinn collection, 11 Feb. 1927, lot 444 (repro); Scott & Fowles, New York; Town & Country Estates (Ireland) sale, 30 Sept.1952, lot 106; Sotheby's (London) sale, 14 Oct. 1953, sold to Margulies; Victor Waddington, London; H. B. Wallis

A big burly man with a bundle on his shoulder, stick in left hand, walks on the horizon silhouetted against a stormy sky.

This has recently been called *Man of the Road*. 'An old Sligo character,' Yeats wrote to John Quinn (12 March 1903), 'a very tall powerful man . . . I remember him tell in the Inn at Rosses Point, Sligo, how he sold a dozen Brummagem knives to a woman up the country for a grand price because he told her that he was a runaway apprentice of Smith's the cutlers and that he had stolen the knives, the best in the shop. "She got a rare take in and didn't it serve her right for buying stolen property".'

273 'When there was nothing between you and Heaven but a pin' ['Where there is nothing between you and Heaven but a pin'] 1900

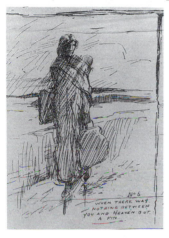

Watercolour, 25.5 x 18

Exh. 1900 Dublin (6); 1960 Sligo (7); 1961 Sligo (12); 1963 Sligo (11)
Coll. Sold to A. Jackson in 1900; Miss Olive Pollexfen-Jackson, Sligo
Lit. A rough sketch of this was published in the *Weekly Independent* (Dublin) (3 March 1900)

A tinker woman walks along a sea road holding a bag in each hand, a baby wrapped in the shawl on her back.

274 'I'm the Greatest R-rogue in [All] Ireland' 1900

Exh. 1900 Dublin (13)
Coll. Sold to Horace Plunkett at the exhibition

Described by the *All Ireland Review* (10 March, 1900) as 'a Connaught ne'er-do-well', this watercolour was probably burned with the rest of Sir Horace Plunkett's collection at Kilteragh, Foxrock, Co. Dublin, when the house was destroyed during the Troubles in 1923.

275 The Short-Haired Man's Wife 1900

Exh. 1900 Dublin (42); 1900 Oxford; 1901 London (44)

276–280 The Bay Pilot, The River Pilot, The Stevedore, The Ganger, and the Gang [a set of 5 sketches] 1900

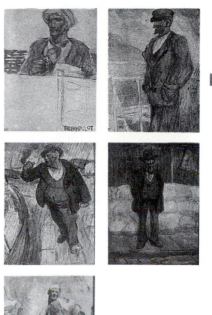
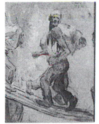

Watercolour, each 11 x 8

Exh. 1900 Dublin (7); 1900 Oxford; 1901 London (4); 1971–2 Sligo/Dublin (4); 1989 Sligo (6) (*The River Pilot* and *The Ganger* repro in col)
Coll. Sold to John Quinn, 1902, and listed in the Quinn Inventory; presented to the Sligo County Library and Museum, 1965, by James A. Healy, New York (SC4).
Lit. *John Quinn 1870–1925: collection of paintings, watercolours, drawings and sculpture* (1926) 22

These five independent studies from a sketchbook reproduce some characters seen about Sligo Quay by Yeats at the beginning of the century. All of them appear again in separate watercolour portrayals, and in more symbolic guise in the late oils: but it is interesting that Yeats considered these studies, with their great humour and skilled use of watercolour, as a

95

group forming one complete watercolour work for exhibition.

281 Came from 'Frisco in the Flour Vessel 1900

Sgd. lower right
 Watercolour, 46 x 31
Exh. 1900 Dublin (28)
Coll. Sold to Lady Layard at the Dublin exhibition; private collection; Phillips Fine Art Auctioneers, Bath; Peter Nahum, London

A returned American of the type frequently seen in Sligo during the early years of this century (also known as 'Yankees'), lounges on Sligo Quay, in his high heeled boots and slouch hat. In appearance he is similar to the melancholy dreamer of *206*, only here he has a jaunty expression, an air of recently acquired confidence, knowing he is a subject of admiration among the local people who have not travelled. Yeats was always fascinated by the local feeling that across the ocean lay a land of vision and promise, and used this as a theme in many paintings. 'I wish I could see San Francisco', he wrote to Anna Russell, 31 July 1951, 'I have just looked again on a map at that city of Imagination' (National Gallery of Ireland, Dublin, archive).

282 The Man Who Told the Tales 1900

Exh. 1900 Dublin (1); 1900 Oxford; 1901 London (1); 1904 New York (4)
Coll. Sold to John Quinn at the New York exhibition; listed in the Quin inventory, 1924.

'Little travelling butcher standing with his clothes all dripping with the rain in front of the store and telling the tale of stoppers' (*Gaelic American*, 5 April 1904). The *Freeman's Journal* (26 February 1900) drew attention to the 'sharp intelligence of the forehead and features, the mendacious expression about the corners of the mouth.' The attraction of the teller of tales

was drawn about the same time by Joyce in *Dubliners,* in Eveline's suitor, Frank, who 'had tales of distant countries.'

283 The Second Engineer's Song also known as The Second Engineer Singing: 'The Captain with the whiskers Took a shy glance at me' 1900

Exh. 1900 Dublin (9); 1900 Oxford; 1901 London (5)
Coll. Sold to Mrs. Twigg at the London exhibition

284 The Star Gazer 1900

Sgd. bottom right
 Watercolour, 46 x 30.5
Exh. 1900 Dublin (32); 1900 Oxford; 1901 London (34); 1904 London (239); 1960 Sligo (3); 1963 Sligo (5); 1971–2 Sligo/Dublin (5); 1989 Sligo (8)
Coll. The artist; sold through Victor Waddington Galleries to Father Senan OFM, Cap., 1945; lent by the *Capuchin Annual* to Sligo Museum 1960 and bought by the Sligo County Library and Museum, September 1962 (SC5)

A jockey, wearing scarlet lake cap and shirt, on the back of a tall horse, near the sea shore. Both man and mount gaze upwards into the sky. This human link with infinity, shared on occasion with the horse, is explored in late

1. The Auction, 1897 (no. 21)

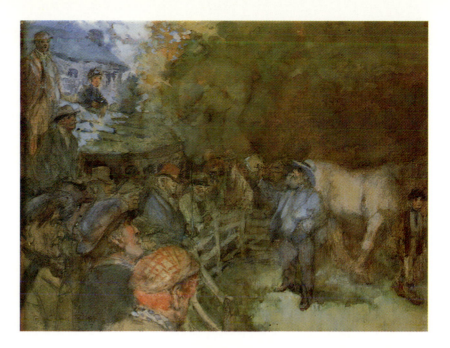

2. Fair Day Dinner, Devonshire,
 1897 (no. 25)

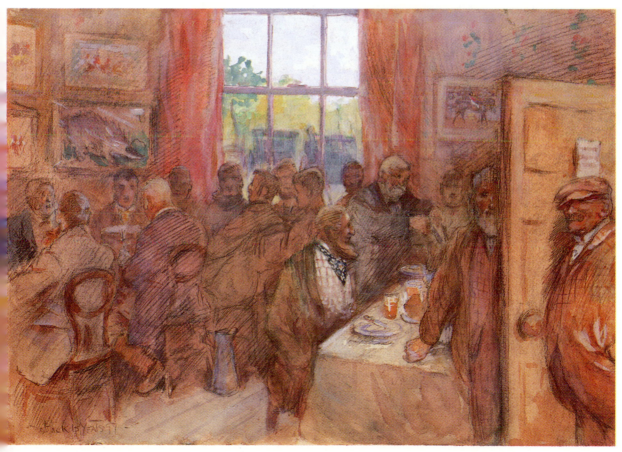

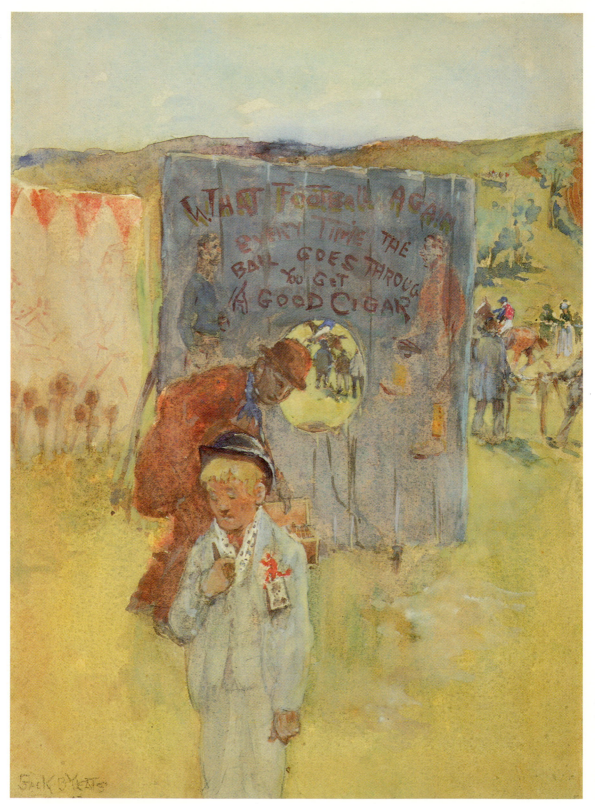

3. A Cigar for a Kick, 1897 (no. 67)

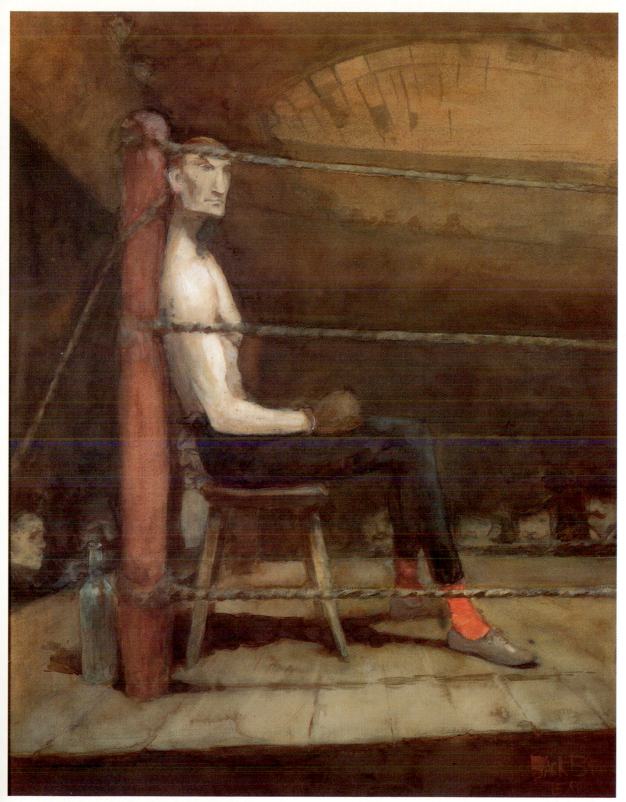

4. Not Pretty but Useful, 1897–9 (no. 203)

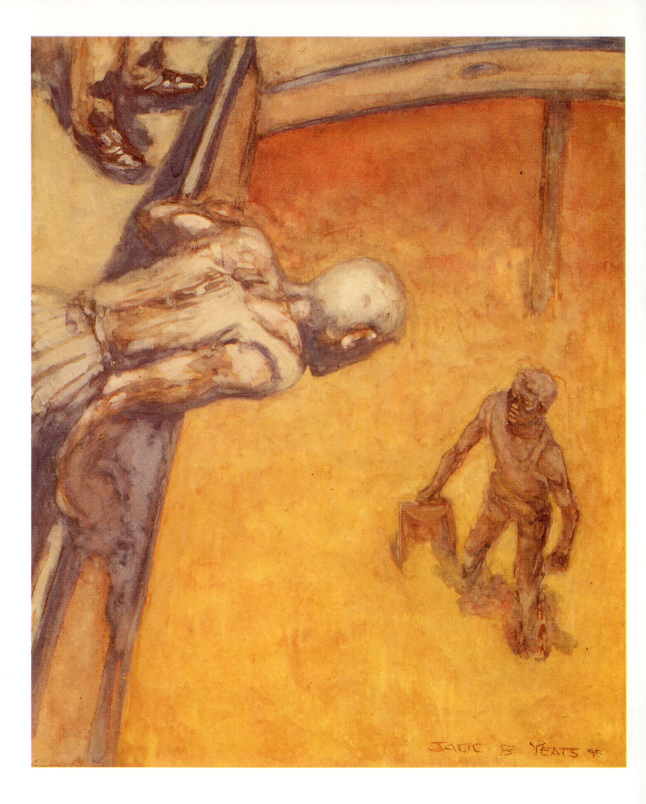

5. The Grain Ship, 1898 (no. 106)

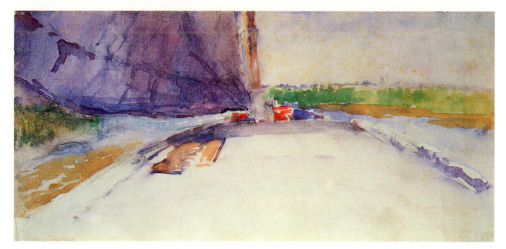

6. On the Broads (2): On Deck, 1899 (no. 131)

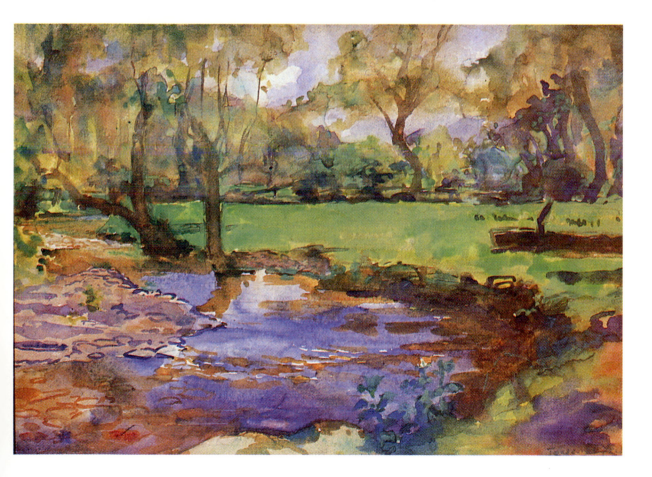

7. On the Gara River, 1899–1900 (no. 158)

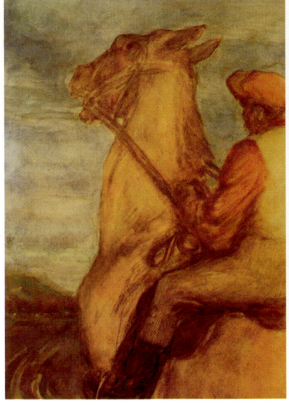

8. The River Pilot, 1900 (no. 277)

9. The Star Gazer, 1900 (no. 284)

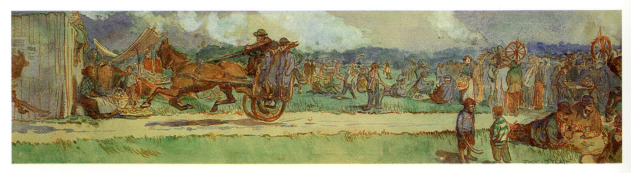

10. Outside the Hurley Match, 1900 (no. 307)

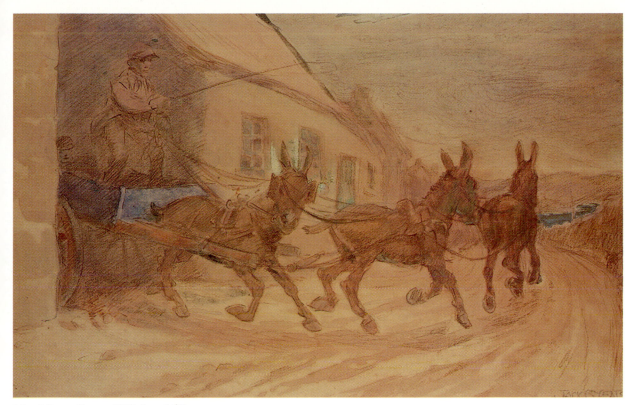

11. A Long Team, 1899 (no. 161)

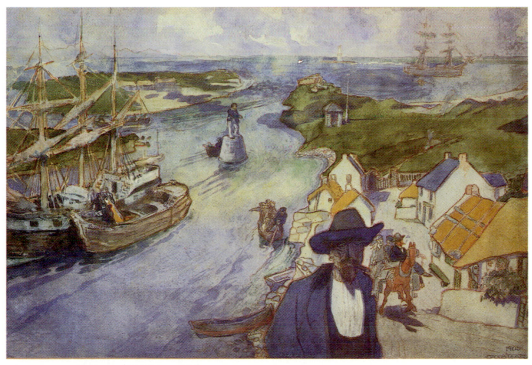

12. Memory Harbour, 1900 (no. 206)

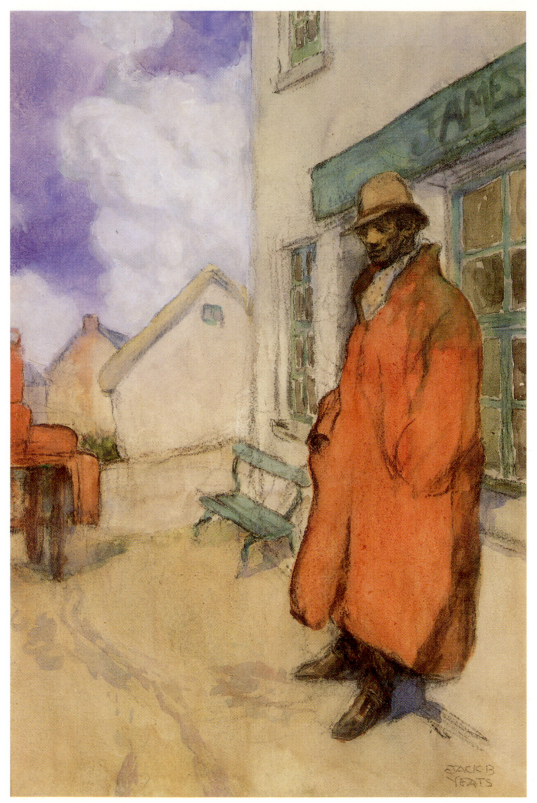

13. Waiting (for Opening Time), *c.*1900 (no. 254)

14. The Valley Wood, Dublin, *c.*1900 (no. 207a)

15. The Lake, *c.*1900 (no. 215)

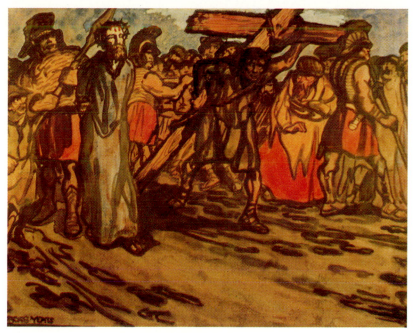

16. Simon the Cyrenian, 1901 (no. 326)

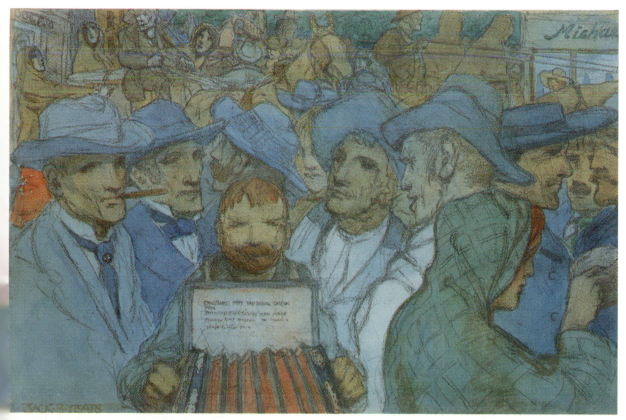

17. The Race Course Town, 1901 (no. 373)

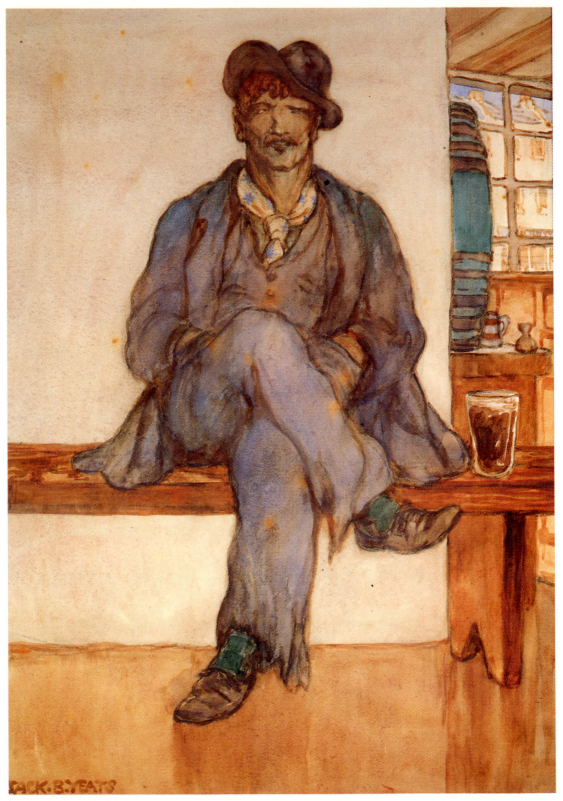

18. The Rogue, 1903 (no. 465)

19. [The] Regatta, 1903 (no. 486) 20. The Look Out, 1910 (no. 692)

21. Lives, Book 2, no. 12

22. Portrait of Synge, 1905 (no. 525)

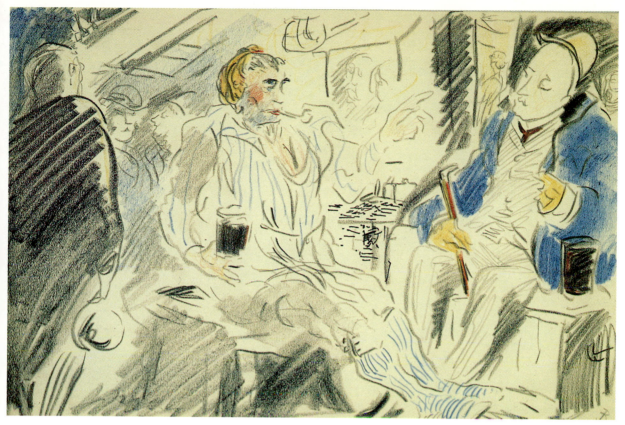

23. Lives, Book 1, no. 5

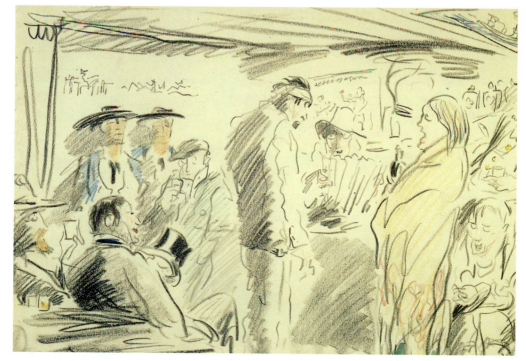

24. Lives, Book 2, no. 14

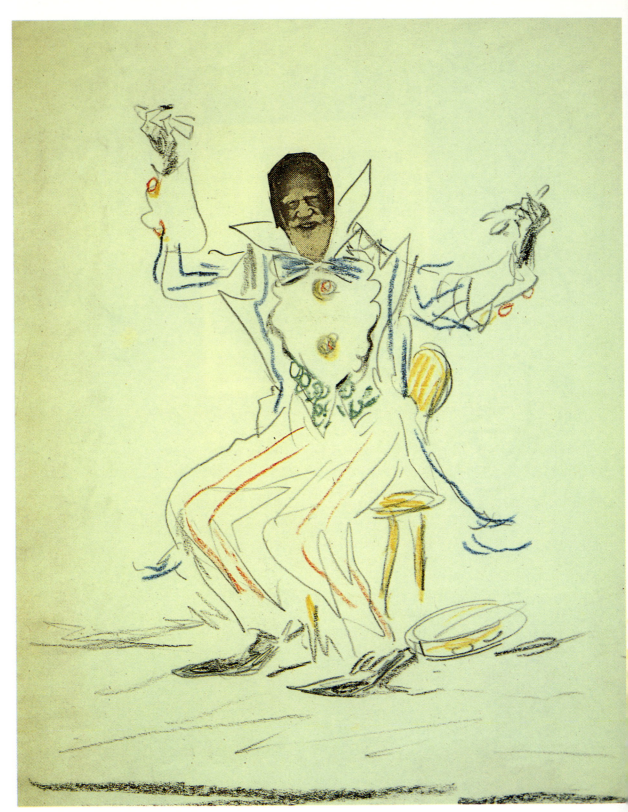

25. G.B. Shaw Playing the Spoons, 1930s (no. 729)

oils such as *The Harvest Moon* (1946; see above) and *There is No Night* (1949).

285 The Last Ostler* *c.*1900–05

Insc. with title
 Pencil and watercolour on card, 21 x 14.5
Coll. Dawson Gallery, Dublin

A study of a bent old ostler with a scarf knotted around his neck, slouching over the cobble-stones, bucket in hand.

286 White Water 1900

Exh. 1900 Dublin (23)
Coll. Sold to Lord Gough at the exhibition

'A cold and rainy day with its accompani-ment of a hackney car' (*Social Review*, March 1900).

287 The Early Car 1900

Exh. 1900 Dublin (3)
Coll. Sold to Isaac Yeats at the exhibition

288 Father and Son 1900

Exh. 1900 Dublin (5)
Lit. A rough sketch of this work was reproduced in the *Weekly Independent* (Dublin) (3 March 1900)
Coll. James Adam (Dublin) sale, 25 March 1992, lot 49 (repro), as *A Western Man*

The head and shoulders of a man. His father's portrait is on the wall.

289 Blue Muffler, Yellow Muffler 1900

Exh. 1900 Dublin (34); 1900 Oxford; 1901 London (35)

290 Trotting and Racing

Sgd. bottom left

Pencil and wash, 24.5 x 34.5
Coll. Sold through L. Smith to a private collector 1945; purchased from Waddington Galleries, London, by Nigel Hollick, Warwickshire

Described by the artist in his records as an 'early watercolour', it is a view of race track and trotting race.

291 Canary Jacket

 Watercolour
Coll. Given by the artist as a wedding present to Miss Ruth Montgomery, August 1945

Described in the artist's records as 'early small watercolour'.

292 Strand Races 1900

Exh. 1900 Dublin (22); 1900 Oxford; 1901 London (16)
Coll. Given by the artist to – – – Prescott, 1901

'The concourse about a racecourse . . . Some of the devices adopted by the riders in selecting jockey costumes is in many cases most amus-ing' (*Daily Independent*, 25 February 1900).

293 The Merry-Go-Round Man's Horse*
 1900–1903

Sgd. lower right
 Watercolour, 49.5 x 28.5
Exh. 1961 London (8) (repro)
Coll. Mr. and Mrs. S. Levy, London
Lit. Rosenthal, T. G. (1966) Plate IIa (col.)

Dated 1893 in the 1961 exhibition, this undoubtedly dates to the Devon period, and probably around 1900 or slightly after. It may have been exhibited originally under a different title. The scene is Drumcliff in County Sligo, on a race day, when a jockey attempts to control a frisky horse.

294 Skinning a Flea* *c.*1900

Sgd. monogram bottom right
Watercolour 27.5 x 23.5
Coll. Victor Waddington, London

Five tipsy gentleman at work on a round table in dark surroundings, their faces lit up.

295 Fiddlers 1900

Exh. 1900 Dublin (18); 1900 Oxford; 1901 London (13)

296 The Dance: 'Play up "The Connaughtman's Rambles"' 1900

Exh. 1900 Dublin (8)
Coll. Sold to Lady Cadogan at the exhibition
'A rural ballroom with a man sporting a huge shirt front and his partner "on the floor" for a set of quadrilles. Seated round the walls on benches are an admiring group of dancers in rustic finery' (*Daily Express*, 20 February 1900).

297 The Play Bill 1900

Sgd. bottom left
Insc. on verso with title
Pencil, watercolour and pastel, 35 x 17
Exh. 1900 Dublin (4); 1900 Oxford; 1901 London (3); 1904 *London*
Coll. Purchased at Egan's Gallery, Dublin, *c.*1920, and presented to P.F. O'Brien, Long Hall Bar, Dublin; purchased by Mr. and Mrs. Gerald Murray, Dublin, at the auction of the Long Hall Bar, March 1972; James Adam (Dublin), 29 May 1991, lot 89 (col. repro)

A boy wearing a cap looks into a shop window, which, along with posters advertising shipping lines, has a play bill announcing a production of *The Corsican Brothers*.

298 In a Liverpool Christy Minstrels' Show, Singing 'The Irish Emigrant' [Singing the Lament of the Irish Emigrant in a Liverpool Christy Minstrels'] 1900

Sgd. bottom right
Pastel, 31 x 46
Exh. 1900 Dublin (24); 1900 Oxford; 1901

London (17); 1904 New York (42); 1943 *Newry*
Coll. Sold to John Quinn, New York 1904; listed as *The Concert* in the American Art Galleries (New York) sale of the John Quinn collection 11 Feb. 1927, lot 397; bought by Ernest Boyd; Dr. P. Quinn, Newry; private collection

The interior of a concert hall, the audience gazing up at the Christy Minstrels on stage, grouped in a semi-circle around the leading singer (a motif used by Yeats in the oil *Singing 'Way Down Upon the Swanee River'* in 1942). The single figure in the back row may be a self-portrait of the artist. '[There are] some Irish girls and a youth in the foreground who are about to emigrate themselves.' (Note by Yeats in the *Gaelic American*, 5 April 1904.)

299 The Sea Chest 1900

Exh. 1900 Dublin (20); 1900 Oxford; 1901 London (15)

300 Untitled* *c.*1900

Sgd. bottom right
Watercolour on card, 18 x 13.5
Coll. Victor Waddington, London

A very stiff girl and her escort join a queue on a wide flagged pavement, beside a hoarding advertising a fight. Colours in the main, and outline, are maroon, with a yellow wash.

301 The [A] Poor Benefit 1900

Sgd. bottom right
Watercolour, 48 x 32
Exh. 1900 Dublin (38); 1900 Oxford; 1901 London (39); 1904 New York (13); 1962 *London* (3) (repro)
Coll. Victor Waddington, London

301

302 The Bruiser 1900

Sgd. top left
 Watercolour, 25 x 17
Exh. 1900 Dublin (41); 1900 Oxford; 1901
 London (43); 1904 New York (11); 1962
 Dublin (47)
Coll. Dr. Graham McCarthy, Stockholm

A boxer on his way into a changing room
which is already crowded. To the left is the
entrance to the ring, where some men and
women are discussing the contest.

303 Saved by the Call of 'Time' 1900

Exh. 1900 Dublin (40); 1900 Oxford; 1901
 London (42)

304 The End of a Round* *c.*1900

Sgd. bottom right
 Watercolour, 25 x 17
Exh. 1961 London (10) (repro)

A boxer supported to his corner by an assistant.
Slightly later than 1894, as stated in the 1961
catalogue, it may be *303* under a different title.

4 *305*

305 Untitled: The Ring* 1900–05

Sgd. monogram bottom right
 Watercolour, 20.5 x 18
Coll. Victor Waddington, London

Two men in the boxing ring at Whitechapel
in London.

306 The Three Cardmen Beaten* 1900–05

Stamped with monogram bottom right
Pencil and watercolour, 13.5 x 19
Exh. 1967 London (74)(repro)
Coll. Victor Waddington, London; Sotheby
 (London) sale, 13 Mar.1974; private collection

A group of labourers around a card table with a
factory chimney visible in the distance. Dated
1905 in the 1967 catalogue, it may be earlier.

307 Outside the Hurley Match 1900

Sgd. bottom right
 Watercolour, 12 x 46.5
Exh. 1900 Dublin (2); 1900 Oxford; 1901
 London (2); 1904 New York (1)
Coll. Offered by the artist through Victor
 Waddington Galleries to John Burke
 December 1947; private collection

**308 'Honest Man' [Honest Man the Hurley
 Player]**

Sgd. bottom left
 Watercolour and pencil, 43 x 30.5

Exh. 1900 Dublin (16); 1901 London (10); 1904
New York (24)
Coll. Private collection, U.S.A.
Lit. Rosenthal, T. G. (1966) 3 (repro fig. 3)

A strong study of a muscular hurler in action.
'"Honest Man" is the same as saying "Good
Man!" or "Well Played!"' (Yeats in the *Gaelic
American*, 5 April 1904).

309 Four Sketches of the Artist's Head* *c.*1900

Pencil and ink, 23.5 x 19
Coll. Lady Gregory; Colin Smythe, London

Four left profile sketches on one page, starting
with two humorous outlines at the top, des-
cending to two fuller studies.

310–313 Four Drawings from a Sketchbook*
1900–05

Sgd. with monogram, except 310
Pencil and watercolour, 311 and 312 with
pen and ink also, 9 x 13
Coll. Christie's (Dublin) sale, 26 May 1989, lots
243–246; private collection

310 Coming home from school on bor-
rowed donkeys (inscribed with title); *311*
Two women; *312* Tossing flame balls; *313*
Conversation

314–315 From a Sketchbook of 1900*

Pencil and watercolour, 13 x 9
Exh. 1982 London Fine Art Society Exhibition of
Sports and Pastimes
Coll. Anthony d'Offay; Tim Vignoles, Surrey; *315*
sold back to d'Offay

314 AE and WB Yeats playing cricket at
Coole (inscribed: AE WBY Coole 1900); *315*
'In the Nets' (a group practising cricket at
Coole)

316 The Toy Boat* 1900–05

Sgd. bottom right
Watercolour, 14 x 34
Coll. Dan McInerney, Dublin; Christie's sale,
Carrickmines House, Co. Dublin, 10 Feb.
1986, lot 345; Waddington Galleries

A sketch dating from the early nineteen hun-
dreds, perhaps of one of the toy boats Yeats
made with Masefield when he lived in Devon.

**317 Jellard putting Pobbles on the Garden
Path** 1901

Sgd. lower right
Insc. title and date
Pencil on buff paper, 19 x 11
Coll. Dan McInerney, Dublin; Christie's (Dublin)
sale, Carrickmines House, Co Dublin, 10
Feb.1986, lot 359; private collection

The garden of Cashlauna Shelmiddy, Yeats's
house in Devon. *Sketchbook 31* has 'Jellard
burning weeds', in March 1900.

318 Galway Bay 1901

Exh. 1901 Dublin (29)

319 A Graveyard on Aranmore 1901

Exh. 1901 Dublin (31)
Coll. Sold to Miss Keilly at the exhibition

320 The Wood Stream April 1901

Insc. on verso with title, April 1901
Watercolour, 16.5 x 24.5
Exh. 1961 London (44) (repro); 1964
Derry/Belfast (33); 1967 London (66)(repro)
Coll. Mr. and Mrs. L. Pollak, England

The soft leaf green colouring, with blues and
dark green, causes the stream to blend in with
the undergrowth. The location has not been
identified: it may be another view of the Valley
Wood, Dublin, see *207–11*.

321 The Fair of Carrick-Na-Gat 1901

Exh. 1901 London (21); 1902 Dublin (9); 1904
New York (16)
Coll. Sold to Lady Gregory in 1901; exchanged by
Frank Persse for *The Sailors' Theatre* (*The
Mechanics' Theatre, 422*) before the Dublin
exhibition; sold to John Quinn 1904;
American Art Galleries (New York) sale
catalogue of the John Quinn collection, 10
Feb.1927, lot 303; bought by J.M. Kerrigan

Yeats made several sketches of Carricknagat
Fair when he was in Sligo in early 1900

(*sketchbook 30*). One reviewer in 1901 praised 'the fine sense of motion and action about the galloping horses and excited men'. This must be the watercolour entitled *The Day of the Sports*, no. 303 in the American Art Galleries sale catalogue of the John Quinn collection, described as 'An animated Irish country scene; in the foreground a figure mounted on a cantering horse'; crayon and watercolour, 33.5 x 47, signed lower right.

322 The Bolter 1901

Sgd. bottom right
Watercolour, 26.5 x 35
Exh. 1901 Dublin (23)
Coll. Dawson Gallery, Dublin
Lit. *A Broadsheet* no. 1 (January 1902): 'The Pooka! The Pooka!'

A riderless horse flies through the landscape, hailed by men waving their hats from a wall in the background, where there are drooping flags and whiskey tents. The composition is similar to that in the pen and ink drawing of the Pooka in *A Broadsheet* no. 1.

323 After the Harvest's Saved 1901

Sgd. lower left
Watercolour, 38 x 29
Exh. 1901 Dublin (26)
Coll. Sold privately to John Quinn in 1902; listed in the Quinn inventory 1924; American Art Galleries (New York) sale of the John Quinn collection, 10 Feb. 1927, lot 295B; bought by William A. Brady, Jr.
Lit. AE in *Freeman's Journal* (23 October, 1901) 5

According to 'E' in the *All Ireland Review* (16 November, 1901) '"After Harvest" . . . showed a bronze-faced, white-shouldered man wading breast-deep in a bright-coloured sea: behind him was a low line of hills.' AE, George Russell, writing in the *Freeman* commented '"After the Harvest's saved" is something elemental. The post-car suggests the horses of the sun, or the stagecoach in De Quincey's extraordinary dream.'

324 The Banner 1901

Sgd. bottom right
Watercolour, 47 x 30.5
Exh. 1901 Dublin (19); 1904 New York (23); 1905 *London* (80); 1910 *Dublin;* 1913 *London* (263)
Coll. Offered to John Quinn 1901 but returned; Dawson Gallery, Dublin 1970
Lit. *Life in the West of Ireland* (1912, 1915) 95 (repro)

The head and shoulders of a young man holding up a huge deep green banner, decorated with wolfhounds and harp and the figure of Robert Emmet, which occupies most of the picture. The location of the scene is briefly indicated by the glimpse of a West of Ireland stone wall to the left of the young man. The banner frames the man's face, billowing with an emotion similar to that in *108*; though this composition is slightly later in date. Cf. 'Banners' sketched during the 1848 celebrations in Sligo (*sketchbook 12*).

325 The Blood of Sheep and of Goats 1901

Exh. 1901 Dublin (43)

See *326*.

326 Simon the Cyrenian 1901

Sgd. bottom left
Watercolour, 23 x 30.5
Exh. 1901 Dublin (34); 1903 London (25); 1963 Sligo (6); 1971–2 Sligo/Dublin (8); 1989 Sligo (10)
Coll. Dawson Gallery; bought in 1963 by Sligo County Library and Museum (SC8)

One of several 'sacred pictures', as Yeats des-

cribed them to Lady Gregory (undated letter [1901] New York Public Library), painted about this date, and of which *325* may be one. The heavily stylised composition is similar to that of the oil of the same subject, painted in 1902. The crowd is grouped in the upper half of the picture, framing Christ, whose sky blue robe distinguishes him from the predominant vandyke brown of the picture and of Simon in the centre, who strains beneath the weight of the cross. The crowd is massed cleverly to leave the road clear before the two men. Both Romans and Jews are shown in the costume of their period, and there is not so much concern to identify the event with the present age as in the larger oil version.

327 The Crucifixion 1901

Sgd. lower right
 Watercolour, 34 x 72
Exh. 1901 Dublin (33); 1903 London (26)
Coll. Sold to John Quinn privately, Dublin 1903; listed in the Quinn inventory; American Art Galleries (New York) sale of the John Quinn collection, 9 Feb. 1927, lot 46; bought by Max J. Sulzberger

'The three crosses were darkly outlined against the sky; only the top parts were visible, so that of each thief one could see little beyond the head and shoulders, and the figure of Christ was not fully given; it was painted with reverend austerity' ('E' in *All Ireland Review*, 16 November, 1901). See *326*. Yeats referred to the work in a letter to Thomas MacGreevy, 22 December 1926 (T.C.D. Ms. 8105/14). 'I painted a watercolour Crucifixion long ago . . . It was just the three heads and shoulders.' 'In the picture the point is made of the penitent thief whose head is in the foreground while the other thief scowls in a half frightened but sullen way at the Saviour,' he told John Quinn (18 February 1903). 'I don't think anyone before has made much of the thieves when painting a Crucifixion.'

328 The Rake 1901

Sgd. bottom right
 Watercolour and chalk, 46.5 x 31
Exh. 1901 London (23); 1901 Dublin (5); 1903 *West Ham*; 1903 *Dublin*; 1961 London (47)(repro)
Coll. Mr. and Mrs. F. S. Hess, London
Lit. *Illustrated London News* (8 April 1961)593 (repro); Rosenthal, T.G. (1966) Plate IIIa (col.); Pyle, H. (1970, 1989) 44, 107

Yeats saw and sketched the 'Rake' in Galway in August 1900 (*sketchbook 37*). The colour tones are light, mainly a pinky beige, with a lemon sky, and the emphasis is on the drawing.

329 The Blind Huntsman 1901

Sgd. bottom right
 Crayon and watercolour, 32 x 47
Exh. 1901 London (22); 1901 Dublin (4)
Coll. Sold to W. T. H. Howe, Ohio, 1937; bought by the New York Public Library, Berg Collection, September 1940

Yeats was sketching Tom Connor, the Blind Huntsman of Sligo, when in Sligo in the spring of 1900 (*sketchbook 30*). This is a large loose crayon study of the head and shoulders of the huntsman, his hand placed on the back of a horse, of whom only part is visible, to the left. There is the head of a concerned spectator to the right, and a glimpse of a hunt with what are almost stencil sketches of figures on horses. The colours of the figures are a typical warm mauvy peach, with vivid green for the field.

330 The Squireen

Exh. 1901 Dublin (20); 1903 London (18)
Coll. Sold to John Quinn at the London exhibition; this is probably *The Thruster*, watercolour, 30 x 38, signed lower right, at the sale of the John Quinn Collection 9 February 1927, lot 298, bought by Ernest Boyd

The artist described this watercolour as 'a horse jumping a stone wall with a young Irish Squireen on his back' (letter to John Quinn, 18 Feb. 1903). See *176*.

331 His Reverence ['His Reverance'] 1901

Exh. 1901 London (30); 1901 Dublin (13)

331a The Coroner 1901

Exh. 1901 London (27); 1901 Dublin (10)
Coll. After 1901 to Miss Lowry's art shop, Belfast

332 The Dispensary Doctor 1901

Exh. 1901 London (25); 1901 Dublin (8)
Coll. After 1901 to Miss Lowry's art shop, Belfast

Described in the artist's records as 'a small picture, different from the previous one'; see *175*.

333 The Mailer 1901

Exh. 1901 London (26); 1901 Dublin (9)
Coll. After 1901 to Miss Lowry's art shop, Belfast
See *79*.

334 The Peeler 1901

Exh. 1901 London (28); 1901 Dublin (11)
Coll. After 1901 to Miss Lowry's art shop, Belfast

335 The R. M. 1901

Exh. 1901 London (29); 1901 Dublin (12)
Coll. After 1901 to Miss Lowry's art shop, Belfast

336 The Bus Conductor* 1901

Sgd. bottom right 1901
 Watercolour stencil, 37 x 22
Coll. Presented by Dr. W. A. Propert to the Victoria and Albert Museum in 1926 (E.1030–1926)

A man of vast proportions, in bowler hat, kerchief and overcoat, three quarter length, making a mass of grey against a blue-grey ground.

337–339 Three Stencils* 1901

Coll. Listed in *Brian Keogh Catalogue 3*, Princes Risborough, Buckinghamshire [n.d., *c.*1974], lots 1178–1180

337 'A Broadsheet' Midsummer 1901

Sgd. with stencilled monogram and lighthouse
 Watercolour stencil on india paper (frayed) (30 x 35.5)

The 3 illustrations are *The Fish in the Case* (with a note in the artist's hand, 'This Trout weighing all but half a pound was caught May 19th 1901 by the younger brother of Isaac Walton Esq.'), *The Fishman in the Orchard* and *Signboard for an Angler*.

338 'Youth' December 1901

Sgd. with green ink and inscribed with monogram
Insc. with title and 'This is not a very good stencil but it goes to wish you a very happy Christmas, Christmas 1901' Watercolour stencil, 29 x 26
 A huntsman in full gallop.

339 'Pannerramarama of the Coronation' 1901

Sgd. lower right
Insc. with title
 Watercolour stencil, 29.5 x 26

A man with soft hat and moustache displaying an unending strip of cards.

Before his more famous collaboration with Pamela Colman Smith, Yeats initiated 'a weird thing called the Broad Sheet . . . just stencils that I used to print myself', he told John Quinn in December 1902 (Murphy, pp. 244, 593). *337*, for Midsummer 1901, is the only issue that has come to light so far. His preoccupation with the stencil about this time was to affect his style of illustration when he came to publishing *A Broadsheet*, 1902–3 (with Elkin Mathews, and with Pamela Colman Smith to help for the first year), making his images—derivative of the nineteenth century woodcut illustrations in the popular broadsides—more broad, and more strongly outlined.

340 Pannerramarama of the Coronation* 1901

Sgd. bottom right
 Watercolour stencil, 23 x 17
Coll. Dr. W. A. Propert: presented to the Victoria and Albert Museum (E.1028–1926)

A man in a small booth at a circus holds a length of paper covered with small squares representing a pictorial summary of the Coronation of Edward VII. Edward VII succeeded Queen Victoria on 22 January 1901, but his coronation was postponed, due to illness, until August. Yeats, to whom the stretch of pictures and the title—presumably chanted by the vendors—would have appealed, probably designed this stencil and *339* and *341* during the autumn of 1901.

341 Pannerramarama of the Coronation* 1901

Sgd.
Insc. with title
Watercolour stencil, 19 x 26.5
Coll. Private collection; Sotheby's (London) sale
12 April1967, lot 161; R. Gray, England

See *340*.

342 Shapes (1)* 1901

Sgd. bottom right 1901
Insc. Shapes
Watercolour stencil, the image 37 x 22 on
paper measuring 50 x 37.5
Coll. The artist's estate; private collection

Stencil of a vast man dressed in grey bowler hat
and long coat, with white scarf, set against a
dark grey ground. See *343*.

343 Shapes (2)* 1901

Insc. Shapes
Watercolour stencil, 50 x 37.5
Coll. The artist's estate; private collection

The same image and colouring as *342*, but
the stencil has been cut on a larger scale, and
the figure occupies the whole of the paper.

344 The Ring Master* c.1901

Sgd. bottom right
Watercolour stencil, 29.5 x 19.5
Coll. Dr. W. A. Propert, who presented it to the
Victoria and Albert Museum (E.1029–1926)

A three quarter length left profile stencil of a
circus ring master, with long moustaches and a
haughty expression, holding a whip. Colours
are browns, brick and blue greys.

345 Stencil Portrait of a Man* c.1901

Crayon on paper, 25 x 18.5
Coll. The artist's estate; private collection

A shadowy representation of a head with a
cap, a broken 'G' placed to the left below it.
Perhaps George Pollexfen, the artist's uncle,
who wears a cap in the oil of 1922, *On the
Old Race Course*.

346 Mexican Noon* c.1901

Watercolour stencil
Coll. The artist; presented to Miss Janet
Cunningham, Killymard House, 1956
[according to Alan Denson]

The back view of a horse and cloaked rider
making a hasty departure.

347 A Fancy Portrait 1901

Exh. 1901 Dublin (38)
Coll. Given to H. J. Garrish by the artist *c*.1901

The artist has written in beside the title, 'John
Armstrong?' The missing picture may be an
imaginary portrait — perhaps a stencil — of
General John Armstrong, one of Marlborough's
generals, a connection of Jack Yeats's family
through their grandmother, Jane Grace Corbet,
see Murphy, p. 21.

348 The Shadow on the Road 1901

Sgd. bottom right
Watercolour, 27 x 36.5
Exh. 1901 London (19); 1901 Dublin (2)
Coll. Sold to John Quinn privately in 1902; listed in
the Quinn inventory 1924; American Art
Galleries (New York) sale of John Quinn
collection, 10 Feb.1927, lot 295A; bought by
William A. Brady, Jr; J. M. Kerrigan; presented
by his sister Miss Kerrigan to her niece as a
wedding present in 1959; private collection

When in County Galway in the summer of
1900, Yeats made a study of a green shadow
of three heads (without figures) thrown in a
boat, calling it 'the shadow in the boat'
(*sketchbook 37*). This watercolour, the back
view of a man driving a side-car mainly in a
soft blue and green, likewise highlights the
shadow, which is silhouetted on the road in a
manner reminiscent of the artist's stencils.

349 The Post Car 1901

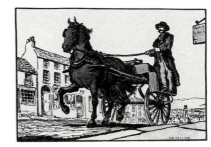

Exh. 1901 Dublin (20); 1901 Dublin (3); 1903
West Ham; 1903 *Dublin*; 1904 New York
(17); 1920 *Society of Dublin Painters*
Coll. Given to Sinéad Ní Chiosáin, Dublin, by the
artist, in 1926

Described in the artist's records as a 'drawing',
it is possibly *350*. Yeats made a pen and ink
drawing of the same subject for the Cuala Press
c.1908 (Cuala Prints (2), *The Post Car*).

350 The Post Car* *c.*1901

Sgd. bottom right
 Pencil and watercolour, 35 x 24.5
Exh. *1962 London (2)* (repro)

The man up on the car with his whip, and
the horse in front of him facing to the right
in the rain, fill the picture. The line is strong
and graphic, the paint thin. Dated 1891 in
the 1962 catalogue, it dates rather to the turn
of the century, and may be *349.*

351 The Unicorn 1901

Sgd. lower left
 Crayon and watercolour, 55 x 75
Exh. 1901 Dublin (7); 1902 *Cork* (298)
Coll. Sold to John Quinn in 1902; American Art
 Galleries (New York) sale of the John Quinn
 collection, 10 Feb.1927, lot 191; bought by
 C.J. Liebman

Lit. Yeats, Jack B., *Sligo* (1930) 8; *NGI* (1986) 68

'It represents three horses attached to a long
car' (*Irish Times*, 24 October 1901). The
long car, developed by Charles Bianconi—an
immigrant from Tregolo near Milan—in the
early nineteenth century, had become a
popular form of public transport between the
country towns of the south and west of
Ireland by 1840; and was still widely used
when Yeats was a young man. For him it was
one of the characteristic images of the west-
ern road, frequently drawn or painted by
him, the most famous composition being *In
Memory of Boucicault and Bianconi* (National
Gallery of Ireland 4206): see *594.*

But it was the 'unicorn' of horses that excited
his imagination most, the tandem of horses,
preceded by a leader, drawing the vehicle.
'One time long cars with unicorns of three
horses, drove away North, East and West of

it', he writes about the sea port of Sligo where
he grew up, in his book *Sligo* (1930), 'and
every now and then boys, going to School in
good time in the morning, had their horse
hearts cheered with the sight of an ordinary
outside car with a tandem.'

**352 The Herd's Tombstone at the Stone
 Mason's** 1901

Sgd. bottom left
 Watercolour, 22.5 x 14
Exh. 1901 Dublin (15)
Coll. Given to Lady Gregory; Dawson Gallery,
 Dublin, 1970; private collection
Lit. *Leader* (2 November 1903) 158–9

'I remember how he saw it with me when I
went one day last year to see the stone I had
ordered for Raftery's grave at Killeenan,'
wrote Augusta Gregory in the *Leader* (op.
cit.).' The stonecutter's wife had lent me a
manuscript book filled with Raftery's poems,
and she had written after a little time asking
to have it back. When I saw her on this day
she was full of apologies for having written. 'I
had no right to be uneasy,' she said, 'but that
book is nearer to my heart.' There
was a herdstone ready in the yard for some
herd, a pair of shears cut on the stone as a
token of his calling, and this had been her
own charming idea. This is the stone shown
in the little picture'. The watercolour shows
the stonecutter's wife looking at the stone,
with a cross on the top, and shears carved
below. Her cottage is in the background.

353 The Light for the Pipe 1901

Exh. 1901 Dublin (27)
Coll. Sold to Horace Plunkett at the exhibition

'Two men were standing on a lonesome road
in a drizzling twilight. One had asked for a
light and was leaning forward to shelter the
match; the other stood almost sullenly erect —
the glare from the lighted match showed both
faces — one gloomy, foreign, sphinx-1ike; the
other weather-beaten, alert, intent on the pipe-
lighting' ('E' in *All Ireland Review,* 16
November 1901). The *Irish Times* (23 October
1901) describes the dark colouring: 'through a
murky atmosphere a tramp apparently is seen
asking . . . for a match from a rather sour-
visaged individual'. Like other artists, Yeats was
fascinated by the chiaroscuro of such a subject,
and explored it elsewhere in oil as well as water-
colour. This watercolour may have perish-
ed with Sir Horace Plunkett's collection at
Kilteragh in the spring of 1923, see *274.*

354 The Pipe *c.*1901

Exh. 1901 Dublin (24)
Coll. Sold to McEnerney of San Francisco at the
exhibition

Described by reviewers as a fisherman sitting
filling his pipe in the stern of his boat, as she
sways in a 'lumpy' sea.

355 The Plough *c.*1901

Exh. 1901 Dublin (32)

356 Midsummer Eve 1901

Sgd. bottom left
 Pastel
Exh. 1901 Dublin (28)
Coll. Sold to Lady Gregory at the exhibition
Lit. *Irish Homestead* (Celtic Christmas issue)(7
December 1901) 4 (col. repro. facing p. 28)

A boy sitting on a stone chair on a moor
looks up at the night sky. A romantic com-
position in blues and greens.

356a Homecoming* *c.*1901

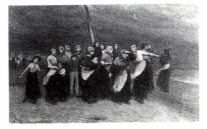

Sgd. bottom left
 Pastel, 19.5 x 31
Coll. James Adam sale April 1975; private
collection

A group of women and children, gathered at

the edge of the stormy sea beside a beacon,
look out desperately for returning boats.

357 The Ballad Singer 1901

'Farewell to Old Ireland, we are now going away,
To fight the brave Bores in South Africa;
To fight those poor farmers we are not inclined,
God be with you Old Ireland we are leaving behind;
Now, to conclude and to finish my song,
I hope you won't say that my verses are wrong;
But, before I will finish I've one word to say,
There is more killed and wounded than in the
 Crimea.'

Exh. 1901 London (14); 1901 Dublin (1); 1903
West Ham; 1903 *Dublin*

A smaller work, according to the artist's
records, than *358.*

358 The Ballad Singer *c.*1901

Watercolour
Coll. Sold to a Mr Freeman, *c.*1901
Lit. Yeats, Jack B., *The Charmed Life* (1938) 35,
39, 61, etc.

Noted by the artist in his records as having the
same title as *357,* but being original, and not a
copy of it. Yeats painted many pictures of ballad
singers in his lifetime, and wrote about them.
In *The Charmed Life* (1938) he refers to their
'wandering with the green and white fluttering
of ballads', and describes their manner of
delivery. 'It was the tall one gave that out with
full style and the harness rattling. Harnessed in
poesy — he was. He, when he sang, or even
recited, always gave the full volume of sound he
was able to command The short one sang
good and lusty. But in recitation he carried the
words forwards on a moaning whirl.' Another
'is a tall hawk of a man and he sings with a caw,
in the old fits and starts style, that only a few of
the old ones understand and appreciate.'

359 The Ballad Singer* *c.*1901

Sgd. bottom left
Watercolour, 35.5 x 25
Exh. 1962 *London* (7)
Coll. Waddington Galleries, London; purchased in
1963 by Geoffrey Holland, Kent

This is probably *357*, or *358*, possibly the latter.

360 The Song Book Shop 1901

Exh. 1901 Dublin (21); 1903 London (19)

361 For the Mainland* *c.*1901

Sgd. bottom right
Watercolour, 26.5 x 36
Exh. 1961 Dublin (22)
Coll. Professor Alfred Schild

Dated 1901 in the 1961 catalogue. Men catch
cattle which are intended for the boat to the
mainland.

362 The Workhouse at the Circus 1901

Exh. 1901 Dublin
Coll. Sold to McEnerney of San Francisco at the
exhibition
Lit. *Leader* (2 November 1901)158–9: 'At
Merrion Row' by A. Gregory

'Another friend I recognize is a little workhouse
boy at Gort', Lady Gregory wrote in her *Leader*
review (op. cit.) about Jack Yeats's Dublin
exhibition in 1901. 'The workhouse children
had been given leave to go to a travelling circus,
and this little fellow, Christie, with a bun in
each hand and his eyes on the horses, caught
Mr. Yeats's fancy.'

363 The Street of Shows 1901

Exh. 1901 Dublin (37); 1905 London (100)
Coll. The Misses Yeats at Gurteen Dhas 1901
*c.*1904; then returned to the artist; present
whereabouts unknown

'Country circus, with lurid posters of Giant
Schoolgirl, Petrified Man and Mermaid, all

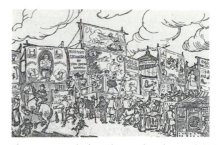

in strong sunlight. Sleepy doorkeeper' (AE in
Freeman's Journal, 23 October 1901). The
description relates to Yeats's pen and ink
illustration, *Shows at the Fair* in *A Broadsheet*
no. 3 (March 1902).

**364 Fourteen Sketches of Scenes from
'Diarmuid and Grania' by W. B. Yeats and
George Moore, 21 October 1901***

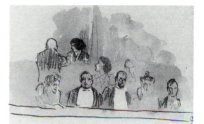

Watercolour and indian ink on paper, some
on pages of a Rowney sketchbook, 9 x 13,
others of a smaller size cut roughly from
larger sheets
Coll. New York Public Library, Berg Collection, in
a copy of *Samhain* (October 1901)
Lit. Murphy, W. (1978, 1979) 227–8; Jeffares,
A.N., *W. B. Yeats: a new biography* (1988) 93

Jack Yeats was present at the first performance
of the play, *Diarmuid and Grania*, written by
his brother and George Moore in collaboration,
which coincided with his Dublin exhibition in
October 1901. His sketches of some of the
scenes are pasted into a copy of *Samhain*,
originally in the possession of Lady Gregory,
and now in the New York Public Library. He
made sketches of Lady Gregory's own play,
Spreading the News, straight into a copy of
Samhain, that of November 1905, also in the
New York Public Library Berg Collection. Cf.
another sketch (private collection) of the
audience at the same event, illustrated here.

**365 Sketch Made during 'Casadh an tSugáin',
Gaiety Theatre, Dublin, 1901 (1)***

Sgd. monogram bottom left

Insc. upper edge: now are ye ready/then let it go
again; lower edge: W. G. Fay
Watercolour and pencil, 13 x 9
Exh. *1967 Dublin (7)*
Coll. Private collection, Dublin
Lit. *Samhain* (Dublin)I (October 1901);
Murphy, W., (1978, 1979) 227–8

Casadh an tSugáin (*The Twisting of the Rope*), a
play in Irish by Douglas Hyde, was first per-
formed at the Gaiety Theatre by the Gaelic
League on 21 October 1901, as a double bill
with *Diarmuid and Grania* by the Irish
National Theatre, see *364*. This drawing taken
from a sketchbook, shows W. G. Fay, dressed
in turquoise green pointing to a figure at the
back of the stage.

366 **Sketch Made during 'Casadh an tSugáin,
Gaiety Theatre, Dublin, 1901 (2)***

Sgd. monogram bottom left
Insc. Dr. Douglas Hyde
Watercolour and pencil, 13 x 9
Exh. 1967 *Dublin* (7)
Coll. Private collection, Dublin
Lit. *Samhain* (Dublin) I (October 1901)

A man and woman arm-in-arm, the drawing
taken from a Rowney Ringback sketchbook,
see *365*.

367 **Untitled: Japanese Pirate (l)*** 1901

Sgd. top right 1901
Insc. — Im a bad man – I've got a junk on the
High Seas
— Im a Piroot I am
April 1901 (in circle)[with Japanese
stampmark]
Watercolour on paper, 37.5 x 25
Coll. The artist's estate; private collection

A simulation of a Japanese print, with Japanese
pirate in full war regalia, posed in fighting
attitude, with sword in teeth. Jack Yeats's pass-
ing interest in the Japanese print coincided with
the growth of Western interest in Japanese
drama and the arrival of some Japanese actors in
London in 1901. Yeats attended the Japanese
plays at the Shaftesbury Theatre, London in
July 1901 (*sketchbook 43*). making drawings of
'The Geisha and the Knight' and 'The Earnest
Statue Maker.' In April 1901, he produced
three Japanese style watercolours, deceptive in
the authenticity of their detail, but recognisable
by the individuality of their humour. It is
unlikely that there are more. These represent
one aspect of his constant experimentation at
the time with style and media. See *368a*.

368 **Untitled: Japanese Pirate (2)*** 1901

Sgd. bottom left
Insc. I said I would if he jollied me any more
and mourn I ve done it,
down by de lonely swamp
an de muntey'll climb up the metty
spoute and tappy tappy at de Windy
And never get inny
I'm a piroot so I am ——.
Watercolour on paper, 16 x 11
Coll. The artist's estate; private collection

See *367*.

368a **Untitled: Japanese Pirate (3)*** 1901

Sgd. bottom left
Insc. —I see em every where—
—I we'rnt munch of a Piroot—
—I know I warnt—
—I'll never be ANOT'R
He died so easy
just a tap [oh my—]
nothing more
some of em are like that
—oh sir mercy—
—on a poor sailor man
Watercolour with ink on paper, 19 x 11.5
Coll. The artist's estate; private collection

369 **A Poet and a Councillor [Counsellor]**
 1901

Sgd. bottom left
Watercolour with varnish, 34 x 24.5
Exh. 1901 London (24); 1901 Dublin (6); 1904
New York (15) .
Coll. Edwin A. Jaffe, U.S.A.

The bust of a farmer with a wise face occupies
the whole composition, with a glimpse of
landscape and a cottage behind him, see *270*
and *370*. The horizon is high rather than low,
which is unusual at this date. There is an
element of satire in the portrayal, as though the

man who prides himself on his wisdom as a counsellor has suddenly himself come face to face with some revelation of truth.

370 The Poet* *c.*1901

Sgd. lower right
Watercolour, 7.5 x 17
Coll. Sigmund W. Kunstadter, Chicago

A large head with water and rocks in the background, see *270, 369.*

371 The Thief, also known as **The Ticket Snatcher** 1901

Exh. 1901 Dublin (35); 1903 London (40)
Coll. Sold to the Earl of Arran at the London exhibition

372 The Right Across 1901

Exh. 1901 Dublin (41)

373 The Race Course Town 1901

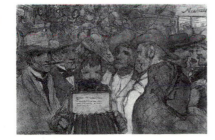

Sgd. lower left
Watercolour, pastel and pencil, 32 x 47
Exh. 1901 Dublin (17)
Coll. Sold by the artist privately to John Quinn in 1902; listed in the Quinn inventory 1924 as *The Race Town Galway,* and in the catalogue of the Quinn Collection 1926 as *The Race-Course Town, Galway,* American Art Galleries (New York) sale of John Quinn

collection, 10 Feb. 1927, lot 301; Edward W. McMahon; Egan Gallery, New York, bought by Joseph H. Hirschhorn and presented 17 May 1966 to the Smithsonian Institute, Washington

Lit. *John Quinn 1870–1925: collection of paintings, watercolours, drawings and sculpture* (1926) 22

A crowd gathered round a blind accordionist carrying a placard asking for alms, a later version of *174.* The man to the musician's left looks like the artist himself.

374 The Horse Trainer Above the Town [The Wild One] 1901

Watercolour, 74 x 54.5
Exh. 1901 Dublin (16); 1962 Dublin (66)
Coll. Sold to Pamela Colman Smith at the exhibition; Mrs. Peter O'Neill, London

From a drawing of 1900 entitled 'The Horse Breaker above the town' (*Sketchbook 30*), which shows a horse pulling at the end of the rope a man is holding, with a view of Sligo and Ben Bulben in the background, it seems this must be the watercolour first exhibited in 1962, as *The Wild One.** The man may be Yeats's uncle, George Pollexfen, who was a horse trainer.

375 The Trotter 1901

Exh. 1901 Dublin (18)
Coll. Given by the artist to the Irish Literary Society 1901 or 1902

376 Muldoon and 'Rattlesnake' 1901

Exh. 1901 London (18)

As early as 1890, in a note to some drawings of Sligo in the *Daily Graphic* (29 August), Yeats referred to 'Mike Muldoo', the sporting farmer' on the Drumcliff horse. Muldoon, the celebrated Sligo jockey of the late eighteen eighties, preoccupied his imagination, see *195,* and the oil painting, *Muldoon and Rattlesnake* of 1928: and there must be many other less specific references to him.

377 The Canal Turn, Liverpool [Canal Turn Liverpool Grand National] 1901

Exh. 1901 Dublin (36); 1903 London (41); 1904 New York (9)
Coll. Sold at a later date to a private collector

378 The Rain — The Rain 1901

Sgd. lower right
Watercolour and pencil, 29 x 37
Exh. 1901 Dublin (22)
Coll. Sold privately by the artist to John Quinn in 1902; listed as *Rain the Rain; Return from Galway Race* in Quinn inventory 1924, and as *Return from Galway Race* in the catalogue of the Quinn collection, 1926, American Art Galleries (New York) sale of John Quinn collection, 11 Feb. 1927, lot 422 , bought by J. M. Kerrigan

Described in the American Art Galleries catalogue, op. cit., as 'A coach and various jaunting cars returning from Galway races; with wash of pale blue.'

379 Conqueror and Conquered 1901

Exh. 1901 Dublin (42); 1903 London (39)

380 The Pugilist* 1901

Sgd. bottom right 1901
Watercolour stencil, 29.5 x 21.5
Coll. Given by Dr. W. A. Propert to the Victoria and Albert Museum (E.2141–1932)

A prize fighter in the ring, three-quarter length, sitting on a stool with his gloved fists placed on his hips. Colours are beige, green and white against a black ground. The muscles are a motif of the stencil, and the tattoo mark on his right arm—a headstone 'In loving memory of Aggie'.

381 To Make a Reputation 1901

Sgd. bottom left
Watercolour on two pieces of paper joined down the centre, 17 x 92.5
Exh. 1901 London (40); 1904 New York (33)
Coll. Waddington Galleries, London; P. J. Goldberg, London; Mrs. A. E. Goldberg; Christie's (London) sale, 2 Dec. 1986, lot 174 (repro); private collection

A long low picture, in soft brown and pink colours, in which the eye is led by the rope of the ring—running the full width of the work—from the shadowy opponent on the left to the other man resting in his own corner. 'The boxer on the right is the novice about to try and make a reputation against the top sawyer on the left' (Note by Yeats, *Gaelic American*, 5 April 1904).

382 Foul, Foul 1901

Exh. 1901 Dublin (39); 1903 London (38)
Lit. *The Open Window* VII (1911 April–September) 38

A lively pencil drawing of a rather supercillious boxer, who looks down at the man he has felled. The audience grip the ropes and look menacing, as they mouth insults and murmur angrily, 'Foul, foul'.

383 That's Enough, Take Him Away 1901

Insc. on verso with title
Watercolour, 8 x 11.5
Exh. 1901 Dublin (40)
Coll. Purchased from the Waddington Galleries in November 1964 and presented to T. R. Henn, St. Catherine's College, Cambridge, by a group of his students

A boxing ring, probably at a country fair. A beery looking man, presumably the proprietor, is leaning over the ropes. In the foreground is the professional boxer — a fine looking character — whose face is almost invisible.

384 On the Gara River 1902

Exh. 1902 Dublin (32); 1903 London (28)
Lit. Pyle, H. (1970, 1989) 48

The stream which ran near Cashlauna Shel-middy, Yeats's Devon home from 1897 to 1910, was called the Gara, and was painted and sketched by him on several occasions, see *236, 580, 581* and *sketchbook 65* (above). The similarity of the name with that of Sligo's river, the Garavogue, was a pleasing coincidence. The watercolours of the Gara, however, with their leafy light and leisurely mood, are a contrast to the more austere paintings of the grey Garavogue. This watercolour was first exhibited in 1902, but may have been painted at a slightly earlier date; see *158*.

385 Beside the Singing River 1902

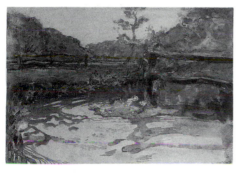

Sgd. bottom right
Watercolour, 24.5 x 35
Exh. 1903 London (27); 1903 Dublin (32); 1962 *London (12)*(repro); 1967 London (71) (repro)
Coll. Victor Waddington, London

This drawing first appears in the artist's records with work sent to Exeter in 1902, before the 1903 exhibition. It is a lyrical work, painted broadly, with wooden fences, woodland and lush fields contributing to the pastoral serenity.

386 A Galway Lake 1902

Exh. 1902 Dublin (28)
Coll. Sold to Professor Cornelius Waygaundt, U.S.A. at the exhibition

Probably Coole Lake, on the estate of Lady Gregory, near Gort, in Co. Galway, where Yeats spent some time in the summer of 1900. Perhaps *216* or *217*.

387 'But for Benbulbin and Knocknarea Many a poor Sailor would be Cast Away' 1902

Exh. 1902 Dublin (18); 1903 London (5)

Ben Bulben on the north side, and Knocknarea on the south of Sligo Bay, with their individual outlines, must have been a vital landmark for sailors in the past finding their way back to Sligo port in stormy weather.

388 Through the Trees ?1902

Sgd. bottom right
Watercolour, 37.5 x 25.5
Exh. 1902 Dublin (37); 1903 London (31); 1962 *London* (10); 1973 London (4)(repro)
Coll. Philip Isles, New York

A scene in South County Dublin, this may belong to the series executed in 1900, see *207 ff.*

389 The Valley Woods ?1902

Exh. 1902 Dublin (36); 1903 London (30)

Like *388* this unlocated watercolour is probably earlier than 1902, when it was first exhibited, see *210*.

390 A Dog Watching a Sea Gull 1902

Sgd. lower right
Watercolour, 48.5 x 36
Exh. 1902 Dublin (13)
Coll. Sold to John Quinn at the Dublin exhibition; listed in the Quinn inventory 1924; American Art Galleries (New York) sale of the John Quinn collection, 9 Feb. 1927, lot 53; bought by Samuel Lustgarten

'A corner of a thatched rambling cottage, with a dog seated upon a stone wall, intently

gazing into a cloudy blue sky' (American Art Galleries catalogue).

391 The Kindly Donkey 1902

Exh. 1902 Dublin (21)
Coll. Given to Lady Gregory at the Dublin exhibition

392 The Seal 1902

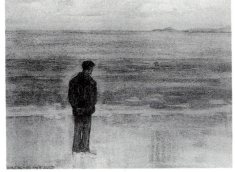

Sgd. bottom left
 Crayon and watercolour, 25 x 35.5
Exh. 1902 Dublin (24); 1903 London (10); 1904 New York (6)
Coll. Christie's (Dublin) sale, Carrickmines House, Co. Dublin, 10 Feb. 1986, lot 342 (repro); private collection

A seal seen at Streedagh Strand, a few miles north of Lissadell, Co. Sligo, where Yeats painted on several occasions.

393 The Political Cartoons 1902

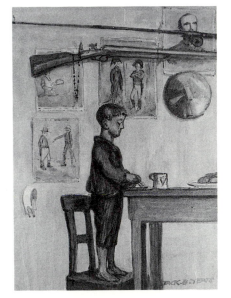

Sgd. bottom right
 Watercolour, 36 x 26.5
Exh. 1902 Dublin (16); 1903 London (12); 1904 New York (8); 1969 Montreal (32)
Coll. Victor Waddington, London

A small boy stands on a chair at a table, toying with the food in his dish. The cartoons, depicting Parnell and other heroes, hang on the wall beneath a gun entwined with a rosary.

393a A Patriot* *c.*1902

 Stamped with monogram bottom left
 Watercolour, 35 x 16.5
Coll. Victor Waddington, London

A picture of Robert Emmet is seen through the open doorway, hanging over the fireplace.

394 Poster for the Irish Book Company* *c.*1902

Sgd. monogram lower right
Insc. The Irish Book Company
 Watercolour and ink, 165 x 91.5
Exh. 1965 Belfast (14)
Coll. Lily Yeats; John Hunt, Dublin

An original cartoon showing a man with a wide brimmed grey hat and grey coat sitting on a stone wall with his legs crossed. He is engrossed in a red backed book, the red being the strongest colour in a generally pale design, whose strength lies in the strong black outlines, similar in style to the *Broadsheet* (1902–3). The Irish Book Company — printers, publisher and bookseller — occupied premises at 6,

112

Dolier Street, Dublin, from about 1902 to 1916. Yeats's poster design was probably never used: but he illustrated Norma Borthwick's *Ceachta Beaga Gaeilge* published by the Irish Book Company 1902–6.

395 Sketches [on a single sheet]* 1902

Sgd.
Insc. A Feis will be held at Killeeneen, Craughwell, on Sunday, August 31st, 1902 to Perpetuate the Memory of Raftery, the Connacht Poet, and aid the Revival of the Irish Language . . . [with initials] J.Q. [beneath John Quinn] Jack B. Yeats The Artist [beneath Jack B. Yeats] Pen and ink, 22 x 17
Coll. W.T.H. Howe, New York; purchased September 1940 by the New York Public Library Berg Collection

The sketches include portraits of Lady Gregory, W. B. Yeats, Douglas Hyde, John Quinn, an Irish dancer and Jack B. Yeats. The drawing has been autographed by An Craoibhín Aoibhinn (Douglas Hyde), W. B. Yeats and Lady Gregory.

396 Portrait of AE (George Russell), with a Sketch of Arthur Roberts as a Waiter on Verso* 1902

Sgd. bottom right
Insc. Recto: AE 1902 verso: Roberts/Taking/A Call Pencil on paper, probably from a Rowney Ringback sketchbook with the punch holes trimmed away, 12 x 9, the verso sketch in pen, ink and watercolour
Coll. Sold by the artist to W. T. H. Howe, Cincinatti, February 1932; bought by the New York Public Library Berg Collection in September 1940
Lit. Summerfield, H., *That Myriad-Minded Man: a biography of George William Russell, "AE", 1867–1935* (1975) 11, 247

A bust sketch of George Russell (1867–1935), poet, painter and editor of the *Irish Homestead* and the *Irish Statesman*, and a sympathetic critic of Jack B. Yeats's watercolour work. Probably executed while Yeats was in Dublin during August and September of 1902, he catches Russell's left profile, with prince nez, thick beard and fringed hair, indicating briefly an interior and a painting behind Russell.
 The New York Public Library Berg Collection also has a copy of *Beltaine* I (May 1899), formerly in the possession of Lady Gregory, into which are inserted two catalogues of Jack

B. Yeats's exhibition held in Dublin in 1900. On the first he has sketched 'The Mystics' — AE and W. B. Yeats in deep discussion — and on the second the heads of WB and AE. Both sketches are in pencil.

397 Michael McGowan, Emigrant 1902

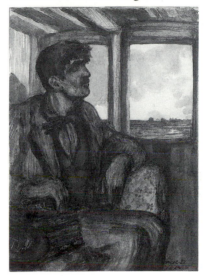

Sgd. bottom right
 Watercolour, 36 x 25.5
Exh. 1902 Dublin (11); 1903 London (7); 1961 Dublin (30)
Coll. Private collection, U.S.A.

Companion studies of a young Sligo man forced to emigrate, and the same young man returning after he has established himself in the New World, the pendants *397* and *398* are instances of Yeats's interest in the effect of environment on character. McGowan was a Sligo name which he used for the heroine of his miniature play *James Flaunty* (1901) and for the hero of *The Treasure of the Garden* (1902): and he used Wolfe T. McGowan for a pseudonym for his own verse published in *A Broadside*.

398 Michael P. McGowan, Returned American 1902

Sgd. bottom right
 Watercolour, 36 x 25.5
Exh. 1902 Dublin (12); 1903 London (8); 1961 Dublin (29)
Coll. Private collection, U.S.A.

A companion piece of *397*. The man in wide brimmed hat, cigar in mouth, one hand tucked in his pocket relaxedly, the other holding the newspaper, who sits back in a railway carriage

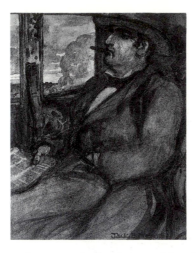

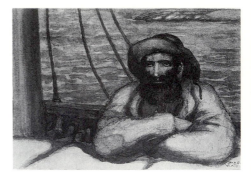

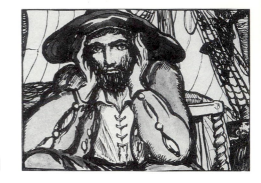

and surveys the landscape with a knowing expression, is typical of the returned American in Yeats's work, the most notable, and most moving example being found in *206.*

399 An Emigrant 1902

Sgd. lower left
 Watercolour, 51 x 38
Exh. 1902 Dublin (14)
Coll. Sold to John Quinn at the exhibition; listed in the Quinn inventory 1924; American Art Galleries (New York) sale of the John Quinn collection 10 Feb. 1927, lot 313; bought by Marie Sterner

'Wistful face of a young girl at the window of a railway carriage, bidding farewell to her mother, a back view of whom is seen in a green shawl; at the right stands the guard' (American Art Galleries Catalogue).

400 The Man of the West 1902

Exh. 1902 Dublin (26)
Coll. Sold to John Quinn at the exhibition

Described in the artist's records as 'small' and, in the Quinn inventory, as 'man with red beard'.

400a A Western Fisherman* c.1902

Sgd. bottom right
 Watercolour, 24 x 34.5
Coll. Photograph in National Gallery of Ireland Archive

This study of a fisherman (whose face appears in the Synge illustrations and elsewhere) is close in composition to Yeats's illustration for 'The County of Mayo' in *A Broadsheet*, July 1903.

401 The Town Shop 1902

Exh. 1902 Dublin (2); 1903 London (3); 1904 New York (14)
Coll. Given to a bazaar in Killybegs by the artist, date unknown

'The peasant leaning up against the counter unconcernedly, after making his purchase of pipe, tobacco and matches . . . and the important looking proprietor, whose whole attention is engaged in fetching down a bottle of sweets from the shelf . . .' (*Irish Independent,* 19 August 1902).

402 Strong Farmers 1902

Exh. 1902 Dublin (19)
Coll. Sold to Byrne, New York, at the exhibition

403 The Ballad Singer's Children 1902

Sgd. lower right
 Watercolour, 25.5 x 35.5
Exh. 1902 Dublin (17); 1903 London (ex catalogue)
Coll. Sold to John Quinn in 1903; listed in the Quinn Inventory 1924; American Art Galleries (New York) sale of the John Quinn collection, 9 Feb. 1927, lot 39A; bought by Samuel Lustgarten

404 Beside the Western Ocean 1902

Sgd. lower left
 Watercolour, 42 x 52
Exh. 1902 Dublin (10)
Coll. Sold to John Quinn at the exhibition;
 American Art Galleries (New York) sale of
 the John Quinn collection 11 Feb. 1927, lot
 436; bought by Ernest Boyd

 'A group of four figures dominated by a stalwart
 bearded figure, in a seascape setting' (American
 Art Galleries catalogue).

405 The Bay Pilot and the Italian Captain 1902

Exh. 1902 Dublin (20)
Coll. Sold to Pamela Colman Smith at the
 exhibition

406 The Man with the Wooden Leg 1902

Exh. 1902 Dublin (27); 1903 London (11); 1904
 New York (5)
Coll. Sent by the artist to the Dawson Gallery,
 November 1945, returned; sold to Victor
 Waddington Galleries 1956

 'A tally man . . . coming down the side of
 the vessel from his work' (*Gaelic American,* 5
 April 1904).

407 The Sea Captain's Car 1902

Exh. 1902 Dublin (5); 1903 London (4)
Coll. Given to Mrs. Melville Smith in 1903

 Painted also in oil, in 1922. The side car bring-
 ing the sea captain back from Rosses Point to
 Sligo is seen first in *206.*

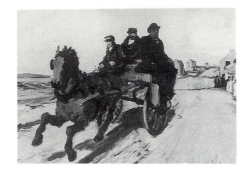

408 The Sailor Boy on a Car 1902

Sgd. bottom right
 Watercolour, 38 x 19
Exh. 1903 London (20); 1903 Dublin (3); 1904
 New York (28); 1964 Derry/Belfast (44)
Coll. Sold by the artist to Victor Waddington
 Galleries, 15 Oct. 1956; purchased from the
 Dawson Gallery by Michael O'Flaherty

 Intended for showing in the Dublin exhibition
 in 1902, and listed as *The Young Sailor Boy on
 the Car (no. 3),* this was not exhibited until
 1903.

409 The Enthusiasts 1902

Sgd. bottom right
 Watercolour, 51 x 35.5
Exh. 1902 Dublin (4); 1903 London (2); 1904 New
 York (18); 1945 Dublin National Loan (172)
Coll. Given by the artist to Thomas MacGreevy in
 1945, before the National Loan Exhibition;
 Mrs. Elizabeth Ryan, Dublin
Lit. MacGreevy, T. (1945) 22 (repro plate 1)

 Three youths, fully clothed in their coats and

caps, whom Yeats observed playing cards on a buoy in Sligo Bay. The village of Rosses Point lies across the water from them; a row boat which perhaps deposited them is seen departing in the right distance.

410 It'll be a Nice Ride Anyway 1902

Exh. 1902 Dublin (31)
Coll. Sold later by the artist to Mrs. Darley

411 Summer 1902

Exh. 1902 Dublin (33); 1903 London (29)

412 The Leppers 1902

Exh. 1902 Dublin (35)
Coll. Sold to John Phelan at the exhibition

'The scene is at a country race-meeting, and the horses are coming over the big jump, a stiff hedge of bracken To the right, a horse, landing badly, lurches heavily on to its knees, while the jockey slips helplessly forward on to its neck. In the centre of the picture, a man who has fallen staggers back against the fence, his hands to his head . . .' (*Leader,* 30 August 1902).

413 A Hero 1902

Exh. 1902 Dublin (15); 1903 London (9)

'A jockey' (*Daily News,* 2 February 1903).

414 The Country Jockey* *c.*1902

Sgd. bottom left
Crayon and watercolour, 35.5 x 25.5
Exh. 1961 London (9) (repro)
Coll. Victor Waddington, London; Hugh Rignold, Birmingham; Raymond R. Guest
Lit. Rosenthal, T. G. (1966) (col. repro on cover)

This study of a successful jockey in green jacket, viewed from below against a blowy sky, is very probably *413* under an alternative name. It was painted about the same date, and not in 1893 as noted in the 1961 catalogue. The man fills the picture, silhouetted three quarter length above the glimpse of the tents and flags and crowd in the background, only the back of his mount visible. The American flag flying prominently in the right background is an ironic reminder of where the local jockey's destination may be. Crayon is used freely to enhance the texture of the thick watercolour, and there is a forceful outlining of forms.

415 A Champion [A Cross County Champion]

Exh. 1902 Dublin (1); 1903 London (6); 1904 New York (7)
Coll. Sold at a later date from the Macbeth Gallery, New York

Yeats's uncertainty about the title of this watercolour when entering it in his records suggests that it had not been recently painted. It may be *69,* a study of a runner in excellent training, dating in style to about 1897.

416 A Goddess of Chance* 1902–5

Sgd. bottom left
Watercolour, 35.5 x 25.5
Coll. Dawson Gallery, Dublin

A red-haired tinker woman with an impassive face, and wearing a green check shawl, sits at a gaming table, eyes lowered towards the dice lying on the shamrock and anchor squares. The fair and races are described briefly in the background.

417 Fortune and her Wheel 1902

Sgd. lower right
Pencil and poster paint on card, 28.5 x 44
Exh. 1902 Dublin (25); 1971–2 Sligo/Dublin (9);
1989 Sligo (11)
Coll. Sold to John Quinn; listed in the Quinn
inventory 1924; American Art Galleries
(New York) sale of the John Quinn
collection, 9 Feb. 1927, lot 40; bought by F.
J. Deordan; James A. Healy, New York, who
presented it in 1965 to Sligo County Library
and Museum (SC9)
Lit. *John Quinn 1870–1925: a collection of*
paintings, watercolour, drawings and sculpture
(1926) 22, listed as an oil

An old woman, silhouetted against a silver sky,
sits on a stone wall with her wheel of fortune,
taking money from a bald pated man who asks
to have his fortune told. Other faces staring up
at her are suspicious, amazed, inspired or cyni-
cal — usual Yeats expressions. An adventurer
wearing a hat with a feather leans from behind
the wall offering a bag of money. Another man
walks away with clenched fists. A third lies
curled up drunk — in the shelter of the wall.
The whole has the character of a fairy tale with
a moral. The wheel on its own, seen in Galway
and decorated with shamrocks, is sketched in
watercolour in *sketchbook 37*.

418 The Circus Procession Starting *c.*1902

Sgd. bottom right,
Black crayon, 30.5 x 48
Coll. Given by the artist to a private collection
*c.*1909

A drawing of the big waggon, covered with
clowns, disappearing down a country road to
the left, towards the town, followed by a minia-
ture carriage with miniature pony driven by a
clown, and the whole procession of horses, acro-
bats and costumed characters. Yeats described it
in his records, when noting down the donation,
as an 'early drawing in coloured chalk': and it

seems to date to the early 1900s, the years of
experimentation. Yeats did several circus proces-
sions, the best known being *A Circus Wagon*
(*Life in the West of Ireland*, repro p. 107).

419 The Circus Poster 1902

Sgd. bottom right
Gouache, 48 x 35.5
Exh. 1902 Dublin (7)
Coll. Sold to Redmond Morris in Sligo; Mrs. G.
Cummings, France

Four children look up at a circus poster on the
wall of a building. A single child with a hoop
looks up at one in the coloured drawing in *Life
in the West of Ireland* (repro p. 71). Yeats always
felt this thrill when he saw the posters. 'A
Circus poster pasted on the wall of the old dis-
tillery would send my little heart galloping in
circles' (*Ah Well*, p. 81): and Joyce, too, in 'The
Sisters' in *Dubliners* relates how his young hero
'walked away slowly along the sunny side of the

street, reading all the theatrical advertisements in the shop windows'.

420 The Mexican of the Circus 1902

Sgd. bottom left
 Watercolour, 36.5 x 26.5
Exh. 1902 Dublin; 1965 Waterford (3); 1971–2
 Dublin New York (20)(repro)
Coll. Given to the Reverend T. A. Harvey in 1902;
 private collection, Waterford

A boy with a wide brimmed white hat, brim folded back, in a circus tent, riding bareback on a prancing white horse, of whom only the torso is seen. The pair are silhouetted against the canvas of the tent, with a couple of heads visible to the right below them. The pink shirt and brown trousers of the youth and the deep blush pink of the man in the foreground blend in with the general effect of mellow russety colouring, rubbed in well, with firm paint outlines.

421 'In the Days of Chivalry' – A Needle Affair* c.1902

Sgd. bottom left
 Watercolour, 36 x 53.5
Exh. 1962 Dublin (19); 1964 Derry/Belfast (11)
Coll. Leo Smith, Dublin

The end of a jousting tournament at a country fair. It is raining heavily. Two men dressed as knights are losing their armour as they persist on continuing the fight, though their lances are broken and their horses have run away. The drawing has been dated 1894: but the style and subjectmatter suggest the period of the juvenile plays. The forms, particularly the horses, are sketched loosely in dark tones, lifted by a wash of pale green and pink.

422 The Sailors' Theatre [The Mechanics' Theatre] 1902

Exh. 1902 Dublin (9)
Coll. Given to Frank Persse in exchange for *The Fair of Carricknagat* (*321*), 1902
Lit. Robinson, L., ed., *Ireland's Abbey Theatre* (1951) 42

The reviewer in *Irish Society* (August 1902) described the 'old man who, with his back half turned to the play, is enjoying a gossip with a friend.' Yeats attended the Mechanics' Institute Theatre — which he called the Sailors' Theatre — several times before it was taken over and rebuilt by the Abbey Company in 1904. His reminiscences of it are printed in Lennox Robinson's history of the Abbey Theatre (op. cit.). When he was in Dublin in 1901 the artist made a sketch of the interior (*sketchbook 49*), and the watercolour is developed from this sketch. See also *569*.

423 In the Days of Boucicault 1902

skb. 60

skb. 76

Sgd.
 Pencil and watercolour, 18 x 13
Exh. 1902 Dublin (6)
Coll. Sold to Redmond Morris, Sligo; Mrs. G. Cummings, France

A melodrama actor in coachman's clothes, with a whip in his hand, stands in front of the footlights. Melodrama was one of the joys of Yeats's youth, and for this reason he dedicated his oil of 1937 *In Memory of Boucicault and Bianconi* (National Gallery of Ireland 4206) to the mem-

ory of the dramatist. Many examples of his drawings of melodrama exist in the sketchbooks, for example, *sketchbooks 60* and *76*.

424 A Bookplate for a Pirate 1902

Exh. 1902 Dublin (34)

This was exhibited with the artist's watercolours in 1902. It may be executed in pen and ink like his later bookplates, which were printed at the Cuala Press and are to be published separately with Yeats's pen and ink drawings and designs for illustration, but equally, at this date, may be a watercolour stencil, see *426*.

425 A Tale of Piracy 1902

Sgd. lower right
Watercolour, 25.5 x 35
Exh. 1902 Dublin (8)
Coll. Sold to John Quinn at the exhibition; listed in the Quinn inventory 1924 as *Tale of a Pirate*; American Art Galleries (New York) sale of the John Quinn collection, 11. Feb. 1927, lot 416A; bought by Cornelius J. Sullivan

A 'boy . . . reads "The Black Avenger"' (*United Irishman,* 23 August 1902).

426 Stencil of a Pirate on a Horse* 1902

Sgd. monogram 1902 bottom left
Watercolour stencil, 21 x 14
Coll. The artist's estate; private collection

427 The Old Pugilist 1902

Sgd. bottom right
Watercolour, 17 x 12.5
Exh. 1902 Dublin (30); 1903 London (32); 1961 London (48)(repro)
Coll. Sold at the exhibition in 1961 to Geraldine Scheftel, New York

A half-length study of an aging, muscular but still fine-looking, man, in a check waistcoat too tight for him and shabby greatcoat. He bows his head, about to replace his hat, in an interior — perhaps an office — lined with sporting pictures.

**428–9 Two Stencils: A Boxer, and a Man
Running in a Race*** *c.*1902

Lit. Gregory, A., *Me and Nu: Childhood at Coole* (1970) 88

In her reminiscences of her grandmother's house, Coole Park, in Co. Galway, Anne Gregory describes Jack Yeats's pictures there and 'some lovely stencils in the hall that he had done. All sporting pictures. One was of a boxer, and another of a man running in a race. They were very clever, as they were done in sort of lines, through the cut-out paper he had made — at least that is how Grandma told us he had done them . . .' . Some of the stencil cut-outs still survive in the artist's archives.

430 An Orchard 1903

Exh. 1903 Dublin (37)
Lit. Murphy, W. M. (1978, 1979) 200

Described in reviews as a Devonshire scene, this may be *431*. Jack Yeats's studio was approached from his house, Cashlauna Shelmiddy, across a laneway, past a small wood, and through an orchard which grew beside the Gara stream.

431 Apple Trees in Devon 1900–3

Sgd. bottom right
Watercolour, 18.5 x 28
Exh. 1962 Dublin (28)
Coll. Allen Figgis, Dublin; James Adam (Dublin) sale, 6 Dec.1973; private collection

A study of twisted tree trunks beneath a flossy burden of white blossom, whose freckled light contrasts with the shadows and green grass below. A little path winds to the left. A painting in the impressionist vein, delicately expressive of Yeats's poetic potential, it may be Yeats's own orchard, but could equally be another one in the neighbourhood. See *430*.

432–434 Three Sketches 1903

Each inscribed with title, *433* also dated Ap. 1903
Pen, ink and wash, 9 x 12.5
Coll. James Adam (Dublin) sale, 19 May 1983, lots 9, 10, 28

432 Circus Man Sleeping at Dartmouth
433 A Schooner leaving Teignmouth
434 Ferry Boats, Teignmouth

These Devon scenes are all from a sketchbook of April 1903.

435 The Edge of the Lake 1903

Exh. 1903 London (22); 1903 Dublin (4); 1904 New York (60)
Coll. Sold to Mrs. Byrne at the New York exhibition

436 A Galway Lake 1903

Exh. 1903 London (21); 1903 Dublin (ex catalogue)
Coll. Sold to O. Warner at the Dublin exhibition

This is presumably Coole Lake, and may be *216* or *217*.

437 The Lake Near the Bell Rock 1903

Exh. 1903 London (24); 1903 Dublin (6); 1904 New York (57)

438 The Island of the Reeds 1903

Sgd. bottom right
Watercolour, 25.5 x 35.5
Exh. 1903 London (23); 1903 Dublin (5); 1904 New York (58); 1973 London (9) (repro)

439 The Auction Bill 1903

Exh. 1903 Dublin (28); 1904 *London* (245)

440 The Little Fair [A Small Fair] 1903

Sgd. bottom left
Watercolour and gouache, 36 x 26
Exh. 1903 London (17); 1903 Dublin (2); 1969 Montreal (35)
Coll. Sent to Victor Waddington Galleries, November 1945; Victor Waddington, London

A Small Fair exhibited in Montreal in 1969, with an inscription on the reverse dating it about 1909, is earlier in date according to its style, and is probably *A Little Fair*, which was first exhibited in 1903. The scene is a field, of a deep green, where various figures, including a shamrock and anchor man, are gathered near a tent.

441 A Boreen 1903

Sgd. lower left
Watercolour, 25.5 x 35.5
Exh. 1903 Dublin (19)
Coll. Sold to John Quinn at the Dublin exhibition; American Art Galleries (New York) sale of the John Quinn collection, 9 Feb. 1927, lot 39B; bought by Samuel Lustgarten

A boreen, or little road, 'the peasant boy riding a donkey . . . cottages in the distance, with what is apparently an inlet of the sea' (*Irish Daily Independent*, 25 August 1903).

442 Catching the Donkey 1903

Sgd. lower right
Watercolour, 26 x 37
Exh. 1903 London (15)
Coll. Sold to John Quinn at the Dublin exhibition; listed in Quinn inventory 1924 as 'Boy trying to catch a donkey'; American Art Galleries (New York) sale of John Quinn collection, 11 Feb. 1927, lot 416B; bought by Cornelius J. Sullivan

443 A [The] Pony Cupid 1903

Exh. 1903 London (36); 1903 Dublin (36)

120

This may be the pen and wash drawing in the artist's archive, *The Cupid Pony*, a pony ressembling *The Red Pony*, in *Life in the West of Ireland*, but with arrows tied to its back.

444 The Red Pony

Exh. 1903 Dublin (25); 1904 New York (39); 1905 London (86)
Lit. *United Irishman* (29 August 1903) 5; Yeats, Jack B., *Life in the West of Ireland* (1912)(col. frontis.)

Probably an earlier version of *The Red Pony* of *Life in the West of Ireland*, this was 'destroyed' after the exhibition in 1905, perhaps damaged in some way on the return journey to Devon. The picture received a great deal of praise, the *United Irishman* commenting, 'Mr. Yeats has expressed in a marvellous way the glorious joy of the water's edge.'

445 G'morrow Strawberry 1903

Sgd. bottom left (in ink) 1903 (in pencil)
Insc. G'morrow Strawberry (bottom right in pencil) [on reverse of frame] To Seumas O Sullivan / President of the P.E.N. Club / with all thanks for a / most happy dinner on / June the 9th 1945 / from Jack B. Yeats

Pencil and watercolour on paper, 14.5 x 9
Exh. 1903 Dublin (38); 1971–2 Sligo, Dublin (10); 1989 Sligo (14)
Coll. Given by the artist to Dr. J. Starkey, June 1945; Mrs. J. Starkey; Miss K. Goodfellow, lent to Sligo County Library and Museum, 1971, and later presented to the collection (SC20)

A cartoon drawing of a donkey standing on its hind legs and stretching up to touch the nose of Strawberry, a roan carthorse. The pencil work is loose and strong, watercolour is applied fluidly, the sky being a loose blue with a long cloud.

446 The Baker Rode a Pie-Bald* *c.*1903

Sgd. bottom right
 Watercolour 18 x 25
Coll. Private collection, Belfast

A humorous, cartoon-like frolic of a piebald horse flying over a low landscape, while his baker mount, holding fast, his coat and apron flying in the wind, wears his bread basket on his head. In greens and brown.

446a 'Souwester' *c.*1903

Insc. Souwester/Red Tie
 Watercolour and pencil, 13 x 9
Coll. Privately owned

A finished sketch taken from a sketchbook of a full length man, seen in profile, wearing a souwester, inscribed 'Souwester'. Beside his head is the bust of a man wearing a cap and tie, inscribed beneath 'Red Tie'.

447 Cartoon for Figure of Christ [The Sacred Heart]* 1903

Sgd. monogram bottom right
 Gouache, 112 x 71
Coll. Miss Lily Yeats; Miss Hyland; purchased by Thomas MacGreevy *c.*1958; Dawson Gallery, Dublin, bought by Sligo County Library and Museum in 1966 (SC10)
Exh. The banners embroidered from this and eleven other cartoons were exhibited at Dun Emer Industries, Dundrum, Co. Dublin, on

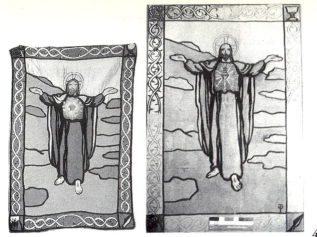

4 and 11 February 1904; this cartoon and its banner 1971–2 Sligo, Dublin (11)(90); this cartoon 1989 Sligo (13)

Lit. *Irish Homestead* (13 February 1904) 134, 'Irish saints at Dun Emer; *Irish Arts Review* I, no. 4 (Winter 1984) 24–8 (ill.), 'The Dun Emer Guild', by P. Larmour

In 1903, Jack B. Yeats and his wife, Mary Cottenham Yeats, were invited to design sodality banners for the new cathedral at Loughrea, in County Galway. These sodalities were in honour of the Sacred Heart, and met once a month in the Cathedral for Mass, the men one Sunday, the women on the following Sunday. The sodalities were divided into groups; and banners, each depicting a saint, were put up among the pews to denote where each group should sit.

Twenty nine banners in all were completed (Coll: Loughrea Cathedral, Co. Galway). Jack Yeats designed the Sacred Heart banner, and all of the men saints, except for St. Patrick [Naomh Padraig] and St. Laurence O'Toole [Naomh Lorcan ua Tuathail], which were designed by AE (George Russell); and Cottie Yeats designed all the women saints. except St. Brighid [Naomh Brighid], which Pamela Colman Smith designed, and St. Agnes [Naomh Aedhnat], by Jack Yeats. Yeats made further cartoons for SS. Aloysius, Alphonsus and Diochu, *458, 459, 456*, which, with St. Agnes, *455*, were not used.

All of the saints are depicted full length, silhouetted against a pale gold ground, and outlined with the thick black line Yeats used in *A Broadsheet*, varied with slim pools of shadows. They wear monastic dress or Old Irish garments in rich colouring, with Celtic ornament, executed in what Paul Larmour has described as 'an almost cloisonné-like manner' (op. cit. p. 25). Their movement is created by the different attitudes or poses they adopt, and by the vigorous lines of the folds of their garments.

The banners were embroidered at the Dun Emer workshop by Lily Yeats and her assistants, using wool and silk thread on linen; and the first twelve of the banners were exhibited at Dun Emer, Dundrum, Co. Dublin, on 4 and 11 February 1904, before going to Loughrea.

For the Sacred Heart banner, Yeats depicts the Christ, with his sacred emblem on his breast, pierced hands raised in blessing. He stands in a hilly landscape. The border design is a crown of thorns, with symbols of the Passion in each corner.

448 Cartoon for St. Joseph [Naomh Iosep]*

1903

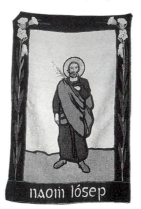

Sgd. monogram bottom right
Gouache on paper, 76 x 46
Coll. Miss Lily Yeats; Miss Hyland; purchased by Thomas MacGreevy *c.*1958 and given to Don McGreevy; North's Auction Rooms (Dublin) sale, 12 Oct.1967; private collection

The saint's only symbol of identity is the lily which he carries in his left hand. He wears purple and red, and walks on a lilac ground, silhouetted against the natural colour of the cartoon paper. See *447*.

449 Cartoon for St. Jarlath [Naomh Iarfhlaith]*

1903

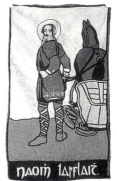

122

Sgd. monogram bottom right
Gouache, 82.5 x 50

Exh. The Naomh Iarfhlaith banner was exhibited 1971–2 Sligo, Dublin (86)

Coll. Miss Lily Yeats; Miss Hyland; purchased by Thomas MacGreevy *c.*1958; James Adam (Dublin) sale April 1968; private collection; James Adam (Dublin) sale, 19 May 1987, lot 158 (repro); James Adam (Dublin) sale, 8 Oct. 1987, lot 132

Lit. Mould, D.C.P., *The Irish Saints* (1964) 199

St. Jarlath is the patron saint of the Diocese of Tuam. He is depicted, as his name (a feudatory lord, or equivalent of an earl) would suggest, as an aristocrat, dressed in Celtic tunic and cross-gartered stockings, leading his horse with unconcern as the wheel of his chariot shatters and falls to the ground. See *447*. The banner embroidered from this cartoon, now in Loughrea Cathedral, was exhibited 1971–2 Sligo, Dublin (86).

450 Cartoon for St. Kevin [Naomh Caoimhghein]* 1903

Sgd. with monogram
Gouache, 76 x 46

Coll. Miss Lily Yeats; Miss Hyland; purchased by Thomas MacGreevy *c.*1958, who gave it to Marie Keily

Lit. Neeson, E., *The Book of Irish Saints* (1967) 106–7

St. Kevin, founder of the sixth century monastery of Glendalough, in County Wicklow, was renowned in legend for his love of birds and animals. According to one tradition, while he knelt in prayer in his tiny cell one day, having to stretch one hand through the window for lack of space, a blackbird laid an egg in his palm. He was so concerned for the bird that he remained kneeling until her fledgling was reared and had flown away. The cartoon shows St. Kevin in the Glendalough setting with a wren

in his hand, two blackbirds above him, and seven swans flying in formation above the trees behind him. See *447*. Mrs. Gogarty commissioned a copy of this, with St. Columcille (*451*), St. Gobnait and the Virgin, worked by Lily Yeats on silk poplin, for Renvyle House, Co. Galway *c.*1930. The whereabouts of the cartoons for the Gogarty banners, if they have survived, is unknown. See *727*.

451 Cartoon for St. Columcille [Naomh Colum Cille]* 1903

Sgd. monogram bottom left
Gouache, 84 x 51

Coll. Miss Lily Yeats; Miss Hyland; purchased by Thomas MacGreevy *c.*1958; Aras an Uachtaráin

Exh. The Naomh Colum Cille banner made from this cartoon was exhibited 1971–2 Sligo, Dublin (85)(repro)

Lit. Mould, D.C.P., *The Irish Saints* (1964) 93–105

See *447*. St. Colmcille, one of the most striking characters of the early Celtic Church, was born at Gartan, in Donegal, in 521, a member of the royal Uí Néill family. Colmcille studied at Moville, Clonard and Glasnevin before returning to the North of Ireland, where he was given an oak wood as the site for his church Doire Choluim Cille, now the City of Derry. While at the monastery of St. Finian of Moville, Colmcille, a noted scholar, asked permission to make a copy of Finian's psalm book, and when he was refused he secretly made his own copy. This led to a major battle, and Colmcille's self-imposed exile in Iona. The cartoon, where Yeats lets his ironic humour add to the design, shows the saint at work copying the forbidden psalter, using for convenience a part of a dolmen, perched on the branch of an oak tree. About 1930, Mrs.

Oliver St. John Gogarty commissioned a further series of four banners from Jack and Lily Yeats, see *450*, one of which was a St. Colmcille identical with the Loughrea Colmcille, but signed with a monogram in the finished embroidery, in wools and silks on silk poplin, the banner now in the National Museum of Ireland (34–1936). See also *452*.

452 Transfer Design for St. Columcille Banner*
1903

Insc. with monogram bottom left and Naomh Colum Cille [in Irish script] lower edge
Ink on linen, 94 x 55

Exh. The banner embroidered from this transfer was exhibited 1971–2 Sligo, Dublin (85); 1990 Dublin (ex catalogue)

Coll. Miss Lily Yeats; Miss Hyland; purchased by Thomas MacGreevy *c*.1958, who presented this and *454* to the National Gallery of Ireland (7946)

Lit. *NGI* (1986) 10–11 (repro)

The linen transfer made from *451* to enable the Dun Emer embroideress to translate the design on to the banner for Loughrea, see *447*. When the Cuala Industries were closing down, Lily Yeats gave the bundle of surviving cartoons and transfers to her assistant, Miss Hyland of Pembroke Cottages, Dundrum, who sold them to Thomas MacGreevy, (as co-executor of Jack Yeats's will) *c*.1958. Dr. MacGreevy had some of the cartoons repaired, mounted and framed for presentation where they were likely to be appreciated (information from Oifig Runaí an Uachtaráin).

453 Cartoon for St. Asicus [Naomh Assith]*
1903

Sgd. bottom right
Gouache, 81 x 51

Exh. 1971–2 Sligo, Dublin (12) with its banner (88)

Coll. Miss Lily Yeats; Miss Hyland; purchased by

Thomas MacGreevy *c*.1958, who presented it to Sligo County Library and Museum in 1967 (SC11)

Lit. Mould, D.C.P., *The Irish Saints* (1964) 30–1

See *447*. St. Asicus is the patron saint of the Diocese of Elphin, which incorporates a large area of County Sligo, including Sligo town. He was one of St. Patrick's priest-craftsmen and a skilled metalworker, which may account for the bell on which he lays his hand, and which is inscribed with symbols of chastity and purity, the tower and the rabbit. He wears a monk's habit, but holds a book as a sign of his priestly status. See also *454*.

454 Transfer for the Asicus Banner*
1903

Insc. Naomh Assith [in Irish script] lower edge
Ink on linen, 95 x 55.5

Exh. The banner embroidered from this transfer was exhibited 1971–2 Sligo, Dublin (88) with *453* (12); 1990 Dublin (ex catalogue)

Coll. Miss Lily Yeats; Miss Hyland; purchased by Thomas MacGreevy *c*.1958, who presented this and *452* to the National Gallery of Ireland (7947)

Lit. *NGI* (1986) 12–13 (repro)

The linen transfer made from *453* to enable the Dun Emer embroideress to translate the design on to the banner for Loughrea, see *447*. For further details of provenance, see *452*.

455 Cartoon for St. Agnes [?Naomh Aedhnat]*
1903

Sgd. monogram bottom left
Gouache, 85 x 53

Coll. Miss Lily Yeats; Miss Hyland; purchased by Thomas MacGreevy *c*.1958; James Adam (Dublin) sale April 1968; private collection

See *447*. Nothing is known about Naomh Aedhnat: and St. Agnes is generally represented with a lamb or the symbol of one aspect of her martyrdom, a flaming pyre. Here the saint is represented crucified—head uplifted—in a low lying purple and dark green landscape. She wears a Celtic garment. Since there is no banner made from this cartoon in Loughrea, it seems the design was not used.

456 Cartoon for St. Diochu [Naomh Diochu]*
1903

Sgd. monogram bottom right
Gouache, 83 x 51

Coll. Miss Lily Yeats; Miss Hyland; purchased by Thomas MacGreevy *c*.1958; James Adam (Dublin) sale, April 1968

Lit. Neeson, E., *The Book of Irish Saints* (1967) 86

See *447*. There were several St. Diochus. This is probably Diochu of Saul, County Down, who was St. Patrick's first convert, and who presented Patrick with the land on which to build his first church. The saint wears a red tunic and holds a staff, and stands in front of the half built church of Saul. Since there is no banner made from this cartoon in Loughrea, it seems the design was not completed, though a transfer was made from it, see *457*.

457 Transfer for the Diochu Banner* 1903

Insc. Naomh Diochu [in Irish script] lower edge
Ink on linen, 95 x 55.5
Coll. Miss Lily Yeats; Miss Hyland; purchased by Thomas MacGreevy *c.*1958; James Adam (Dublin) sale, April 1968; private collection
The linen transfer made from *456* to enable the Dun Emer embroideress to translate the design on to the banner for Loughrea, see *447*.

458 Cartoon for St. Aloysius* 1903

Sgd. monogram bottom right
Gouache, 77 x 47
Coll. Miss Lily Yeats; Miss Hyland; purchased by Thomas MacGreevy *c.*1958; James Adam (Dublin) sale, April 1968; private collection
Lit. *Oxford Dictionary of the Christian Church* ed. F. L. Cross (1974) 39

See *447*. Presumably St. Aloysius Gonzaga (1568–91), who died during his ministration to victims of the plague in Rome. He was canonised in 1726. The saint, in blue cassock with beads in his sash, and holding a cross in the crook of his left arm, stands on a pavement. Since there is no banner made from this cartoon in Loughrea, it seems the design was not used.

459 Cartoon for St. Alphonsus* 1903

Sgd. monogram bottom right
Gouache, 77 x 47
Coll. Miss Lily Yeats; Miss Hyland; purchased by Thomas MacGreevy *c.*1958; James Adam (Dublin) sale, April 1968; private collection
Lit. *Oxford Dictionary of the Christian Church* ed. F. L. Cross (1974) 39

See *447*. This must be St. Alphonsus Liguori (1696–1787), Founder of the Redemptorist Fathers. He wears a purply red cloak and cassock, and walks on a path with his head bowed. Since there is no banner made from this cartoon in Loughrea, it seems the design was not used.

460 Portrait Sketch of Masefield* 1903

Sgd. monogram bottom right
Insc. Masefield on the beach at Haul Sand 1903
Pen, ink and watercolour, 8 x 12 (from a sketchbook, the sketch cut down a little)
Coll. Sold by the artist to W.T.H. Howe, Cincinatti, in February 1932; purchased September 1940 by the New York Public Library Berg Collection
Lit. Pyle, H. (1970, 1989) 73ff.

John Masefield (1878–1967), the English poet, was a close friend of Jack Yeats, and, when in Strete in 1903, paid a visit with him to Haul Sands on April 7 (*sketchbook 66*). The artist sketched him lying on the sand, wearing a blue striped jacket, and looking at an object in his hand.

461 The Gypsy 1903

Exh. 1903 London (34); 1903 Dublin (34)

This is probably *462*.

462 Portrait of Man with a Hat* 1903–5

Sgd. bottom right
Gouache on paper mounted on card, 13 x 7
Coll. Private collection

This must be *461*. It is the head and shoulders of a gipsy with patterned scarf and a wide-brimmed hat, framing a dark, lined face.

463 Untitled Sketch: 'Gypsies of Long Ago' (1)* c.1903

Sgd. lower left
Watercolour on card, 11.5 x 9
Coll. Given by the artist as a wedding present to Oonagh Vickerman, later Mrs. Dominic Mitchell, Navan, August 1954; private collection
A gypsy in blue, with earrings, yellow scarf and caubeen, strikes an attitude, leaning on his whip in a casual fashion. The figure is sketched with a brush without background — like a design for a play. See *464*. Yeats called these two sketches 'gypsies of long ago', when writing to Miss Vickerman in 1954.

464 Untitled Sketch: 'Gypsies of Long Ago' (2)* c.1903

Sgd. lower right
Watercolour on card, 11.5 x 9
Coll. Given by the artist to Oonagh Vickerman, later Mrs. Dominic Mitchell, Navan, August 1954; private collection

A bent man in brown with blue scarf and a check blue lining to his coat — sketched with a brush without background — like a design for a play. See *463*.

465 The Rogue 1903

Sgd. bottom left
 Watercolour, 53.5 x 35.5
Exh. 1904 New York (49); 1904 *Dublin* (230); 1945 Dublin National Loan (173); 1969 *Mayo/Donegal* (49); 1971–2 Dublin New York (22) (repro); 1988 Dublin (21)
Coll. Given by the artist to Hugh Lane's permanent exhibition in Ireland; Hugh Lane Municipal Gallery of Modern Art, Dublin (358)
Lit. Bodkin, T., *Hugh Lane and his pictures* (1956) 7–12

The Rogue lounges on a bench against the wall of a pub with his glass of porter beside him. The weak character of his facial features is complemented by the dustiness of his dress. The background has been varied by projecting the room into the picture plane on the right, leading to a view of the street beyond, a perspective which Yeats was to use frequently in his oil paintings. The blue-grey of the man's suit and the rust of his hair act as unifying colours through the picture.

466 The Policeman at the Railway Station 1903

Exh. 1903 Dublin (21)
Coll. Sold to Dr. Boyle at the exhibition

467 The [An] Island King 1903

Exh. 1903 Dublin (12); 1904 New York (55)
Lit. Mason. T. H., *The Islands of Ireland* (1938) 25–33

'The king or chieftain of Ennis Murray Island in

Donegal Bay' (note by Yeats. *Gaelic American*, 5 April 1904). Inishmurray lies about four miles off the coast of Sligo, opposite Mullaghmore, and is approached from Streedagh Strand or Rosses Point. Yeats may have visited it when he was at the Point in September 1902. The work was damaged on the way home from New York and later destroyed.

468 A Relic of the Rebellion 1903

Exh. 1903 Dublin (17); 1905 London (82)
Lit. *United Irishman* (29 August1903) 5

469 The Old Timer* 1900–5

Sgd. bottom left
 Watercolour, 25.5 x 35.5
Coll. Victor Waddington, London

A man, holding a glass of porter in his hand, looks up at the fire-arm on the wall above the barman's head with its label 'Old Musket Used [By] A Rebel in the 1798 Rising'. The barman rests his elbows on the counter and gazes contemplatively in front of himself. This is very probably *468*; and may be another version of *467*, which, according to the reviewer in the *United Irishman* (29 August 1903) was of the same subject.

470 The Barber 1903

Exh. 1903 London (1); 1903 Dublin (1)

'What might be the head and shoulders of a mummy or of a corpse placed in an upright position . . . There is . . . the distinguishing feature of the end of a razor protruding from a pocket . . .' (*Irish Daily Independent*, 25 August 1903).

471 A Wise Old Man 1903

Exh. 1903 Dublin (13)

472 The Returned American and the Farmer
 1903

Exh. 1903 London (14)
Coll. Sold to the Earl of Mayo at the exhibition

473 The [A] Bottle of Florida Water 1903

Sgd. bottom left
Watercolour, dimensions unknown
Exh. 1903 Dublin (16); 1904 New York (46)
Coll. Waddington Fine Art, Montreal: private
collection, Montreal

'Florida water is always brought home by Irish
sailors who have been in the States. This shows
the girl's sweetheart is a sailor' (Yeats in the
Gaelic American, 5 April 1904).

474 The Mission* *c.*1903

Sgd. lower right
Watercolour, 18 x 26
Coll. Christies' (London) sale, 7 June 1985, lot 34
(repro)

475 Many Miles Before Them 1903

Exh. 1903 Dublin (14)
Coll. Sold to Mrs. Byrne, U.S.A. at the exhibition

476 The Melodeon Player 1903

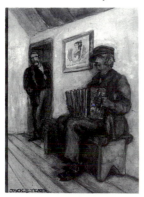

Sgd. bottom left
Watercolour and pencil, 53.5 x 37
Exh. 1904 New York; 1904 *Dublin* (226); 1969
Mayo/Donegal; 1988 Dublin (22)
Coll. Given by the artist to Hugh Lane's permanent
exhibition in Ireland; Hugh Lane Municipal
Gallery of Modern Art, Dublin (356)

Yeats claimed to be tone deaf, though through-
out his life he painted musicians and singers,
from *The Music (109)* to *The Music of the
Morning*—a joyous dawn procession painted in
oil over fifty years later. In the western Irish
culture which he represented the musician was
regarded with particular veneration.

The melodeon player sits alone on a bench,
perhaps playing for a party before some depar-
ture, and watched by a man who looks in
through the door. The image of 'The Belle of
the Pacific' placed after some thought by the
artist in its position between the heads of the
men on the wall (the *pentimento* is visible) sug-
gests one or both of the men may be a sailor,
bound for a foreign sea. The overall tones of
the watercolour are warm and light, enriched
with shots of deeper colour.

477 Dancing for a Cake [The Dancer] 1903

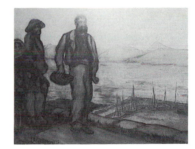

Sgd. bottom left
Watercolour, 42 x 52
Exh. 1903 London (16); 1965 Massachussetts (4)
Coll. Sold to John Quinn at the exhibition in
1903; Boston College, Bapst Library

A local competition in Donegal, where the
champion dancer was awarded a prize of a
cake. A local man, cap in hand, performs on an
improvised floor—perhaps a door borrowed
for the occasion—watched by a group behind
him. Below are Donegal Bay and the sea.

478 The Model 1903

Exh. 1903 Dublin (11); 1904 New York (59);
1905 London (83)

479 An Old-Fashioned Bagman 1903

Exh. 1903 Dublin (22); 1905 London (84)

Yeats did pictures of commercial travellers at various periods, see *172, 698.*

480 To Catch the Liverpool Boat 1903

Sgd. lower right
Watercolour, 72 x 53.5
Exh. 1903 Dublin (26)
Coll. Sold to John Quinn at the exhibition; American Art Galleries (New York) sale of the John Quinn collection, 10 Feb., 1927, lot 192; bought by Samuel Lustgarten

'Two eager figures in a jaunting car drawn by a swiftly trotting horse along the quay, under a showery sky' (American Art Galleries catalogue).

**481 He told Tales of Adventure on the
'Merrican Coast** 1903

Exh. 1903 Dublin (27)
Coll. Sold to Mrs. Noel Guinness at the Dublin exhibition

482 The Shores of Ireland

Exh. 1903 Dublin (18); 1905 London (108)

483 The Horse Trainer in the Town 1903

Exh. 1903 Dublin (15)
Coll. Sold to Mr. MacCarthy of Dublin at the exhibition

484 The Gypsy Jockey [The Gypsy] 1903

Sgd. bottom left
Watercolour, 48.5 x 35.5
Exh. 1903 London (35); 1903 Dublin (35); 1904 New York (35); 1961 Dublin (1); 1971 *Cork* (132)
Coll. Gerald Y. Goldberg, Cork
Lit. *Leader* (Dublin) (5 September 1903) 23; Barrett, C., *Irish Art in the 19th century* (Rosc Chorcaí exhibition catalogue 1971) 75

In the *Gaelic American* (5 April 1904) Yeats described it as 'an English scene at a small country race meeting.' It is certainly not as early as 1887, as the inscription on the back of the frame states (see also Cyril Barrett, op.cit.), but the style is typical of the period about 1903.

485 The First Time Round 1903

Sgd. bottom left
Insc. with title

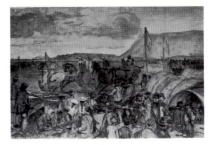

Watercolour, 91 x 136
Exh. 1903 Dublin (7); 1971–2 Dublin, New York (21)(repro); 1990 Monaco/Dublin (5)(col. repro)
Coll. The artist's estate; private collection

Yeats's earliest drawings are of the horses he saw racing and hunting in Sligo as a boy: and his first contribution to the Royal Hibernian Academy, in 1895, was *The Strand Races, West of Ireland (7).* The content and bustling activity of *The First Time Round*, another strand races, is not dissimilar to that of earlier examples: but the style has developed from the jocular humorous treatment, in the tradition of Somerville and Ross and the nineteenth century Irish novelists, to a more intense realism. His watercolour style by 1903 was strong and assured, but still open to experiment. This large composition indicates that he was still somewhat intrigued by the popular *Pannerramarama of the Coronation* he had seen being circulated in the streets of London, and used as the subject of stencils *339–41*, and essayed a panorama of a scene he knew very well, the strand races at Drumcliff in County Sligo. The watercolour is on an unusually large scale, larger than the second largest size he would ever attempt in oil, and the freedom of brushwork and colour pre-empt his style of future years.

Drumcliff has been made immortal by W. B. Yeats because of the significance of the parish for the family. 'An ancestor', their great grandfather, another John like Jack and his father—'was rector there', at St. Columba's Church, seen on the horizon of the watercolour. The Reverend John Yeats was also an outdoor man, and probably enjoyed similar sporting occasions on the strand below his rectory. Ben Bulben stands on the right horizon, painted in a soft pinky mauve against a yellow sky, touched with pinky mauve clouds, colours that anticipate the very late work. The horses in middistance run against each other, one riderless, and the jockeys are full of individual personality as is typical of Yeats. In the foreground, all the characters dwelt on in the early watercolours stand on or crowd against the carts, to see the race better, or con-

tinue with their side entertainments near the mouth of the whiskey tents in the right foreground. A balladsinger holds up his ballad sheet, which he hopes to sell for a penny eventually, and sings on regardless of the excitement at the completion of the first length of the course marked out with coloured flags. Despite the accuracy of the vivid scene, Yeats nevertheless needs the title, *The First Time Round*, to clinch the exciting immediacy of the event, an example of how important titles are in his work.

486 [The] Regatta 1903

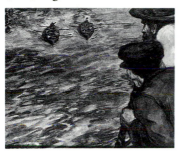

Sgd. bottom left
Watercolour, 23.5 x 28.5
Exh. 1903 Dublin (9); 1904 New York (27); 1961 London (45)(repro); 1987 *Pyms Gallery (17)*(repro)
Coll. Lt. Col. Beddington, England; James Adam (Dublin) sale, 26 Mar. 1987, lot 56 (repro); Pyms Gallery, London
Lit. Yeats, Jack B., *Sligo*, (1930) 8

Perhaps a regatta on Lough Gill, in County Sligo, such as Yeats describes in the opening pages of *Sligo*. Two men to the right are craning over the side of a launch to see the contest between two well matched teams in row boats. The close perspective of the foreground contrasts with the minute size of the figures seen below in the boats and the spectators seen at the edge of the shore in the left distance.

487 The Duck Hunt 1903

Sgd. bottom right
Watercolour, 26.5 x 36

Exh. 1903 Dublin (23); 1904 New York (34)
Coll. Victor Waddington, London

'At a regatta the man in the small boat is the duck and has to be caught by the four-oared boat' (note by Yeats, *Gaelic American*, 5 April 1904). The watercolour shows two sailors in a boat, the one at the oars looking back at his companion who leaps towards the small boat they have touched, while the man in it dives away from them into the water. Beyond is a small strand with figures, and beyond again a row of cottages.

488 A Hop, Step and a Leap 1903

Exh. 1903 Dublin (20); 1904 New York (61)

'The young men are very fond of trying their skill at a hop, step and a jump' (note by Yeats, *Gaelic American*, 5 April 1904). The picture was damaged on the way back from New York and later destroyed.

489 The Whirly Horses and [in] the Rain 1903

Sgd. bottom right
Watercolour, 21.5 x 49
Exh. 1903 Dublin (24); 1904 New York (29); 1961 London (5)(repro)
Coll. Keith Waterhouse, London
Lit. Rosenthal, T.G. (1966), plate 1A (col)

A young man with wide-brimmed hat and bright face, and a madonna-like girl with a green shawl, are transported in imagination as they ride above the crowd, on their spotted whirly horses on the merry-go-round at a country fair. Under the light of the canopy, they are separated from the dark drench of rain in the fairground, and the sober-looking bearded man who looks up at them.

490 Telling the Cards 1903

Exh. 1903 Dublin (10)
Coll. Sold to John Quinn at the exhibition; probably the watercolour, signed lower left, 26.5 x 36, described in the Quinn Sale, American Art Galleries, New York, 11 February 1927, lot 430B, as 'Two female figures, seated by placid green water, conversing', sold to Ernest Boyd

129

The reviewer of the 1903 exhibition in the *Irish Daily Independent* commented, 'The figures of the two women are cleverly drawn. The expression on the fortune-teller's face is suggestive of what might be a feeling of confidence that her subject is one of an innocently receptive character.'

491 At the Feis 1903

Exh. 1903 Dublin (8)
Coll. Sold to John Quinn at the exhibition 'Portrait of a blind enthusiast' (*Irish Times,* 31 August 1903). *At the Feis* is not mentioned in the catalogue of the sale of John Quinn's collection, February 1927, but it may be the picture called *The Politician* (26 x 35) listed in the catalogue of Quinn's collection (ed. Forbes Watson, New York, 1926, p. 11), and called *The Orator,* signed lower left, in the catalogue of the 1927 sale, lot 430A. The sale catalogue's description of an 'impressive figure of a man, with head delineated before a green banner, addressing an audience' relates to the pen and ink drawing, *At the Feis* (*Life in the West of Ireland*, 15), the figure of the storyteller standing on a platform in a mountain setting, with flags framing his head.

492 Royal Music Hall, Old Holborn 1903

Insc. Title
Last Week of the Old House
Watercolour, pen and ink, and pencil, 9 x 13
Coll. Christie's (London), 10 Nov. 1989 (336)(repro)

A view from the circle of the Royal Music Hall down on to the stage, to vague scenery and a woman mounted on a horse. Yeats sketched at the Royal Theatre of Varieties, Holborn, in London, both in the spring and the autumn of 1903 (*sketchbook 62* and see above *76*).

493 Crystal Palace *c.*1903

Watercolour, 18 x 26.5

Exh. 1961 London (6)(repro)
Coll. Mr. and Mrs. F. Hess, London
Lit. *Illustrated London News* (8 April 1961) 593 (repro)

A man on roller skates at the Crystal Palace, London, dressed up as a Red Indian sitting on a hobby horse, waves his tomahawk aloft. The skirts of the dummy steed hide his real legs. Yeats used his memory of this illusion in 1943 when he painted his oil, *The Attack on the Deadwood Coach.* The scene of the indians attacking the Deadwood Coach is envisaged realistically, but he has placed the hoofs of the horses of the attacking indians on roller skates. The watercolour is not as early as 1892, as stated in the 1961 catalogue, though he attended the Crystal Palace then, but in style relates to the 1903 works, when he was already making drawings in his sketchbooks from memory.

494 Buffalo Bill — A Stencil *c.*1903

Exh. 1903 Dublin (39)
Lit. *Buffalo Bill's Historical Scenes* (1892); Pyle, H. (1970, 1989) 24–5

Yeats continued to be interested in Buffalo Bill, Colonel W. F. Cody and the Wild West. after his visit to the Buffalo Bill show in Earl's Court in 1888; and he continued to collect what was published about him and his Wild West shows. This stencil may be slightly earlier, see *337–9, 426,* but is probably about 1903.

495 The Pirate 1903

Sgd. lower right
Watercolour, 72 x 53.5
Exh. 1903 London (33); 1903 Dublin (33)
Coll. Sold to John Quinn at the Dublin exhibition; listed in the Quinn inventory, 1924; American Art Galleries (New York) sale of the John Quinn collection, 9 Feb.1927, lot 57; bought by Cornelius J. Sullivan

'A fearful-looking figure is stepping up the poop stairs of a ship. His slouched hat hides a bandaged forehead . . . his hands are bound behind him . . . he has been taken prisoner,

and is about . . . to "walk the plank"' (*Freeman*, 5 September 1903).

496 **'Bill Corbet Boxed with Green', with 'Referee at Wonderland' on verso** 1903

Sgd. monogram lower left (recto and verso)
Insc. titles (recto and verso)
Watercolour and pencil, 12 x 8
Coll. Christies' (London), 7 Mar.1986, lot 306

Yeats was at Wonderland, London's boxing arena, in 1903 (*sketchbooks 63* and—see above—*65*, when he would have sketched the Corbet/Green fight and the referee who is on the reverse side of the drawing.

496a **The Old Pugilist*** *c.*1903

Sgd. bottom right
Watercolour, 35.5 x 25.5
Coll. Photograph in National Gallery of Ireland Archive

A study of a broken-down fighter, in an interior with prints of pugilists on the wall. The watercolour may originally have had a different title, perhaps *535*.

497 **Sketch of Cows** *c.*1903

Exh. 1904 New York (30)

This and *498* were described as 'rough notes for illustrations to stories of life in Galway, Sligo and other West of Ireland towns', when they were exhibited in New York.

498 **Sketch of Sky** *c.*1903

Exh. 1904 New York (31)
See *497*.

499 **Old John** 1904

Exh. 1904 New York (20)
Coll. Sold to Clausen's buyer, Mrs. Jarvis, at the exhibition

According to Yeats *Old John* was a small farmer, and *Young John* and *Michael* (*500–1*) were his sons (note in the *Gaelic American*, 5 April 1904).

500 **Young John** 1904

Exh. 1904 New York (21); 1904 *London* (75); 1905 Dublin (8)
Coll. Sold at the Dublin exhibition to Jack Geoghegan, with its pendant *501*

'John is the industrious stay-at-home and Michael is the bold, bad prodigal. Michael is a fine study of lawless strength, but John with vacuous countenance and a rabbit's mouth, would be better named "Village Idiot"' (*Dublin Evening Mail*, 5 October 1905). See *501*. Among his watercolours of local scenes, customs and chance events in the West of Ireland, Yeats made some penetrating character studies. His matter of fact, unidealistic, approach at this period was paralleled in literature by Canon James O. Hannay, Rector of Westport, who under the pseudonym of George Birmingham was publishing his socio/political Irish novels, which were quite frank in their comments. The two men came together in Hannay's prose work, *Irishmen All* (1913), which Yeats illustrated with twelve individual character studies, this time painted in oil. See also *499*.

501 **Michael** 1904

Exh. 1904 New York (22); 1905 *London* (79); 1905 Dublin (9)

Coll. Sold with its pendant *500* to Jack Geoghegan at the Dublin exhibition

See *500* and *499*.

502 **Looking at a Horse** 1904

Exh. 1904 New York (45)
'A farmer is showing his colt off to a priest who is a possible purchaser' (note by Yeats, *Gaelic American*, 5 April 1904). The watercolour went to the Macbeth Gallery after the exhibition, and was later destroyed.

503　The Crest of the Hill　　　　1904

Sgd.　bottom left
　　　Watercolour, 71 x 53
Exh.　1904 New York (38); 1971–2 Sligo Dublin
　　　(14)
Coll.　Sold to John Quinn at the exhibition; listed
　　　in the Quinn inventory 1924; James A.
　　　Healy, New York, who presented it to Sligo
　　　County Library and Museum in 1965 (SC13)

This watercolour was known as *Horseman*
when it came into the Sligo collection, but has
been identified as *The Crest of the Hill* from a
description in the *New York Times* (5 April
1904): 'An Irish farmer on horseback resting
with his feet out of the stirrups as he reaches for
his pipe during the wait in the fox hunt.' The
farmer wears a mauve swallow-tailed coat, and
gazes gravely around him from his rocky
height, silhouetted against the sea and sky, a
dignified figure on his resting mare.

504　The Car is at the Door　　　　1904

Sgd.　bottom right
　　　Pencil and watercolour, 53 x 38
Exh.　1904 New York (47); 1971–2 Sligo Dublin
　　　(13)

Coll.　Sold to John Quinn in New York; James A.
　　　Healy, New York, presented to Sligo County
　　　Library and Museum in 1965 (SC12)

This was known as *The Drunkard* when it
came into the Sligo collection, though Yeats
never recorded a work of that name. It is
identified as *The Car is at the Door* (Quinn col-
lection) from a description by the artist in the
Gaelic American (5 April 1904) of 'a car driver
standing by the front door. A rainy night out-
side', and from the *New York Times* (5 April
1904) description of a 'dripping driver of the
jaunting car'. The freedom of execution is due
to the vigorous drawing rather than the use of
watercolour, which is a harmony of soft amber
and pink. The grim anxious figure of the car
driver is poised to go out again into the driving
wine-coloured rain.

505　Hair Cutting

Exh.　1904 New York (44); 1905 *London* (76);
　　　1905 Dublin (10)
Coll.　Sold at the Dublin exhibition to Tom Kelly

'Little boys cutting each other's hair in a hay
loft. The small boy sitting down is rubbing his
cropped head to feel how nice and smooth it is'
(note by Yeats, *Gaelic American*, 5 April 1904).

506　Johnnie the Rock　　　　1904

Exh.　1904 New York (51); 1905 *London* (88);
　　　1905 Dublin (3)

'Gives sticks of home-made candy for rags'
(note by Yeats. *Gaelic American*, 5 April 1904).
'An Irish village street with a lot of little boys
following a rag and bone man to change their
bundles of rags for . . . "Peg's leg" and barley
sugar' (*Irish Society and Social Review*, 3
September 1905).

507　Bathers [III]*　　　　*c.*1904

Sgd.　bottom left
　　　Watercolour with pencil, 34.5 x 16
Exh.　1961 London (46)(repro)
Coll.　Victor Waddington, London; Christie's
　　　(London) sale, 14 July 1967, lot 80, bought
　　　by Lord Dufferin
Lit.　Pyle, H. (1970, 1989) 56, 70–2

Yeats painted several pictures during his life-
time of bathers, with various titles, both in oil
and watercolour, see *104, 141, 230*. The ear-
liest example, *104*, is dated 1898: and, though
it bears a different title, it may be that the artist
renamed it late in life, and it is *The Bathers*

(first version) first exhibited in 1899, see *141*. *Bathers* (II) (*230*) was exhibited in 1900, under that title, and has not yet been located. *Bathers* [III] was exhibited as *The Bathers* in 1961, and dated 1902, though it must be of a later date, for the following reason.

The watercolour shows two men, one perhaps the artist, the other a clergyman ressembling Yeats's friend, Arnold Harvey, whom he met when Harvey was tutor to Robert Gregory at Coole. They approach the spectator along an unmade road, eyed curiously by some local people near some low buildings behind them. The two tall men carrying their bathing towels, Yeats with his slung round his neck beneath his bowler hat, Harvey—who was a very handsome dark haired man—wearing a low widebrimmed black hat and his clerical garb, with his towel stuck under his arm, would have been a striking sight in the country.

But the fact that Harvey is dressed in his clerical collar puts the watercolour in 1903 or later. Thomas Arnold Harvey (later Bishop of Cashel) was ordained deacon in 1903 for St. Stephen's Church, Mount Street, Dublin. There is no record of him being at the sea with Yeats that year, though there is the possibility that Yeats painted the work from his imagination. It is more likely, however, that it dates from the following year, when, in September 1904, Harvey paid a visit to Yeats and his wife at Strete in Devon. *Sketchbook 89* has sketches of 'Parson T. A. Harvey'—an idea which obviously amused Yeats—in the orchard behind the house. Perhaps they went swimming in the locality—there is nothing particularly Irish about the watercolour—and Yeats would have taken some pleasure in his friend's new appearance and in painting him in what was now his regular garb as a priest of the Church of Ireland.

508 A Féis [Feish] in County Galway 1904

Exh. 1904 New York (53); 1905 *London* (71); 1905 Dublin (5)

Coll. Sold at the Dublin exhibition

In 1893 Douglas Hyde founded the Gaelic League in an endeavour to revive Irish customs and the Irish language; and this led four years later to the foundation of the Féis Ceoil (Festival of Music), where Irish musicians playing both Irish and European music had the opportunity to play in competitions of the highest standard in cities and towns. Local *féiseanna* [pronounced 'feshenna'] then sprang up around the West, as part of the nationalist movement. Yeats described his watercolour as 'A big Gaelic Language Society meeting with songs and stories in Irish for small prizes' (*Gaelic Ameri-*

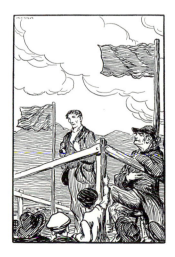

can, 5 April 1904). *At the Feis*, the drawing in *Life in the West of Ireland* (1912, p. 15), showing a young man trying his art in a Gaelic storytelling competition, is another example of Yeats treating this aspect of western life.

509 The Day of the Sports 1904

Sgd. bottom right
 Watercolour, 37 x 53.5
Exh. 1904 New York (48); 1904 *Dublin* (228); 1988 Dublin (23)
Coll. Given by the artist to Hugh Lane's Permanent Exhibition in Ireland; Hugh Lane Municipal Gallery of Modern Art, Dublin (357)
Lit. *Municipal Gallery of Modern Art Illustrated Catalogue* (1908, 1984) 47, no. 259

A note in the *Gaelic American* (5 April 1904), when Yeats exhibited this work for the first time in New York, explains how 'a young man [is] giving advice to another as to how he will run in the races. The second young man is in his racing clothes.' The warm blues and greens, and the russet of road and roofs, bind together the disparate elements of the background, and lead the eye to the central incident in the foreground.

510 The Winner of the Boys' Race 1904

Exh. 1904 New York (52); 1905 *London* (73); 1905 Dublin (6)

511 American Quayside Seafood Seller* 1904

 Pen, ink and wash, 9 x 12
Coll. Adam Salerooms (Dublin) 19 May 1983, lot 39
Lit. Pyle, H. (1970, 1989) 83–85

Taken from one of the New York sketchbooks, March/April 1904.

512 A Side Walk of New York 1905

Sgd. bottom right
 Watercolour, 36 x 26.5
Exh. 1905 Dublin (39); 1908 London (49)

Coll. Adam Salerooms (Dublin), 19 Sept. 1985, lot 43 (repro); private collection
Lit. Pyle, H. (1970, 1989) 83–85

A watercolour view of one of the streets of New York which Yeats saw during his visit to America, March/April 1904. 'Peopled with characters coming and going, including a Red Indian, and it makes New York look like a one horse mid west town', according to the *Irish Times* (14 September 1985). The child in the right foreground takes his eyes for a moment off the Red Indian standing in front of the side walk, to look at the sailor, a familiar Yeats character, who passes him on his left.

513 Orchard in Winter 1905

Exh. 1905 London (91); 1905 Dublin (29)

514 Rosses Point 1905

Sgd. bottom right
 Watercolour, 28 x 44.5
Exh. 1905 *London* (106); 1905 Dublin (20)
Coll. Sold at the Dublin exhibition to Sir Philip Hanson; Rev. Professor A. T. Hanson, Hull; private collection

Sand dunes looking across the bay to the Lissadell peninsula. The lighthouse is to the left, and there is a ship in the centre distance.

515 S.S. Olive in Killybegs* October 1905

Sgd. October 1905

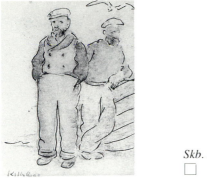

Skb. 108

☐

Insc. with title
Watercolour, 25.5 x 35.5
Coll. Given to his cousin Olive Pollexfen by the artist; Mrs. A. M. Stewart, Belfast; private collection

Yeats was in Killybegs in the autumn of 1905 (*sketchbooks 107–8*); and painted the harbour, with the S. S. Olive, named after his cousin Olive Pollexfen, moored beside the pier. A fairly conventional view, though in delicate soft colouring, it is realistic and includes the telegraph pole. Yeats told the owner that the hardest thing to paint was a whitewashed wall.

516 Daffodils 1905

Exh. 1905 *London* (93); 1905 Dublin (30)

517 A Political Meeting, County Sligo 1905

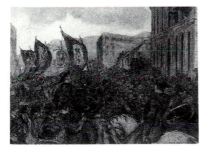

Sgd. bottom right
Pencil and watercolour on card, 53.5 x 73.5
Exh. 1905 Dublin (21); 1913 *New York;* 1918 *New York* (75); 1971–2 Sligo, Dublin (16); 1978 *Washington* (77) (repro); 1989 Sligo (18)
Coll. Sold to John Quinn in 1905; listed in the Quinn inventory 1924; American Art Galleries (New York) sale of the John Quinn collection, 11 Feb. 1927, lot 415 (repro); Mrs Cornelius J. Sullivan, New York; bought by James A. Healy 1939, and presented to Sligo County

Library and Museum in 1965 (SC15)
Lit. *Sligo Champion* (11 February 1905) 11
The watercolour depicts the 1905 annual reunion in Sligo of the local branch of the Irish National Foresters, which included nearly all the prominent members of the Catholic and Nationalist Party in the locality. The wearing of sashes denotes their close affiliation with the Ancient Order of Hibernians, a Catholic organisation akin to Orangeism in its intensity, from whom the Foresters had originally separated, and who had recently been released from a clerical ban.

The meeting, on 11 February 1905, was the occasion of the Lily of Lough Gill Branch of the INF welcoming the Lord Mayor of Dublin—the general secretary of the Irish National Forresters Association in Ireland and the only surviving member of those who had initiated the order in Ireland—to their reunion. The event began with a torchlight procession to the Imperial Hotel, where he spent the night, followed the next day by a meeting at Sligo Town Hall, where he addressed the branch on the evils of emigration.

Yeats was not in Sligo on 12 February, the day of the big meeting, but was in London to watch boxing, and later to see the Whistler exhibition: so he must have been working from a photograph. The whole scene, worked largely in pencil, has a detached vividness, representing the artist's view from behind the jostling grey blue crowd, who look up intently at the man leaning out of the town hall window. The Forresters have blue coats, and these brighten the greyness of the scene as do the nationalist banners and the view of the mountains at the end of the street. For Yeats the Robert Emmet banners with the Irish harp were redolent of the 1898 procession and celebrations in Sligo, which had awakened his own national consciousness, see *108, 184, 324.* In a letter to John Quinn (5 April 1909, New York Public Library) who had bought the picture as soon as it was exhibited, Yeats said he regarded *A Political Meeting* as one of the best works he had done.

518 Masefield Lecturing November 1905

Probably a sketch from a sketchbook, watercolour and pencil, 13 x 9 or 9 x 13
Coll. Sold by the artist to Heffer, Cambridge in November 1931

In November 1905 Yeats sketched Masefield—a shaded silhouette with moustache and worried forehead—lecturing on Nelson at Chipping Camden in London *(sketchbook 111)*: and this is

probably another sketch from the same occasion. See *519*.

519 John Masefield* 1905

Sgd. bottom right
Insc. with title 1905
Watercolour, 35 x 25
Exh. 1961 London (52)(repro); 1971–2 Dublin
New York (17(repro)
Coll. Mr. and Mrs. J. Burke Wilkinson,
Washington D.C.
Lit. Rosenthal, T.G.(1966) plate IIIb (col.); Pyle,
H. (1970, 1989) 73–80

Jack B. Yeats and John Masefield the poet (1878–1967) were close friends during the early years of this century, and Masefield paid several visits to Cashlauna Shelmiddy in Devon, publishing the illustrated edition of *The Fancy* together with Elkin Mathews, in 1906. This head and shoulders portrait, three quarter face turning right, was probably made after, and partly from, the Chipping Camden sketches of November 1905 (*518*), and is one of Jack Yeats's few straight portraits.

520 Stencil Portrait of Synge* 1905–7
Indian ink stencil on verso of writing paper stamped with Cashlauna Shelmiddy address, 23 x 18
Coll. Lady Gregory; New York Public Library, Berg Collection
Lit. Pyle, H. (1970, 1989) 87–90, 94

One of several stencil portrait heads of John Millington Synge, the dramatist (1871–1909), who became a close friend of Yeats after their trip to Connemara and Mayo together in 1905, *521–3*. It is placed loose in a December 1904 issue of *Samhain*, originally in the possession of Lady Gregory. Ann Saddlemyer, who has a copy of this, suggests that the por-

trait was done when Synge visited Yeats in Cashlauna Shelmiddy in early June 1907. See also *259, 337–9* ff.

521 Stencil Portrait of Synge* 1905–7
Indian ink and wash on verso of writing paper with blind stamp address of Cashlauna Shelmiddy, 24 x 19
Coll. Sotheby sale from Lady Gregory estate, 15 Dec. 1982, lot 204; Tim Vignoles, Surrey

See *520, 522–3*.

522 Stencil Portrait of Synge* 1905–7

Sgd. with monogram
Indian ink and grey wash on white lined paper torn out of an exercise book, 20 x 13
Coll. Purchased from the artist thorugh Messrs Bumpus in 1929 for the Royal Library, Windsor Castle
Exh. 1971–2 Dublin, New York (23)(repro)

See *520*. The silhouette portrait head, left profile, was reproduced as the J. M. Synge centenary 10p stamp.

523 Stencil Portrait of Synge* 1905–7
Indian ink on white lined paper, 20 x 13
Coll. Purchased from the artist through Messrs. Bumpus in 1929 for the Royal Library, Windsor Castle

See *520*.

524 Portrait of Synge* 1905
Sgd. bottom right 1905
Insc. J. M. Synge Greystones
Taken from a sketchbook, the page trimmed at the side, pencil and indian ink, 9 x 11.5
Coll. The artist's estate; private collection

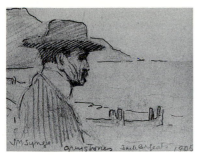

Bust behatted, right profile, silhouetted against the headland, he looks out to sea at Greystones, County Wicklow.

525 Portrait of Synge* 1905

Sgd.	bottom right
Insc.	J. M. Synge 1905
	Taken from a sketchbook, the page trimmed and mounted on card, pencil and watercolour, 12.5 x 9
Coll.	The artist's estate; private collection

Full length, arms folded, seated on a rock wearing a sombrero. See *524*. Presumably sketched on the same occasion.

526 Portraits of Synge* probably 1905

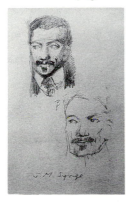

Sgd.	monogram centre
Insc.	J.M. Synge
	Pencil, 25.5 x 18
Coll.	The artist's estate; private collection
Lit.	*J. M. Synge: Collected Works* II ed. A. Price (1966) 283ff.; *NGI* (1986) xvi–xvii (repro fig.11)

Two studies of Synge's head, full face, his ear placed to the wall, and his eyes regarding it, as if he is listening intently. These may have been made during their trip around Connemara together in June 1905, see *520*.

527 The Causeway [The Causeway Bridge]
 1905

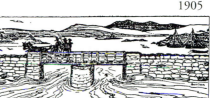

Sgd.	lower right
Insc.	on reverse:
	The Causeway Bridge
	With J. M. Synge in Connemara
	Watercolour, 18.5 x 26.5
Exh.	1906 Dublin (32); 1908 London (26)
Coll.	Sold by the artist to W. T. H. Howe, Cincinatti, in August 1935; purchased September 1940 by the New York Public Library Berg Collection
Lit.	Bourgeois, M., *John Millington Synge and the Irish Theatre* (1913, 1965) repro p. 84; Skelton, R., *J. M. Synge and his World* (1971) repro p. 94; Pyle, H. (1970, 1989) 87–9

The causeway from Lettermore to Gorumna in South Connemara, where Yeats and Synge spent June together preparing articles for the *Manchester Guardian*, in 1905. The watercolour has been developed from the drawing of the same name, illustrating Synge's article 'Among the relief works' in the *Manchester Guardian* (17 June 1905), and shows a horse and side-car carrying Synge, Yeats and a jarvey across the bridge. Yeats, who enjoys a touch of humour, represents Synge looking down fearfully at the water. The picture is predominantly a warm purply blue, with touches of emerald green and a warm brown.

528 The Man from Aranmore [Arran More]
 1905

Sgd.	bottom right
Insc.	on reverse: Man from Aranmore

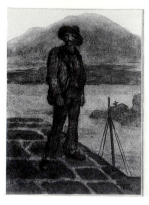

Chalk and watercolour on Whatman board,
38 x 27.3

Exh. 1905 Dublin (23); 1908 London (28); 1908
Belfast; 1961 London (11)(repro); 1964
Derry/Belfast (10); 1967 London
(17)(repro); 1971–2 Dublin, New York
(12)(repro); 1986 Dublin (7)(col. repro);
1990 Monaco/Dublin (6)(col. repro)

Coll. Mrs. N. Pulvertaft; purchased from Victor
Waddington, London in 1967 by the
National Gallery of Ireland (6317)

Lit. Pyle, H. (1970, 1989) 44, 87–90 (repro)

'Aranmore', the name Yeats uses here for the
largest of the three Aran Islands, off the coast of
Galway, is more generally known as 'Inish-
more', which means 'big island'. J. M. Synge
uses the term 'Aran Mór', in his book *The Aran
Islands*; and the islanders themselves refer to the
big island as 'Arann'. Jack Yeats painted this
watercolour after he had visited the Irish
speaking districts of South Galway with Synge
in June 1905. An islandman stands on the
quay of some local harbour in South Galway,
the mast of his hooker rising from the water
below him, a cormorant stretching its wings on

a rock beyond that. Aranmore, and the hill
beside Kilronan, the main town on the
island, form a background to the man. There
has always been constant traffic between the
mainland and the island, and he has evidently
come on some business.

The combination of warm mauves and
gold, that characterize this watercolour, were
used elsewhere by Yeats at this period. The
water is a gold colour beyond the rocks, reflect-
ing the light yellow of the smooth pale sky. The
hill, mauve with heather, and gold with gorse,
repeats the conical shape of the man's wide
brimmed hat worn in Galway at this date, and
seems to guard him from the ravages of the
Atlantic Ocean on the barren West coast. He
stretches his legs on the quay, confident and self
contained.

The lighting is typical of the soft, spray-
filled atmosphere of the Connemara seaboard.
The islander wears a coat over his fisherman's
jersey, a pair of tweed or flannel trousers, and
shoes rather than the pampooties described by
Synge, and with which Yeats provides the Aran
islanders in his illustrations to Synge's book,
The Aran Islands, published in 1907. The
location may be in Carraroe, one of the small
quays Yeats and Synge observed on their
Galway trip, possibly in Doleen Harbour.

**529–531 Three Sketches from a Belmullet
Sketchbook*** 1905

Each stamped with monogram
Pencil and watercolour, *530–1* with ink also,
each 13 x 9, except *531* which is 9 x 13

Coll. Private collection, Dublin

Lit. J. M. Synge: *Collected Works* II ed. A. Price
(1966) 316–20

529 Outside door of shop in Belmullet
(inscribed with title)
530 Captain of Westport Hooker (inscribed
with title)
531 Belmullet jetty

Three sketches of the quay at Belmullet,
where Synge and Yeats were struck by the
extreme poverty of the people. See *532*.

532 A Windy Day Belmullet* 1905

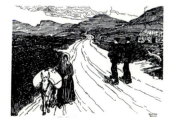

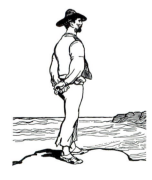

Sgd.
Insc. with title
Taken from a sketchbook, watercolour,
9 x 13
Coll. A wedding present from the artist, 1926, to
Mrs. Frances Farrell, Dublin
Lit. *J. M. Synge: Collected Works* II ed. A. Price
(1966) 316–20 (see illustration)

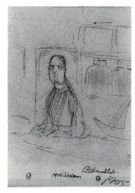

A North Mayo sketch from the trip with
Synge in June 1905. See *529–31, 532a*. Yeats
immortalised one character of Belmullet, the
shopkeeper Mrs Jordan, who appears in *The
Country Shop* in *Life in the West of Ireland*,
29. Cf. also sketch of Mrs Jordan (private col-
lection) illustrated here.

532a Near Geesala* 1905

Stamped with monogram
Black ink, pencil and wash, 9 x 13
Insc. Nr. Geesala
Coll. Dawson Gallery, Dublin; private collection,
Ireland

Taken from one of the artist's sketchbooks.
Yeats was in Geesala, Co. Mayo (beyond
Belmullet, on Erris) with Synge in June 1905.

532b The Lighthouse Steamer* ?1905

Stamped with monogram
Pencil and watercolour, 9 x 13
On reverse: Achill from Geesala
Coll. Taylor Gallery, Dublin; Tim Vignoles, Surrey

A boy holding a toy boat looks out to the
steamer in the bay, with mountains and woods
beyond. See *532a*.

533 The Old Quay Watchman 1905

Sgd.

Watercolour, 36 x 26
Exh. 1905 Dublin (25); 1906 *Limerick;* 1908
Belfast
Coll. Sold by the artist to John L. Sweeney,
Boston, in 1950

Described in an undated cutting from the
Manchester Guardian as 'An ancient man,
wooden-legged and feeble, standing on the
rugged paved edge of the quay, looking over
dark water under a starless sky. All these
watchmen, it seems, are old and one-armed
or one-legged. Mr. Yeats asked what help
they could give in the case of need. He was
told that if anyone falls into the water the
watchman shows a light. "D'ye see this stick?
That's all I can do for ye. Ye'll be on the
Ballast strand in the morning'.

534 The Old Attorney* c.1905

Sgd. bottom left
Watercolour with pencil, 35.5 x 25.5
Exh. 1961 London (51)(repro); 1981 London (3)
Coll. Victor Waddington; Mr. and Mrs. A.D.F.
Gilbert; Theo Waddington, London; T.G.
Rosenthal, London

535 An Old Timer 1905

Exh. *1905 London (74)*; 1905 Dublin (12)

536 A Professional Man* c.1905

Sgd. lower left
Watercolour on card mounted recently on
board, 60 x 51

Coll. James Adam (Dublin) sale 5 Apr. 1979, lot 85; Taylor de Vere Auctions (Dublin) 1989; Trinity Gallery, London

A professional man, in old-fashioned frock coat and trousers, clutching umbrella and book, pushing against the wind. The strong flat figure, stylised with strong shadow, draws part of its strength from the way it is silhouetted against a sky composed of broad theatrical elements, echoing the blustery personality of the man. The watercolour has had some damage, and has lost some of its original colour.

537 The Yard Man 1905

Exh. 1905 London (95)

538 A Solid Man 1905

Sgd. bottom right
Insc. with title
 Watercolour with pencil, 17.5 x 14
Exh. 1905 Dublin (26); 1908 London (31)
Coll. Sold at the London exhibition to Mrs. Meeking
Lit. *The Open Window* II (1910 November) 78

A man in a long coat, holding a whip, prepares to mount a sidecar. Only the hind leg of the pony shows, against a low horizon, wide sky and a row of cottages.

539 The Tinker [Travelling Woman] 1905

 Watercolour, 25 x 17
Exh. 1905 *London* (85); 1905 Dublin (19); *1910 Aonach*
Coll. Dr. Karl Mullen, Dublin; private collection

A long thin woman with red hair walks on a road carrying a bag in each hand and a child wrapped in the shawl on her back. The whole picture is mainly soft pinks and greens worked into each other, lightened by the gleam of water behind the figure. There is the atmosphere of a soft day.

540 Untitled: Tinker* 1900–5

Sgd. bottom right
 Gouache on paper mounted on card, 12 x 8
Coll. Victor Waddington, London

A study of a weatherbeaten tinker's face. He wears a lightcoloured scarf decorated with triangles.

541 A Tinker* *c.*1905

Sgd. bottom right
 Watercolour on board, 36 x 25.5
Exh. 1961 London (14)(repro)

Coll. Waddington Galleries, London; P. J.
Goldberg, London; Christie's (London), 14
Oct. 1987, lot 432 (repro); private collection

Lit. *Life in the West of Ireland* (1912, 1915) 93;
'Wanderers of the Western World' by C.
Stuart in *Yorkshire Observer* (10 September
1938) repro as *An Irish Tinker, Ireland of the
Welcomes* 20, no.2 (July–August 1971)18
(repro)

One of the artist's finest character studies, it was
dated 1895 in the 1961 catalogue, but belongs
with the character portraits of about ten years
later. The man of the road, seen three-quarter
length, walks on his own on a stormy evening.
There is a dramatic play between the whites of
his eyes, the brilliant reflection of the lake
behind him, and the gentler light of the snug
cottage he leaves behind to his right.

542 The Tinker's Curse 1905

Sgd. bottom right
Watercolour, 35.5 x 25.5
Exh. 1906 Dublin (20); 1913 *London* (182); 1945
Dublin National Loan (174); 1980
Birmingham (Alabama)(3)
Coll. Sold to George Russell (AE) at the 1906
exhibition; C. P. Curran, S.C.; Elizabeth
Curran, now Mrs. Josef Solterer, Arlington, Va.
Lit. *A Celtic Christmas* (Dublin) (December
1905) repro facing p. 12; Colum, P., *My
Irish Year* (1912) 92 (repro); Bourgeois, M.,
John Millington Synge and the Irish Theatre
(1913, 1965) 180

A dramatic study of a tinker in a village street,
contorted in a paroxysm of rage, raising his
arm and stick with a malevolent howl and
uttering his curse. The lower part of his waist-
coat is at the centre of the painting, leaving
space to each side of him and above him. One

foot is bandaged. The lighted cottages behind
him watch like bewildered eyes.

**543 The Gypsy's Horse [The Gypsy Woman's
Horse]** 1905

Exh. *1905 London* (102): 1905 Dublin (28)

544 The Beach Comber 1905

Exh. 1905 *Dublin*; 1905 Dublin (27); 1906
Limerick
Coll. Sold through Victor Waddington Galleries,
1950, to a private collector

545 A Country Newsagent [Newsagent's Shop]
 1905

Exh. 1905 *London* (92); 1905 Dublin (34)

See *545a.*

545a The 'News' in Devon 1900–5

Sgd. bottom left,
Pencil and watercolour, 16.5 x 17
Coll. Victor Waddington, London

An old fashioned newspaper shop in a village
street. Possibly *545.*

546 The Humorist 1905

Exh. 1905 *London* (103)

547 The Non-Humorist 1905

Exh. 1905 *London* (105)

**548 A Strange Visitor at the Inn [The
One-armed Tally Man]** 1905

Sgd. bottom right
Insc. on verso: The one armed The Tallyman
Watercolour on card, 37 x 26.5
Exh. 1905 *London* (87); 1905 Dublin (13)
Coll. Sold to W. T. Howe, 1940; purchased
September 1940 by the New York Public
Library Berg Collection

A very dark painting. The one armed tallyman, a credit merchant, who wears a wide-brimmed brown hat and a navy blue coat, stands in the room, looking about him with a guarded expression. Through the window, in a setting of mauvy blue with touches of green, is seen a steamer moored in the rain.

549 Laying Plans 1905

Exh. 1905 *London* (96); 1905 Dublin (31)
Coll. Sold at the Dublin exhibition to a private collector; this is probably *Laying Plans*, sgd. bottom right, pen, ink and watercolour, 10.5 x 16.5 Christies 10 June 1983, lot 83; private collection, Ireland

There is no contemporary description of the *Laying Plans* exhibited in 1905 at Baillie's Gallery, London. The Christie's drawing shows a race meeting.

550 'There was an Old Prophecy found in a bog' 1905

Sgd. lower left
Watercolour on card, 37 x 26
Exh. 1905 *London* (78); 1905 Dublin (17)
Coll. Sold to John Quinn at the Dublin exhibition; Catalogue of the John Quinn Collection (1926) repro p. 160; American Art Galleries (New York) sale of the John Quinn collection 9 Feb. 1927, lot 54 bought by J.N. Tobin; Adam Salerooms (Dublin) 27 Sept. 1990, lot 42 (repro.)

The title comes from the well-known anti-Jacobite song *Lillibulero*. The 'old prophecy' foretold the iniquities of James II and his deputy, Tyrconnel:

'There was an old prophecy found in a bog,
 Lillibulero bullen a la,
That we should be ruled by an ass and a hog
 . . .

'So now this old prophecy's coming to pass
 . . .
For James is the hog and Tyrconnel's the ass
 . . .'

In the watercolour two Irish farmers are seated on a bog cutting, one reading from a piece of paper to the other. As usual when he borrowed from a song or ballad, Yeats is not illustrating the ballad itself, but rather using the words — which amuse him — as a pivot for his own paradoxical satire. He was painting at a period when Home Rule was in the air, and idealism among Irish writers and artists was at its height:

though they were wary of political polemics, and viewed the situation with a certain degree of cynicism. The humour with which Yeats treats the two old-fashioned figures — taken from a nineteenth century burlesque, and set in the bog landscape he knew well — is typical, the manner of painting is broad and free. In a letter to Quinn on 4 April 1909 (New York Public Library), Yeats described the *Old Prophecy* as 'too much of just a little group with a title and not enough of a *picture*.' He asked Quinn to return it to him and exchange it for another work, but Quinn decided to keep it. The watercolour, seen in 1990, has been cleaned, and almost all the blue washed from the sky. The signature may have been restored because of over cleaning: yet the watercolour images are in his recognisable manner.

551 Micky Mack and John Devine 1905

Exh. *1905 Dublin*; 1905 Dublin (43B)
Coll. Sold to George Moore at the exhibition

552 Egglers [Talk]* 1905

Sgd. bottom left
Insc. on verso [at a later date] 95
Watercolour on board, 26 x 35
Exh. *1905 London (69)*; 1905 Dublin (18); 1961 London (13) (repro) as *Talk*
Coll. Victor Waddington, London; N. Bernstein, Dublin
Lit. *Studio* 162 (July 1961) 27 (repro)

Described as 'Two typical countrymen . . . bargaining or preparing to bargain' in the *Irish Society and Social Review* (October 1905), this must be the watercolour more recently known as *Talk*, which shows the heads of two men conversing, or bargaining, in a room, rendered in warm brown tones. The sunlit street is visible through the window behind them. *Talk* was dated 1895 in the 1961 exhibition, but in style it dates to 1905; and like some other early watercolours appears to have been given a new title.

553 Rum and Barnacles 1905

Exh. 1905 *London* (81); 1905 Dublin (15)
Coll. Sold by the artist to W. Marmion, 1945

Described as 'probably large' in the artist's records. 'Mr. Yeats's story is that this cask was found on the beach, and the people carried the rum away in pails; the coastguards appeared to claim the trove, but as the cask was not yet empty the retreating peasants dashed into it a few bucketfuls of seawater to spoil the rum for the coastguards' (*Manchester Guardian*, 1 Mar. 1905).

554 Sailors Bringing a Present Ashore 1905

Sgd. bottom right
Watercolour, 26 x 36
Exh. *1905 London (70)*; 1905 Dublin (16)
Coll. (Photo in National Gallery of Ireland archive)

555 The Ram 1905

Exh. 1905 *London* (107); 1905 Dublin (7)
Coll. Sold to Tom Kelly at the Dublin exhibition

'A gentleman in a purple coat running away from a pink ram' (*Dublin Evening Mail*, 5 Oct. 1905).

556 A Breeze 1905

Exh. 1905 Dublin (40); 1908 London (46)

557 The Passing of the Motor Car 1905

Exh. 1905 *London* (97)

558 A Student [A Paris Student] 1905

Exh. 1905 *London* (99); 1905 Dublin (32)

559 John Bull's Hat 1905

Exh. 1905 *London* (101)

560 A Pony Race [Pony Races] 1905

Exh. 1905 *London* (104); 1905 Dublin (33)
Lit. Yeats, Jack B., *Sligo* (1930)8

In *Sligo*, Yeats writes, 'The Pony races are older than the boat races and they have Taught the younger the joyful game of 'Win Tie or Wrangle'.

561 The Start 1905

Exh. 1905 Dublin (42)
Coll. Sold to Lady Mayo at the exhibition

562 A Stern Chase 1905

Exh. 1905 Dublin (37)

563 Only Two in it 1905

Sgd. bottom right
Watercolour, 26 x 37
Exh. 1905 *London* (72); 1905 Dublin (14)
Coll. Sold through the Dawson Gallery February 1948; Malcolm Rhodes MacBride, California; the Dawson Gallery, Dublin; Dan McInerney, Dublin; sold at Christie's (Dublin) Carrickmines House sale, 10 Feb. 1986, lot 338 (col. repro); private collection
Lit. *Life in the West of Ireland* (1912, 1915)105

A strand races with the upper part of two jockeys vying with one another in the foreground, a third galloping in mid-distance. Low purple hills beyond, and a pale cloud puff sky.

564 The Blind Piper at the Feis 1905

Sgd. bottom right
Watercolour, 71 x 53.5
Exh. 1905 *London (89)*; 1905 Dublin (1)
Coll. Victor Waddington, London; Dan McInerney, Dublin; Christie's (Dublin) sale, Carrickmines House 10 Feb.1986, lot 352 (repro)

The blind piper seated on stage, with a back drop of greenery and castles, his head thrown back in an expression of inspiration while he plays the iolann pipes.

565 The Pedlars* c.1905

Sgd. bottom right
Watercolour, 25.5 x 35.5
Exh. 1960 Sligo (6); 1961 Sligo (53)(repro); 1963 Sligo (12); 1971–2 Sligo, Dublin (17)
Coll. Town & Country Estates (Ireland) sale 30 Sept.1952, lot 105, as *The Three Hobos*; the Yeats Country Hotel, Rosses Point, for many years on indefinite loan to Sligo County Library and Museum

A humorous study of three frequenters of the country race course, silhouetted against the sky, a few tents outlined on the horizon behind them. Two of the men are tall, one with a paunch, and carrying a dart board. The other, long and mournful, looks threateningly at the third man, who is small, with spectacles and drooping moustaches, holding a box under his arm. Their expressions are delightful. The sky is blue and windy, all rendered in strong warm colours, with a delicate touch.

566 Design for a Poster c.1905

Sgd. bottom left
Insc. on verso: For a Circus, 1888
Watercolour, 45 x 59
Exh. 1905 Dublin (38); 1961 London (1)(repro)
Coll. Waddington Galleries, London; Mrs. D. H. Daly, London

Design for a Poster is listed twice by the artist in an index to reproductions of his work, once as *Design for Poster (2 horses)* and once as

Poster of two white horses (watercolour). No early reproduction has been discovered: but the *Design* is probably the watercolour *For a Circus (design for a poster)* exhibited in 1961, which is a good deal later than 1888 in style and form of signature. The inscription on the reverse dating the poster to 1888 was added many years after the design was made. The design shows two white horses leaping forward, reined in by a charioteer, who is seen in part in the bottom right-hand corner.

567 The Fair of Ballinasloe 1905

Exh. 1905 Dublin (24); 1908 London (29)

568 The Lasso Act at the Cicrus 1905

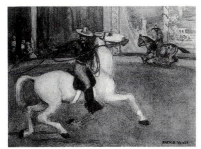

Sgd. bottom right
Watercolour, 53.5 x 72
Coll. Victor Waddington, London; Dawson Gallery, Dublin, c. 1972; Dr. John O'Driscoll, Kildare; Dan McInerney, Dublin; Christie's (Dublin) sale, Carrickmines House, 10 Feb.1986, lot 357 (col. repro); Waddington Galleries, London; James Adam (Dublin) sale 15 Mar. 1990
Lit. Pyle, H. (1970, 1989) 24–5

A circus performance in London in the eighteen eighties or early nineties. Probably a memory of a cowboy team from Buffalo Bill's Wild West show at Earl's Court, the excitement of the lasso act is recreated with skill and beauty, the attention focussed on the magnificent white horse in the foreground. The young boy in the audience in the background, mesmerised by the horse, is a forerunner of the idealistic youth who later appears in the oil paintings.

569 A Little Dublin Theatre 1905

Sgd. lower right
Insc. on verso with title
Watercolour on Whatman board, 36.5 x 26.5
Exh. 1905 *London* (77); 1905 Dublin (2); 1965 *Dublin* (102); 1971 Dublin Peacock Theatre (8)

Coll. Sold to Miss Horniman in 1905; Abbey
Theatre, Dublin

Lit. O hAodha, M., *Pictures at the Abbey* (1983)
9, 15 (col. repro plate 7)

The watercolour, now known as *Willie Reilly at
the Old Mechanics Theatre*, and exhibited in
1965 and 1971 under that title, records the
interior of the Mechanics Institute Theatre, in
Lower Abbey Street, Dublin, which Yeats also
called 'The Sailors' Theatre' (*422*), and which
with the Penny Bank in Marlborough Street
was converted by Joseph Holloway to become
the Abbey Theatre in 1904. The sailors in the
audience chat to one another and light their
pipes, keeping half an eye on the drama on the
stage, where two soldiers with muskets are
watched by an old woman. One of Yeats's first
oils depicts a scene from the October 1901 per-
formance of the melodrama *Willie Reilly*
(*sketchbook 49*): and this may be a memory of
that performance. A banner of Robert Emmet,
and another of Erin, hung high on the walls,
dominate the small interior. Willie Reilly , who
excited Yeats's imagination, became the subject
of the late oil, *Rise Up Willie Reilly* (1945).

570 Harvey Duff 1905

Exh. 1905 London (90); 1905 Dublin (4)
Coll. Sold through Victor Waddington, November
1945, to a private collector

Harvey Duff, a police agent disguised as a peas-
ant, is a character in Dion Boucicault's melo-
drama, *The Shaughraun*, which, according to
Yeats, was the first play he ever saw. He
constantly acknowledged Boucicault's influence
on his imagination from boyhood; and, in
1937, painted one of his most important oil
paintings, *In Memory of Boucicault and Bianconi*
(National Gallery of Ireland collection).

571 The Twisting of the Rope 1905

Exh. 1905 Dublin (43A)
Coll. Sold to T. Kelly at the exhibition

The title is taken from Douglas Hyde's play,
Casadh an tSugáin (*The Twisting of the Rope*).
Yeats saw and sketched the play when he was
in Dublin in October 1901 (*sketchbook 49*).
See *365–6*.

572 Lafitte, A Pirate 1905

Sgd. bottom left
Watercolour, 39 x 29
Exh. 1905 Dublin (36); 1908 London (47)
Coll. Mrs. Eleanor B. Reid, San Francisco; private
collection

Lit. *Irish Society and Social Review* (23 September
1905) (repro); Cowie, A., *The Rise of the
American Novel* (1948) 288–92

Jean Lafitte, the French pirate and smuggler of
the late eighteenth and nineteenth centuries,
was something of a legend during his lifetime.
He was granted a pardon by the American
government for his heroism at the Battle of
New Orleans. Yeats undoubtedly adopted the
character, for whom he created Theodore, *573*,
623, from Ingraham's melodramatic novel,
Lafitte, the Pirate of the Gulf, published in
1836. The watercolour shows the ferocious,
but elegantly attired pirate standing on a height
above the sea. Behind him may be seen a
group of slaves working with logs on a tropical
island, some further pirates and a two-masted
schooner. See also *624*.

573 Theodore, A Pirate 1905

Exh. 1905 London (98); 1905 Dublin (35)
Coll. Sold to Tom Kelly at the exhibition
Lit. Pyle, H. (1970, 1989) 77–8

Theodore was an imaginary invention of
Masefield and Yeats, a graceful effeminate
young pirate, follower of the famous — and
real life — Lafitte, *572*. Yeats made numerous

drawings of him, and he appears in *A Broadside*, August 1908, January 1909, May 1910 and in *Treasure*, *A Broadside*, April 1911. Here, dressed in a typically elegant fashion, head bared, he strikes a haughty pose. Behind him a shadowy man walks the plank [photograph in artist's archive].

574–579 Six Pages from a Sketchbook of 1905*

574, 579 signed with monogram
Pencil and watercolour, *574* with pen and ink also, *576* pencil only, 9 x 13 or 13 x 9
Exh. 1973 London (58–67)[with four other pages]
Coll. Dan McInerney, Dublin; Christie's (Dublin) Carrickmines House sale 10 Feb 1986, lots 383–388; *579* Adam Salerooms (Dublin) 10 July 1986, lot 22

574 Beauty and the Barge *and* At Wonderland (verso, inscribed with title); *575* Beauty and the Barge *and* Beauty and the Barge (verso); *576* Pedlar Palmer (a second at Wonderland) (inscribed with title) *and* Housekeeper in Beauty and the Barge (verso, inscribed with title); *577* Alf Freer of St. Lukes (inscribed with title) *and* Young Cockney Cohen of Leeds (verso, inscribed with title); *578* Comedy Juggler at the Palace (inscribed with title) *and* The Follies Great Scene (verso, inscribed title); *579* Bad Organ Grinder in the little play at the Coliseum (inscribed with title)

Scenes sketched by Yeats at the Theatre Royal, Haymarket, and at Wonderland, in February, May or July 1905, when he was in London (see *sketchbooks 91, 92, 94, 103, 104*).

580 On the Gara River 1906

Sgd. bottom left
Watercolour, 25 x 35.5
Exh. 1906 Dublin (34); 1908 London (38); 1961 London (53)(repro); 1967 London (75)(repro)
Coll. Mrs. F. Bierer, U.S.A.

A sylvan view, with a plank bridge by a tree

in the foreground, and a cottage in mid-distance. See *236, 384*.

581 The Gara River* *c.*1906

Sgd. bottom right
Watercolour, 25 x 35.5
Coll. Mr. and Mrs. M. Lederman, New York

A bend of the Devon stream with reflections, painted loosely. It could be slightly earlier than 1906. See *158, 236, 384* and *580*.

582 Start Bay 1906

Exh. 1906 Dublin (41); 1908 London (51)

Described in the artist's records as 'Start Bay (the second)'. There is no record of a first version. Start Bay is on the South Coast of Devon, near Strete.

583 A Galway Lake 1906

Exh. 1906 Dublin (30); 1908 London (25)

Presumably Coole Lake. Yeats visited Coole Park, in County Galway, in the summer of 1906, where he picnicked beside Coole Lake with the Rev. T. A. Harvey, Robert Gregory and his wife, Cottie, and a pony named Sarsfield who got tea up his nose (*sketchbook 116*).

584 Ardbear Bay, Connemara 1906

Exh. 1906 Dublin (26); 1908 London (24)
Lit. Pyle, H. (1970, 1989) 106–7

Ardbear Bay, near Clifden, Connemara, where Yeats stayed in September 1906 at the Quay House Hotel (*sketchbook 116*). He made a watercolour sketch of the same bay in 1907 in *sketchbook 125*. Clifden was where Yeats painted his first oil landscape — in 1906. This deeper interest in pure landscape painted in oil led him to abandon watercolour about four years later.

584a Roundstone, Connemara* c.1906

Stamped with monogram, c.1967
Watercolour, 13 x 18
Coll. Waddington Galleries, London

Probably dating from Yeats's visit to Clifden, Co. Galway, in 1906.

585 The Little Town [Returning from the Fair]
1906

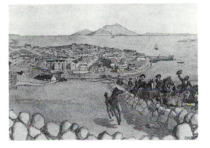

Sgd. bottom right
Watercolour, 26 x 35
Exh. 1908 London (14)
Coll. Sold to John Masefield at the exhibition; Christie's (London) sale, 19 July 1968, lot 45, as *Returning from the Fair;* Victor Waddington, London

A group of local people riding away from Belmullet, in North Mayo, wave to a foal galloping alongside them in a field.

586 Lough Gill, Sligo* c.1906

Sgd. bottom right,
Watercolour, 9 x 13
Coll. Dr. and Mrs. Theodore J. Edlich, Jr., New York

A sketch, taken from one of the sketchbooks, of cows grazing by water.

587 Untitled: Knocknarea* c.1906

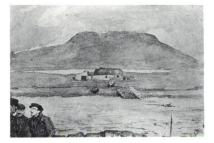

Monogram bottom right added at a later date
Watercolour, 18.5 x 26
Coll. Victor Waddington, London; Dan McInerney, Dublin; Christie's (Dublin) sale, Carrickmines House 10 Feb. 1986, lot 340 (repro); Hamilton & Hamilton (Dublin); Jack Murphy, London

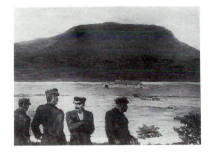

A composition very similar to that of the oil *Knocknarea and the Flowing Tide* (1921). Three men stand by a wall near Rosses Point. Beyond is the small promontory, Horse Island. Knocknarea is on the far side of the narrow sea inlet.

588 Lough Gill, Sligo* 1906

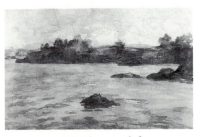

Sgd. monogram 1906 bottom left
Watercolour, 25 x 36

Exh. 1961 London (58)(repro); 1964 Derry/
 Belfast (41); 1986 Dublin (9)(col. repro)
Coll. Victor Waddington, London; purchased by
 the National Gallery of Ireland in December
 1967 (6321)
Lit. Pyle (1970, 1989) 106; *NGI* (1986) 18–9
 (repro)

Lough Gill lies south-east of Sligo, surrounded by woods, and covered with islands. Jack Yeats was in Sligo in the summer and early autumn of 1906, and perhaps made this watercolour on the spot, as he was beginning to do now, working on a drawing block. It is a realistic representation of part of the lake on a typical Irish day. The water reflects the breeze in its dark ruffles. The foliage of the trees on the islands is broadly sketched with wet paint, while the near rocks are worked more firmly. The general tone is neutral and harmonious, in blue, green and brown.

589 The Deadman's Point 1906

Exh. 1906 Dublin (22); 1908 London (22)
Lit. Yeats, W. B., *Reveries over Childhood &
 Youth* (1916) ix

The Deadman's Point is the tip of the peninsula of Rosses Point, County Sligo, so called because according to local tradition (W. B. Yeats, op. cit.), a sailor who died was buried in a hurry so that the ship would not miss the tide. Jack Yeats made a drawing for *A Broadsheet* (August 1903) with the same title, showing a group of sailors carrying coffin and spade to the Point.

590 Market Day [Fair Day] 1906

Sgd. bottom right
 Watercolour, 25.5 x 35.5
Exh. 1906 Dublin (7); 1908 London (15); 1910
 Cork; 1910 *New York*; 1912 *White City*; 1945
 Dublin National Loan (176); 1960 Sligo (4);
 1961 Sligo (50)(repro); 1963 Sligo (4);
 1971–2 Sligo Dublin (21); 1989 Sligo (20)
Coll. Given by the artist to the Irish Red Cross
 Sale in 1944; bought by Father Senan OFM,
 Cap., for the *Capuchin Annual*; lent by the
 Capuchin Annual to Sligo Museum 1960;
 bought through public subscription in
 September 1962 for Sligo County Library
 and Museum (SC17)

This watercolour is sketched in a letter from the artist to William Macbeth, 22 September, 1910 (Macbeth Archives), and entitled *Fair Day*. Elsewhere in his records he calls it *Market Day*, or *Woman with Cake Cart*. A woman wearing a broad brimmed hat that shadows her face sits at a canopied stall. The stall is arrayed with a galaxy of objects — apples, pipes, jars of sweets, books, including a *Book of Fate* and *The Linnet Song Book*. In the sunlit street beyond her, men gallop by on horses. The woman and her stall are subdued by a blue wash and low toned colour. The street beyond is mainly yellow and pink, dashed with the same blue. The effect is a contrast in stillness and movement, which Yeats developed in an archetypal way in his oil of 1918, *The Cake Cart at the Races* (see above).

591 A Pony Fair 1906

Exh. 1906 Dublin (38)

592 The Ass Catcher 1906

Exh. 1906 Dublin (4)

593 The Sea Captain 1906

Sgd. bottom right
 Watercolour on card, 11 x 9
Exh. 1906 Dublin (12); *1906 London*
Coll. Sold at the London exhibition to a private
 collector; Serge Philipson, Dublin; private
 collection

A redbearded captain looking out to sea, with a background of sea shore, sailing vessel, blue green water, and scattered islands painted in an earth colour.

594 The Long Car Driver 1906

Exh. 1906 Dublin (31)
Coll. Sold to Mrs. Meeking at the exhibition

Lit. Praeger, R. L., *The Way that I Went* (1937) 20–1; *NGI* (1986) 68

The long car, or Bianconi car, as it was called after its inventor, Charles Bianconi, was a larger version of the outside car used widely throughout western Ireland in the latter half of the last century for public travel. Yeats painted it in many pictures, the most important being *In Memory of Boucicault and Bianconi* (National Gallery of Ireland 4206).

595 The Coroner's Inquest 1906

Exh. 1906 Dublin (16)
Coll. Sold to Lady Aberdeen at the exhibition

596 The Judge's Stand 1906

Exh. 1906 Dublin (6); 1906 *London*
Coll. Sold in London in December 1906 to a private collector

597 The Pannier Market 1906

Exh. 1906 Dublin (1); 1906 *London*
Coll. Sold in London in December 1906 to a private collector

598 The Landing Stage 1906

Exh. 1906 Dublin (8); 1908 London (16)

599 The Ganger 1906

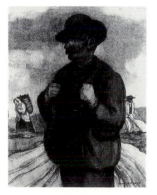

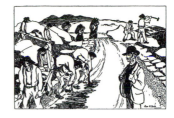

Sgd. bottom right
Watercolour, 37 x 26.5
Exh. 1906 Dublin (5); 1908 London (13); 1908 *Newbury*; 1910 *Dublin*; 1961 Dublin (17); 1971 *Cork* (134)
Coll. Gerald Y. Goldberg, Cork
Lit. Yeats, Jack B., *Life in the West of Ireland* (1912, 1915) 81; Synge, J. M., *Collected Works* II (1966) 296–8 (see above)

A study of a foreman in charge of the relief works mending the road at Gorumna in Connemara. The watercolour is based on the drawing Yeats provided for Synge's article published in the *Manchester Guardian* (17 June 1905). See also *sketchbook 99*.

600 Bonfire Night [St. John's Eve (Belmullet)]
 1906

Sgd. bottom right
Watercolour, 23.4 x 30
Exh. 1906 Dublin (18); 1908 London (21); 1908 *Newbury*
Coll. Sold to John Burke, U.S.A., in 1947; James Adam (Dublin) sale, 15 Mar. 1984, lot 119 (repro)
Lit. Synge, J. M., *Collected Works* II (1966) 327

The scene described by Synge in his article on Erris for the *Manchester Guardian*, in 1905. He and Yeats reached Belmullet on St. John's Eve, and were witnesses to the excitement of bonfire night. Small boys build up a pyramid of planks, wooden boxes, and broken furniture in the town square, with its mountainous background. Another group appear at the other end of the street.

601 The Big Ball Alley 1906

[image of The Big Ball Alley]

Sgd. bottom left
Watercolour, 26.5 x 36
Exh. 1906 Dublin; 1908 London (20); 1908
Newbury; 1962 Dublin (48); 1964
Derry/Belfast (39)
Coll. Dr. Karl Mullen, Dublin; private collection
Lit. Yeats, Jack B., *Life in the West of Ireland* (1912,
1915) 87; Pyle, H., *Images in Yeats* (1990) 35

Four boys, two in striped jerseys, have a game
in a ball alley, built at the side of the stream
which runs in the foreground. They are
watched by other boys, with a background of
fields, stone walls and a wood. It is a study in
movement and light and open space, with a
striking blue shadow thrown from the right
of the ball alley on to the golden beige of the
back wall and the ground. Yeats made a
sketch for this when he was in Swinford, in
County Mayo, with Synge in 1905 (*sketch-
book 102*): and used the same colours of pale
blue grey with yellow twenty years later in
his oil, *The Ball Alley* (1927; Hugh Lane
Municipal Gallery of Modern Art 1337), to
create a surreal atmosphere.

602 Singing 'Since the Year '47
He lies in Glasnevin' 1906

Exh. 1906 Dublin; *1906 London*
Coll. Sold at the London exhibition to a private
collector

A ballad singer in the rain (*Irish Times*, 2
October 1906), singing a street ballad about
Daniel O'Connell (1775–1847), the Irish poli-
tical leader known as the Great Liberator.

603 The Street Juggler [Juggler Act] 1906

Sgd. bottom left
Watercolour, 44 x 25
Exh. 1961 Dublin (33); 1964 Derry/Belfast (45)
Coll. Dawson Gallery, Dublin; Michael O'Flaherty

603 604

604 Bacchus 1906

Sgd. bottom right
Watercolour and pencil, 29.5 x 23
Exh. 1906 Dublin (3); 1906 *London*; 1968
London d'Offay Cooper *Fifty Drawings* (50)
Coll. Sold in London in December 1906 to a private
collector; d'Offay Cooper, London, 1968;
Christie's (London) 13, 14 Nov. 1986, lot
362; James Adam (Dublin); private collector

A dazed young man raises his eyes and a pint of
porter to the sky in a toast to the god, while his
companion behind him in the 'whiskey tent'
(or perhaps a covered waggon) smiles in stupe-
fied approval. The background is of hills and
stone walls. Yeats treats the figure in his own
gentle satirical way. See also *194, 605*.

605 In a Tent 1906

Exh. 1906 Dublin (24); 1906 London
Coll. Sold in London in December 1906 to a
private collector

Described in a contemporary review as the
interior of a whiskey tent — 'two individuals
in a confab, and the most notable features
about them are their long straight noses.'

606 English Beer 1906

Exh. 1906 Dublin (35); 1908 London (42)

607 The Little Book 1906

Exh. 1906 *Dublin*; 1906 Dublin (13)

608 The Pony Bather 1906

Exh. 1906 Dublin (14); 1908 London (18)

609 Proud of his Charge* 1906

Sgd. bottom right
Watercolour 10 x 16
Exh. 1961 Dublin (38)
Coll. Privately owned

A small boy in blue is perched on the back of a
chestnut mount wading through blue water,
with a stretch of mauve hills beyond. The image
is strong, with an impressive sense of space and
distance. This may be *608*.

610 The Toy Theatre 1906

Sgd. bottom right
Watercolour, 37 x 26
Exh. 1906 Dublin (11); 1908 London (17); 1962
Dublin (64); 1964 Derry/Belfast (48);
1971–2 Sligo, Dublin (22); 1989 Sligo (19)

A boy in Victorian costume stands on a footstool playing with a toy theatre on a table. Through the window is a view of a house, of sea and the mast of a ship. This may be a memory of childhood; but is also a reference to the Pollock juvenile stage and drama which Yeats himself adapted at Cashlauna Shelmiddy, and with which he entertained the local children. Yeats wrote several miniature plays for his toy theatre between 1900 and 1906, which he performed each Christmas for the children. Three of his miniature dramas, *James Flaunty*, *The Scourge of the Gulph*, and *The Treasure of the Garden*, were published in 1901 and 1903 by Elkin Mathews, London.

611 Turnip Lantern-Time 1906

Exh. 1906 Dublin (23); 1908 London (23)

612 Youth 1906

Exh. 1906 Dublin (2); 1910 *Dublin*

613 Rain 1906

Exh. 1906 Dublin (29); 1906 *London*

614 The Scratch Man 1906

Exh. 1906 *Dublin*; 1906 Dublin (15); 1908 London (19)

615 A Flapper Meeting* 1906

Sgd. top left
Pencil and watercolour, 8.5 x 11
Exh. 1961 London (54)(repro)
Coll. Victor Waddington, London; Mabel Waddington

A lively drawing, taken from a sketchbook, of a jockey and horse pursuing another mounted figure through rough country.

616 The Barrel Man (No. 1) 1906

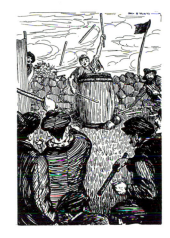

Sgd. bottom left
Watercolour and gouache, 25.5 x 35.6
Exh. 1906 Dublin (9); 1906 *London*
Coll. Sold in London in December 1906 to a private collector; Mrs. B. Doncaster, Isle of Wight; Christie's (Scotland) sale, Belfast Castle, 18 Oct. 1988, lot 330 (col. repro); private collection
Lit. Yeats, Jack B., *Life in the West of Ireland* (1912) 61

The man in the barrel, set against a wall, holds up a baton to defend himself from the wooden batons flying about his head. He, and the farmer who collects the batons, and two farmers with wide brimmed hats who watch in a relaxed way from the left, are rendered in soft dun colours, in contrast with the rich green grass, and the red wheel of the farmer's cart. Even the sky is pale. This is the first of several studies of the barrel man, one of the side shows at the fairs and strand races, of which the better known examples are *The Barrel Man* (the vivid

black-and-white drawing in *Life in the West of Ireland)*, and *Humanity's Alibi*, the oil painting of 1947 where the subject has reached metaphorical proportions.

617 Carnival 1906

Exh. 1906 Dublin (39); 1908 London (41)

618 The [A] Travelling Circus 1906

Sgd. bottom right
Watercolour, 26 x 35.5
Exh. 1906 Dublin (21); 1945 Dublin National Loan (175); 1965 Waterford (1); 1972 *Lund* (42); 1988 Dublin (24)
Coll. Sold at the exhibition in 1906 to Miss J. Webb; bequeathed by Miss Webb to the Dublin Municipal Galley in Harcourt Street; Hugh Lane Municipal Gallery of Modern Art, Dublin (599)

One of many circus scenes depicted by the artist, a scene of activity in a field dominated by the Big Top. Yeats observes the spectators who have gathered to have a look, as well the individual characters of the troupe.

619 A Circus Clown 1906

Exh. 1906 Dublin (10); 1906 *London*
Coll. Sold in London in December 1906 to a private collector

620 A Mother's Pride 1906

Sgd. bottom right
Watercolour, 15.5 x 10.5
Exh. 1906 Dublin (37); 1908 London (45); 1961 London (49)(repro) as *Mother*
Coll. Mr. and Mrs. F. Hess, London

This watercolour has more recently been known as *Mother*. It is a music hall turn, where a comedian, dressed as a dumpy lady, with hat, shawl and umbrella, walks on stage arm-in-arm with a haughty harlequin. The pair are treated with humour and delicacy. The green check of the harlequin's suit is echoed in the pale green ground, and in the green openings in the deep cobalt of the dark house behind the entertaining figures.

621 At Buffalo Bill's 1906

Exh. 1906 Dublin (42); 1908 London (44)

622 A Mounted Pirate 1906

Sgd. bottom left
Pencil, chalk and wash on brown paper, (22 x 18)
Exh. 1906 Dublin (36); 1908 London (40); 1939 *Dublin*; 1971–2 Sligo, Dublin (20)
Coll. Given by the artist to the Refugee Artists' Fund Exhibition, Dublin, in February 1939; bought by J. Starkey; Mrs. J. Starkey; Miss K. Goodfellow, lent indefinitely to Sligo County Library and Museum, 1971

A sketch of a purposeful pirate on a white horse which rears up over a flowing sea of grass. Most of the work is done in strong pencil, with a tinting of wash and chalk.

623 Theodore* *c.*1906

Sgd. bottom right
Insc. And who do you think was on that ship
was on that ship
was on that ship
Our old friend Theo the silly young rip
On Christmas day in the morning.
 J.M.
To wish you a very happy Christmas
Pen, indian ink and watercolour on paper d'oily, 18.5 diam.
Coll. W. T. H. Howe, purchased September 1940 by the New York Public Library Berg Collection
Lit. Pyle, H. (1970, 1989) 77–8

One of the many sketches of Masefield's and Yeats's invention, the pirate Theodore, see *573*. His mistress, Constanza, is depicted on the foredeck, with a bird perched on her wrist,

while Theodore steals out of the cabin below her.

624 A Warning Against Book Borrowers
1906–7

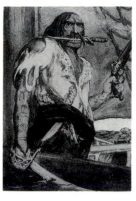

Sgd. lower right
Watercolour, 26 x 18
Coll. Sold by the artist to John Quinn March 1907; listed in the Quinn Inventory, 1924; American Art Galleries (New York) sale of John Quinn collection, 11 Feb. 1927, lot 417; Parke-Bernet (New York) sale of books 1965, bought by William Young; Sotheby's (London) sale, 13 Dec. 1967, lot 40, bought by Spink; Spink (London) sale of English watercolours, May 1968; private collection

Quinn must have commissioned the watercolour from Yeats in the summer of 1906. Yeats wrote to him on 7 September from the Quay House Hotel, Clifden, to say, 'I will do you the little picture of the buccaneer guardian of your books. I'll try and make him look as if he was gnashing his eyeballs till they smoked. I'll try and make his aspect good enough to make not only borrowers of books cease from borrowing, but old borrowers return conscience books . . .' The portrait of the ferocious pirate, armed to the teeth with weapons of every description, was sent by post to Quinn on 12 March 1907 (correspondence in New York Public Library. Manuscript Collection).

625 The Gaffer*
*c.*1907
Stamped with monogram in 1967 bottom left
Watercolour, 35.5 x 25.5
Exh. 1967 London (72)(repro)
Coll. Erich Sommer, England

A successful proprietor stands in front of his melodrama theatre, which has advertisements

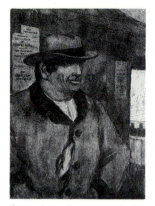

for various dramas, including *The Shaughraun* (by Boucicault) and *The Corsican Brothers*, pasted behind his head. It is a strong charcterful portrait, half length, occupying the greater portion of the picture space. Yeats attended many performances of melodrama in London, Liverpool and Dublin during his youth, and melodrama plays an important part in his paintings and writings.

626 Two Sketches of Pegeen Mike in 'The Playboy'
1907
Coll. Sold by the artist to a private collector in 1931
Lit. Pyle, H. (1970, 1989) 93–4

Yeats was not at the opening performance of J. M. Synge's controversial play, *The Playboy of the Western World*, at the Abbey Theatre, Dublin, on 26 January 1907, though he had advised Synge about the jockey costume for Christy. These are probably sketches from the London production in June, see *sketchbook 123*.

627 A Stoker*
*c.*1907

Coll. J. M. Synge, December 1907
Lit. *The Collected Letters of John Millington Synge* II, ed. A. Saddlemyer (1984) 93

On 1 December 1907, Synge wrote to Molly Allgood from Glendalough House, 'Did I tell

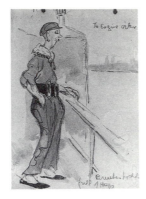

you I have got Jack Yeats' sketch of the stoker
framed?' The sketch he mentions, as yet
unidentified, is likely to have been one of
Yeats's drawings made on his journey down the
Rhine during the summer, when he studied
steamboats, barges and their crews, one sketch
being of the 'engine oiler' (*sketchbooks 127* —
see ills. above—and *128*). No pictures by Jack
Yeats were found among Synge's possessions
when he died (op.cit. I, 334, fn.2).

628 The Lake at Coole* *c.*1907

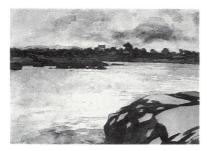

Sgd. bottom right
 Watercolour, 24.5 x 35
Exh. 1962 *London* (13); 1967 London (76)(repro)
Coll. Victor Waddington, London; Clarges
 Gallery, London; private collection

A view of the lake under a blowy sky, focussing
on the far bank with hedges and house; the
view taken from beside a massive rock in the
right foreground. The view may have been
worked on the spot (see *588*) when the artist
visited Coole in the summer of 1907 (*sketch-
book 124*) on his way to Clifden. Yeats was in
pursuit of reality in the watercolour landscapes
of this period, so there is a certain harshness
and solidity, in contrast with the earlier effects
of medium and colour which are so attractive
in themselves: but his handling of atmosphere
is masterly.

629 Aran Island, Galway Bay *c.*1907

Exh. 1908 London (34)
Coll. Sold to Mrs. Bernard Shaw at the exhibition

Yeats was in Galway at Coole in the summer of
1907, before going to Clifden to paint land-
scape: and this view was presumably taken
from the coast on his way north to Clifden.

630 Untitled: Lough Gill* *c.*1908

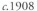

Watercolour, 24.5 x 33
Coll. The artist's estate; Victor Waddington,
 London

A view of one of the islands taken from a rocky
foreground. The colouring is similar to that in
628. Yeats stayed with his friend, the Rev. T.
A. Harvey, Rector of Lissadell, in Sligo in 1908
(see also *sketchbook 106*), and probably painted
it then.

631 Donegal 1908

Exh. 1908 London (35); 1909 Dublin (12)
Coll. Sold to J. Geoghegan at the Dublin exhibition

632 Untitled: Interior* *c.*1908

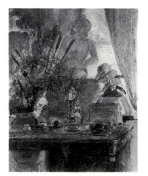

Sgd. monogram bottom right
 Watercolour, 35 x 25

Exh. 1961 London (59)(repro)
Coll. The artist's estate; Victor Waddington, London; private collection, London

From time to time, Jack B. Yeats made studies of rooms, see *140*; and in the nineteen thirties painted some important interiors in oil, as well as a series of still lifes of a rose in a room. This corner of a room beside a window with candlestick, and ornaments crowded casually on a table in the foreground, is interesting in part for the plaster nude against the window behind them. Yeats rarely painted the nude: but a female nude appears in some fantasies, again painted in the nineteen thirties.

633 Catching a Runaway in the Town 1908

Exh. 1908 London (5)
Coll. Sold to Mrs. Meeking at the exhibition

634 Coming from the Fair (and a Very Good Fair it was too) 1908

Sgd. bottom left
Insc. on verso: (and a very good fair it was too) Watercolour, 9 x 8
Exh. 1908 London (3); 1909 Dublin (3); *1911 Dublin*
Coll. Given to Victor Waddington by the artist, March 1945; Mabel Waddington, London

A sketch of two men, it was originally exhibited as *Leaving the Fair Town*, before the artist gave it its present title.

635 The Pig Buyer Returns from the Fair 1908

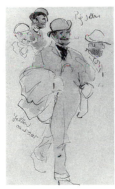

Sgd. bottom right
Watercolour, 38 x 30.5
Exh. 1908 London (8); 1909 Dublin (7); 1945 Dublin National Loan (178); *1948 Tuam (32)*
Coll. Sold at the exhibition in 1909 to Norreys Connell; Patrick O'Leary; *Capuchin Annual*; J. McCourt, Dublin

Lit. *Sinn Féin* (29 May 1909)1; *Sunday Independent* (3 June 1945)(repro)

One of Yeats's studies in character. A prosperous local pig dealer, marching into a pub with his bowler hat cocked at an angle, is eyed with cautious respect by the capped countrymen making way for him at each side. Yeats first sketched the pig jobbers ten years before (*sketchbook 9*).

636 A Wintry Morning [A Frosty Morning] 1908

Exh. 1908 London (4); 1909 Dublin (4); *1910 New York*
Coll. Sold through L. Smith, 1946, to a private collector

A sketch of this in a letter from the artist to W. Macbeth, 22 September 1910, shows a horse and hay cart, with a man perched on top (Archives of American Art).

637 The Rake 1908

Sgd. top left (in ink) and bottom right
Watercolour, 37 x 26.5
Exh. 1908 London (6); 1909 Dublin (5); 1965 Waterford (2)
Coll. Given by the artist to the Rev. T. A. Harvey in 1909; private collection, Waterford

A man walking across one of the Sligo bridges, his head looking down at an angle, with a gay and curious smile, his feet twisting as if about to step dance. The general effect is pinky orange, with black outlining softened into the rich paint, and black shading, cf. *328*. This watercolour has also been known as *Sligo Bridge*.

638 A Mariner 1908

Exh. 1908 London (37); 1909 Dublin (14); 1910 *New York;* 1934 *London*
Coll. Given by the artist to Christie's Tribute to Greece Sale, April 1944

This is sketched in a letter from Yeats to W. Macbeth, 22 September 1910, a three-quarter length portrait of a seaman (Archives of American Art).

639 The Widow Woman 1908

Sgd. top left
Watercolour, 26 x 35.5
Exh. 1908 London (7); 1909 Dublin (6); 1910 *Cork;* 1910 *New York;* 1912 *White City*
Coll. Victor Waddington, London; Franz Winkler, New York

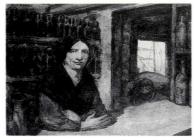

The widow woman sits behind the counter in her shop, 'ready to hand out porter and gossip and pieces of her mind, and to take in the filling of the till' (*Sinn Féin*, 5 May 1909). Through the door beside her is a view of headlands and sea, and the mast of a boat. Yeats sketched this in a letter to W. Macbeth, 22 September 1910 (Archives of American Art).

640 The Card Players 1908

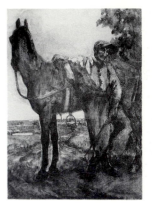

Sgd. bottom right
Watercolour and pencil, 35 x 25.5
Exh. 1908 London (10); 1909 Dublin (9)
Coll. Sold to Mrs. Sophie Stewart at the Dublin exhibition; Serge Philipson; private collection

Four card players around a table in a street.

641 Tinkers 1908

Exh. 1908 London (2); 1909 Dublin
Coll. Sold to Madame Gonne MacBride in 1909

642 A Soft Day 1908

Sgd. bottom left
Watercolour, 43.5 x 31
Exh. 1908 London (9); 1909 Dublin (8); 1909 *Dublin;* 1910 *Cork;* 1910 *Belfast:* 1911 *Paris*
Coll. Private collection; Sotheby's sale, 1 Dec. 1954, lot 99, as *A Jockey Standing by his Mount*, bought by Belfast Museum and Art Gallery, now the Ulster Museum
Lit. *Sinn Féin* (5 June 1909) 1

A jockey, disconsolate, looks down at the ground as he leans against his horse, which waits patiently in the rain. There is a low landscape behind. The colours are brown madder and blue, worked with other touches of colour to give a solid effect.

643 The Racing Donkey 1908

Sgd. bottom right
Watercolour on board, 27 x 36
Exh. 1908 London (11); 1909 Dublin (10)
Coll. Sold to J. Geoghegan at the exhibition in 1909; Mrs. Rachel Parker, bequeathed to Margaret Griffith, Dublin, 1969

A sailor with a red beard instructs a boy on a donkey about to take part in a race.

644 The Lady of the Circus 1908

Exh. 1908 London (12); 1908 *Newbury;* 1909 Dublin (11); 1909 *London;* 1910 *Santiago*
Coll. Sold to a private collector, perhaps in Santiago

Described in the *Court Circular* (February 1908) as 'a woman in a red coat driving on the high seat of a brake filled with a band of musicians, whose heads show low down at the bottom of the picture, on the level of her gloved hands, which hold the reins. The red coat against a sunny sky is very broadly and simply painted.'

645 The Circus Clown 1908

Sgd. bottom right
Watercolour, 35.5 x 25.5
Exh. 1908 London (1); 1909 Dublin (1); 1961 London (7)(repro)
Coll. Dr. Pomeraniac, London
Lit. *Sinn Féin* (15 May 1909) 1; *Art Journal* (April 1908)124;.*Illustrated London News* (8 April 1961) 593

A clown wearing a long check coat over his

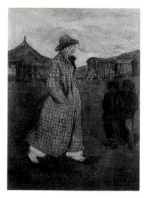

costume walks swiftly through the fair ground under a sky with mauvish clouds, his painted face strangely sad under his old brown hat. Two boys watch him. Tones are mellow, merged into each other.

646 Buckalawns 1908

Exh. 1908 London (36); 1909 Dublin (13)

647 Portrait Sketch of Robert Gregory* 1908

Sgd. monogram bottom right
Insc. Robert Gregory 1908
 Pencil, 9 x 13
Exh. *1967 Dublin (7a)*
Coll. Private collection, Dublin

Half length, seated reading. Robert Gregory (1881–1918), the only son of Lady Gregory, trained as a painter, and designed on occasion for the Abbey Theatre. This drawing may have been made at the Abbey, where Yeats was sketching in October 1908 (*sketchbooks 140–1*).

648–50 Three Sketches of 'The Suburban Groove' 1908

Pencil and watercolour, on pages removed from a Rowney Ringback sketchbook, *648–9*: 13 x 9, *650*: 9 x 13
Coll. New York Public Library Berg Collection
 648 The Suburban Groove at the Abbey
 Theatre (inscribed with title)
 The Piper at the Abbey Theatre (verso,
 inscribed with title)
 649 The Suburban Groove (inscribed with
 title)
 650 Melodramatic scene at the Abbey [? *The
 Spreading of the News*]

The sketches are pasted into Lady Gregory's copy of *Samhain* for November 1908. In a copy of *Samhain* (November 1905), also in the NYPL Berg Collection, there are sketches of *Spreading the News*, Lady Gregory's own

play, drawn and coloured straight on to the pages of the magazine. In a letter to Lady Gregory, pasted into the November 1908 *Samhain*, Yeats explains both sets of sketches: 'I have done 3 little drawings of "Spreading the News" in Samhain. I have done them from memory for I found when I looked through my books that I have hardly sketched at all at the Abbey Theatre—I think it is because the auditorium is generally dark.

'But I send three of the little sketches which I found. You might like to paste them in another Samhain.'

The Suburban Groove, by W. F. Casey, was first produced at the Abbey Theatre on 1 October, 1908, and the sketches for it (see also *sketchbook 140*) date from the first production. The sketches from memory may have been done in 1909, when the letter was written.

651 Ballycastle Bay, Mayo. S. S. Tartar 1909

Watercolour, 25 x 34
Coll. Victor Waddington, London

A pale green blue sea, with the ship in the right middle distance. The headland is to the left, beneath a colourless sky. Yeats stayed at Ballycastle in County Mayo in 1909, painting several oils, as well as sketching and painting in watercolour. He was impressed by the distinctive shape of Downpatrick Head. He sketched the Tartar many times (*sketchbooks 147* and *148*), and its crew.

652 Downpatrick Head (Ballycastle, Co. Mayo) 1909

Sgd. bottom left,
 Watercolour, 35 x 25
Exh. 1910 Dublin (19); 1912 London (24)
Coll. Sold to John Burke 1945; Alexis Fitzgerald,
 Dublin; private collection

Lit. Yeats, Jack B., *Life in the West of Ireland* (1912, 1915) 103

A horseman under the stone arch, through which may be seen the headland, beyond the stone wall and stunted tree. The sky is pallid, as it tends to be in the oils too of this period; yet the watercolour is full of movement, soft clear colour and light.

652a Near Ballycastle* *c.*1909

Stamped with monogram bottom right
Watercolour, 24 x 32

Coll. Waddington Galleries, London
Yeats's interest in rocks is evident too in his oils of the same date. See *651.*

652b Near Ballycastle, County Mayo* *c.*1909

Stamped with monogram bottom right
Watercolour and gouache, 23 x 33
Coll. Waddington Galleries, London

See *651.*

653 Sketch: 'Daisy Fields', Ballycastle* 1909

Pencil and watercolour, 12 x 9
Coll. Dr. Thomas MacGreevy; John Cullen; C. P. Hyland, 1983
Lit. Hyland, C. P., *Catalogue of books of Irish interest* 155, January 1983, lot 891

A sketch from a Ballycastle sketchbook of 1909, noted by Cal Hyland as 'Sketch by Jack B. Yeats 12 x 9 cm. from a notebook and 4pp. ALS from Tom McGreevy, presenting it to a mutual friend of his and Yeats, John Cullen, 2 pages of which discuss this sketch. McGreevy reads the title as 'Daisy Fields' from a 1909 book, & in the context of other sketches taken around Ballycastle (Co. Mayo).'

654 The Avenue 1909

Exh. 1909 Dublin (40)

One of eight leaves from a sketchbook.

655 Sea Fog Rolling In 1909

Exh. 1909 Dublin (42)

One of eight leaves from a sketchbook. See *666.*

656 Donkeys at Kilronan

Exh. 1909 Dublin (41)

One of eight leaves from a sketchbook.

657 The Crew of the Ketch 1909

Exh. 1909 Dublin (37)
Coll. Given by the artist to J. P. Rooney (*Irish Times*) as a prize for a golf tournament in connection with the Institute of Journalism in May 1931

One of eight leaves from a sketchbook.

658 The 'Lamb' of Aran 1909

Exh. 1909 Dublin (38)
Coll. Given by the artist to Miss S. Allgood

One of eight leaves from a sketchbook.

659 The Jockey 1909

Exh. 1909 Dublin (35)

One of eight leaves from a sketchbook.

660 Market Day 1909

Exh. 1909 Dublin (39)

One of eight leaves from a sketchbook.

661 A Windy Fair 1909

Exh. 1909 Dublin (36)

One of eight leaves from a sketchbook.

662 On the Road to the Fair *c.*1909

Sgd. bottom right
Watercolour, 36 x 26
Exh. 1965 Massachussets (3)
Coll. Given by the artist to Pádraic Colum as a wedding present
Lit. Yeats, Jack B., *Life in the West of Ireland* (1912, 1915) 101

A redbearded farmer, wearing a blue suit, gallops on his chestnut horse brandishing a stick, silhouetted against a pale sky, low hills, and a winding road. A strong vigorous image, rendered in fine firm brushwork.

663 Racing Cars 1909

Exh. 1909 Dublin (18)
Coll. Sold at the exhibition to a private collector

'Race of people home from some kind of gathering, trying their horses against each other. A woman on one of the cars' (*Sinn Féin*, 15 May 1909).

664 The Owner of the Turf Boat 1909

Exh. 1909 Dublin (29); *1909 Dublin*; *1910 Belfast*; 1912 London (29)

665 Sea Weed 1909

Sgd. bottom left
Watercolour and gouache, 23 x 33
Exh. 1909 Dublin (24)
Coll. Sold to Isaac B. Yeats at the exhibition; bequeathed to his niece, Mrs. Jamieson; James Adam (Dublin) sale, 16 July 1968, lot 259; private collection

666 Sea Fog 1909

Sgd. lower right
Watercolour, 36 x 26
Exh. 1909 Dublin (22)
Coll. Sold to John Quinn in 1909 (perhaps *The Captain Ashore* in the Quinn inventory, 1924); American Art Galleries (New York) sale of John Quinn collection, 10 Feb. 1927, lot 305; bought by J. Toner

Described in the American Art Galleries catalogue as the 'figure of an old seafaring man, wearing a pea-jacket and muffler, sauntering from the quay, enveloped in a dull mist through which the masts of a brig faintly gleam in the background.' See *655*.

667 A Courtier [The Sycophant] 1909

Sgd. bottom left
Watercolour, 35 x 25
Exh. 1909 Dublin (23); 1909 *Dublin*; 1912 London (32); 1965 Massachussetts (1); 1980 Birmingham (Alabama)(9)
Coll. Sold through Victor Waddington Galleries, August 1950, to H. L. Shattuck, Boston; Museum of Fine Arts, Boston

'The figure of an old man bowing and scraping to some unknown personage on the road' (*Daily Express*, 11 May 1909). Yeats developed the notion of the sycophant, called *A Courtier* when it was originally exhibited, from a sketch (*The Sycophant*) made in 1908 at Strete, of a huntsman and a beggar (*sketchbook 137*). Here the foolish old figure appears on his own, walking on a road past the railings of an estate. He throws a blue shadow on the purpley grey road. Colours are mainly light beige and blue, with a touch of red in the row of trees behind the whitehaired man.

668 A Witness [Decision] 1909

Sgd. bottom right
Watercolour, 25 x 35
Exh. 1909 Dublin (31); 1909 *Dublin*; 1912 London (33)
Lit. Yeats, Jack B., *Life in the West of Ireland* (1912, 1915) 83 (repro)

669 The Second Hand Clothes Dealer 1909

Sgd. bottom right
Pencil and watercolour, 37 x 24.5
Exh. 1909 Dublin (20)

670 The [A] Raw Team 1909

Exh. 1909 Dublin (25); 1909 *Dublin;* 1910 *Cork;*
1910 *Belfast;* 1912 London (30)
Coll. Sold to Miss Kinnear

Described by a contemporary reviewer as 'three
fresh horses of a Bianconi car'.

671 Philosophers 1909

Exh. 1909 Dublin (19); *1909 Dublin*

'The car has broken down on the lonely west-
ern road. The horse is philosophically helping
himself to the scanty herbage on the wayside.
The driver is on the seat, which is tilted to an
angle of forty-five, more or less, and, with one
leg crossed over the other, is smoking in fath-
omless contentment of mind' (*Sinn Féin*, 29
May 1909).

672 A Fair Wind 1909

Sgd. bottom right
Watercolour, 24 x 34
Exh. 1909 Dublin (30); 1945 Dublin National
Loan (177)
Coll. Sold to George Russell at 1909 exhibition; C.
P. Curran, Dublin; Dawson Gallery, Dublin;
Nesbit Waddington, Drogheda; private
collection
Lit. *Irish Review* (Sept. 1911)(repro frontis. opp.
p. 337 as *Romance*)

Mainly blues, with beige. A boy wearing a wide
brimmed hat sits reading in a boat, with the
oars loose, on a quiet water. He reads *The
Buccaneer Chief,* which has a pirate on the
cover. Yeats did several oil paintings of readers,
the best known being *Dumas* (1942).

673 One of the Boys 1909

Sgd. bottom right
Pencil and watercolour, 24.5 x 16
Exh. 1909 Dublin (44)

674 Bird Singing Contest 1909

Exh. 1909 Dublin (45)

675 Trotting in the Rain 1909

Exh. 1909 Dublin (46)

676 Remounted 1909

Sgd. bottom right
Inscribed on verso with title and instructions
for framing in a brown Irish mount and an
antique Irish frame
Watercolour, 18 x 25.5
Exh. 1909 Dublin (28); 1910 *Belfast;* 1911
Oireachtas; 1912 London (31)
Coll. Sold by the artist to W. T. H. Howe in
1935; bought in September 1940 by the
New York Public Library Berg Collection
Lit. *New Age* (21 July 1910): 'Remounted: a
poem suggested by a drawing by Mr. Jack B.
Yeats' by Norreys Connell

A blue jacketed jockey on a green mottled
horse (which is only partly visible) sways in
the saddle, watched anxiously from the left of
the drawing. In the background is a glimpse
of a field, jockeys racing, and sea. The heads
of the jockey and his horse are silhouetted
against a stormy sky.

677 Regatta [Regatta in the Rain] 1909

Sgd. bottom right
Watercolour, 23 x 23
Exh. 1909 Dublin (34); 1909 *London;* 1910
Santiago; 1912 London (35); 1914 Dublin
(29); 1961 London (3)(repro)
Coll. Sold by the artist to Victor Waddington
Galleries, October 1956; private collection,
New York
Lit. *Illustrated London News* (8 April 1961) 593;
Dublin Evening Mail (6 April 1961)

Regatta in the Rain, was exhibited in 1961 as a

painting of 1891. Since stylistically it belongs to a much later date, it is must be *Regatta*, described in *Sinn Féin* (15 May 1909) as 'some boats ploughing through a deluge of rain'. See also *Regatta* in *Life in the West of Ireland* (1912, 1915) 39.

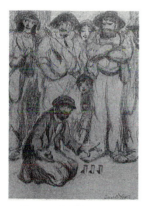

678 A Game of Skill ?1909

Sgd. bottom right
Pencil and wash, 20 x 14
Exh. 1909 Dublin (15)
Coll. Mr. and Mrs. H. Abrahams, London

This may be the work first exhibited in 1899, see *191a*.

679 Washing the Circus Horses 1909

Sgd. lower right
Crayon and watercolour, 25.5 x 35.5
Exh. 1909 Dublin (26)
Coll. Sold to John Quinn at the exhibition in 1909; American Art Galleries (New York) sale of John Quinn collection, 10 Feb. 1927, lot 170; bought by Mrs. D. J. O'Brien

'Scene in the West of Ireland, vigorously drawn in crayon, portraying an ostler mounted on a gray horse and leading others through a picturesque village to the water' (American Art Galleries catalogue).

680 The Old Ring Master 1909

Sgd. bottom right
Watercolour, 25.5 x 17.5
Exh. 1909 Dublin (16): 1939 *Dublin Refugee Artists Fund Exhibition*
Coll. The artist; private collection, Dublin

A half length realistic study of a ring master, with white flowing moustache and hair, behind him the tent and the audience. Colours are generally subdued except for his brilliant blue coat and blue bow tie. The composition is similar to that of *The Ring Master* in *A Broadside* (February 1912).

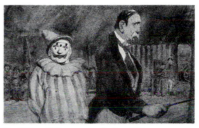

681 The Ring Master and the Clown 1909

Sgd. bottom left
Watercolour, 24.5 x 34.5
Exh. 1909 Dublin (21)
Coll. Peter Katz; sold to Victor Waddington, London, 1967; James Adam (Dublin) sale 14 July 1983 (repro); private collection, Dublin
Lit. Yeats, Jack B., *Life in the West of Ireland* (1912, 1915) 75; Yeats, Jack B., *And to You Also* (1944, 1974) 120

In *And to You Also* Yeats writes of 'the parasol of the auditorium' of the circus tent. 'The sad-faced clown stumbles along on the ring-master's left, while up above the ring-master on his right, sits the beautiful girl . . . on the back of a grand old cream horse . . .'. The picture remained indelibly in his memory, to be recreated in its various versions, notably *The Haute École Act* and *That Grand Conversation was under the Rose*, the oils of 1925 and 1943. Here the clown is in merry mood, looking out coyly at the spectator.

682 A Persian at the Circus 1909

Sgd. bottom left
Watercolour, 16.5 x 27.5

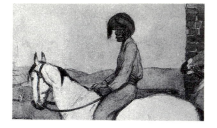

Exh. 1909 Dublin (47); 1962 *London* (5)
Coll. Mr. and Mrs. F. Hess, London

The Persian, who is elderly with a whitish moustache, sits on a white horse, looking around with a suspicious expression. He wears pale green and a red turban and sash, and is in a landscape setting. Probably a memory from boyhood, see *568*.

683 The Canvas Man 1909

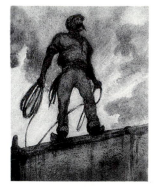

Sgd. bottom right
 Watercolour, 33 x 23.5
Exh. 1909 Dublin (27); 1961 London
 (35)(repro); 1964 Derry/Belfast (26)
Coll. Theo Waddington, Canada; T.G. Rosenthal,
 London
Lit. *Sinn Féin* (29 May 1909) 1; *Illustrated
 London News* (8 April 1961) 593

A dramatic picture of the moustached muscular canvas man, silhouetted against the windy sky as he stands on the frame of the circus tent ready to throw the noose of his coiled rope.

684 The Valley of Glencree* 1910 or 1900

Sgd. monogram bottom right
 Watercolour, 28 x 43
Exh. 1962 Dublin (65); 1964 Derry/Belfast (47)
Coll. Dawson Gallery, Dublin; J. McKinney,
 Belfast; Cynthia O'Connor Gallery, Dublin,

December 1988; Oriel Gallery, Dublin; Mr. and Mrs. P.J. Murphy, Dublin, 1991

Dated 1910 when it was first exhibited in 1962, the watercolour resembles the Valley Wood watercolours of 1900 in its liquid broad style and lush colouring. Glencree lies to the west of Enniskerry, on the borders of Dublin and Wicklow. Yeats left Devon in July 1910, to settle in Greystones, County Wicklow, and may have painted this watercolour soon after the move. However, from the point of view of manner and approach it is more probably one of his Dublin landscapes of 1900.

685 Untitled: Farmyard* *c.*1910

Insc. on reverse: Greystones
 Watercolour, 28.5 x 45
Coll. The artist's estate; Victor Waddington,
 London

Sketch of a farmyard, in browns, pinks and mauves, the view taken from a stable in the foreground.

686 To Buy the Fair and All That's There
 1910

Exh. 1910 Dublin (20); 1911 *Paris*; 1914 London
 (29)
Coll. Sold to Charles Hamilton Walter at the
 exhibition in 1914

'A "strong" farmer, a man of imposing and solemn mien, gravely conscious of his own dignity and importance. He is riding along the road "to buy the fair and all that's there". On the roadside stand some humbler folk, who watch him pass with deep respect' (*Irish Times*, 8 December 1910).

687 The Grey 1910

Exh. 1910 Dublin (26); 1911 *Dublin Oireachtas*;
 1912 London (39)
Coll. Sold to Miss Kinnear

688 The Bargain 1910

Sgd. Watercolour, 33 x 25.5
Exh. 1910 Dublin (17)
Coll. Sold through Victor Waddington Galleries
to Father Senan, OFM Cap., *Capuchin
Annual*, 1945; Mrs. P. Kelleher, Dublin

689 Porter [Porter at the Fair] 1910

Sgd. bottom left
Watercolour, 35.5 x 25.5
Exh. 1910 Dublin (11); 1912 London (36)
Coll. Sold to Victor Waddington Galleries
October 15, 1956; private collection

The window of a crowded inn with the upper
half open. Two men, one with a vast mous-
tache, the other with a thick beard and a clay
pipe—both with glasses of porter—lean out
talking happily.

690 Going Home 1910

Exh. 1910 Dublin (10)
Coll. Sold to Lady Ardilaun at the exhibition

**691 Hare and Hounds [Donkey, Hare and
Hounds]** 1910

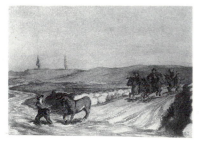

Sgd. bottom right
Watercolour, 24.5 x 34.5
Exh. 1910 Dublin (8); 1912 *Arts Companions*;

1912 London (34); 1961 Dublin (25)
Coll. Privately owned

A boy tries to drag his donkey across a ford,
looking back anxiously at three boys who pur-
sue him down an unmade road on the right.

692 The Look Out [The Pilot House] 1910

Sgd. bottom right
Watercolour, 24.5 x 34.5
Exh. 1910 Dublin (15); 1911 *London;* 1912 *Paris;*
1912 London (5)
Coll. Sold by the artist to W. T. H. Howe,
Cincinatti, in August 1924; Dan McInerney,
Dublin; Christie's (Dublin) sale,
Carrickmines House, 10 Feb. 1986, lot 354
(col. repro); Dillon Antiques, Dublin; private
collection, California

Yeats depicted the pilot look out at Rosses
Point, near Sligo, many times, see *206, Life in
the West of Ireland* (1912, 1915)37, etc., in this
late watercolour being preoccupied with the
evening light. Most of the watercolour is ren-
dered in a beautiful midnight blue and ultra-
marine, with faint detail in the distance. The
upper half of the pilot with his glasses, looking
back at the house, is lit up from the look out
window.

693 The Diver 1910

Sgd. lower right

Watercolour, 38 x 25.5
Exh. 1910 Dublin (13); 1912 London (23); 1913 *London (228)*; 1913 *Dublin Aonach*
Coll. Bought by the University of Wisconsin, 1914
Lit. Yeats, Jack B., *Life in the West of Ireland* (1912, 1915) 97 (repro)

The diver seated on a box on the pier, his helmet laid beside him, with a crane or pulley visible beyond. He is seen from below, silhouetted against a cloudy sky, with a seagull wheeling above him.

694 The Old Coachman 1910

Sgd. bottom left
Watercolour, 35 x 25
Exh. 1910 Dublin (4); 1965 Massachussetts (2); 1980 Birmingham (Alabama)(1)
Coll. Sold through Waddington Galleries to H. L. Shattuck, 1950; bequeathed by Henry L. Shattuck to the Museum of Fine Arts, Boston

The old man, with a brown wistful face beneath a bowler, walks slowly with his stick across the bridge. He wears a hip-length coat. His head is silhouetted against the blue sky: and, below that may be seen the country scenery, with grass and waterfall. His form throws a small dark blue shadow on to the pavement below him.

695 The Wheelwright 1910

Exh. 1910 Dublin (21)
Coll. Sold at the exhibition to a private collector

'Brawny industry in full play outside a blacksmith's forge' (*Daily Express*, 8 December 1910).

697 The Zither Player 1910

Sgd. bottom right
Watercolour, 35.5 x 25.5
Exh. 1910 Dublin (33); 1911 *Dublin Arts Club*;

1912 London (27); 1962 *London* (11)
Repro. Colum, P., *My Irish Year* (1912) 10

A man with long hair and moustache, eyes closed, playing a zither in a street. He is silhouetted against the sky.

698 The Bagmen [Commercial Travellers]
 1910

Sgd. bottom left
Watercolour, 25.5 x 35.5
Exh. 1910 *Dublin* (14); 1911 *London*; 1967 London (73) (repro)
Coll. Sold at the exhibition in 1911 to a private collector; Mrs. C. E. Lane-Poole, N.S.W.; Sotheby's (London) sale, 19 July 1967, lot 165, bought by Victor Waddington, London; Henry L. Shattuck, Boston; Museum of Fine Art, Boston

The bagmen, or commercial travellers, sit on top of their boxes on the waggon, drawn swiftly by two horses in tandem through the low-lying western landscape.

699 Derelict 1910

Sgd. bottom right
Watercolour, 34 x 25
Exh. 1910 Dublin (16); 1911 *Paris*; 1914 London (30)
Coll. Sold through Victor Waddington Galleries to S. Philipson, June 1945; private collection
Lit. MacGreevy, T. (1945) 23

A redheaded, red-bearded seaman in patched blue clothes leaning against a post is compared with the fishing boat, sails down, moored to the left of the painting. Colours are predominantly blue.

700 A Man with a Broken Head 1910

Sgd. bottom right
Watercolour 35.5 x 25.5
Exh. 1910 *London Allied Artists*; 1910 Dublin (40); 1911 *Dublin Aonach*; 1912 London (26)
Coll. F. E. Benner, Belfast; Sotheby's in Ireland at

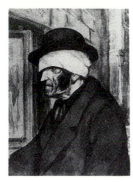

Slane Castle, 12 May 1981, lot 368
Lit. Yeats, Jack B., *Life in the West of Ireland* (1912, 1915) 85

The half-length of a man with a grim face and a bandaged head, topped by a bowler, opening the door of a pub. Behind is a street lamp, and a cobbled street.

701 Corner Boys 1910

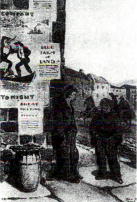

Sgd. bottom right
Watercolour and gouache, 36 x 24
Exh. 1910 Dublin (7); 1945 Dublin National Loan (179); 1971–2 *Reading/Dublin* (91)
Coll. Sold to Commissioner Baily at the exhibition in 1910; Samuel Beckett, Paris; private collection, London
Lit. S. Beckett in *Les Lettres Nouvelles* 2, no. 14 (avril) 619; Brater, E., *Why Beckett* (1989) 27 (repro)

Corner Boys, which belonged at one time to Samuel Beckett, is a Galway scene. Two local youths have established themselves at a street corner in the hope of selling the fish displayed beside them on a barrel. Their loitering attitudes, and the posters on the wall above them advertising local events and melodrama, suggest

that their minds are on anything but business. The side car spinning along in the background, the glimmer of sunshine throwing small shadows, and the calm backdrop of old houses and hills, create a realistic scene. 'High solitary art uniquely self-pervaded, one with its wellhead in a hiddenmost of spirit, not to be clarified in any other light', is how Beckett described Yeats's late painting in 1954: yet this unpretentious watercolour may have been more directly influential on his own writing, with its concentration on life at its most immediate level.

702 The Shelter Gable 1910

Sgd. bottom right
Watercolour, 34 x 24
Exh. 1910 Dublin (18); 1912 London (28)
Coll. Given by the artist to his cousin Hilda Pollexfen on her marriage in January 1928; Mrs. Hilda Graham, Winchester

Three Sligo sailors standing in the shelter of a high wall. All wear sailors' coats and peaked caps. One has a pointed red beard. A grey-beard is smoking a short pipe. There is an glimpse of sea to the left, in a scene of greys and blues.

703 War 1910

Sgd. bottom left
Watercolour and pencil, 36 x 25.5
Exh. 1910 Dublin (25); 1911 *Paris*; 1961 Dublin (27)
Coll. Sold by the artist to Victor Waddington Galleries, October 1956; Howard Robinson, Dublin; private collection

This has been given the date of 1902, but was probably painted not long before it was first exhibited in 1910. It shows the heads of two men, one with a red beard, the other a dark moustache, talking seriously with one another. Behind their disturbed faces flags flutter on a hill, one above a scaffolding. It may refer to some local feud. It was described in the *Irish*

Times, 8 December 1910, as 'two grim-visaged tillers of the soil facing one another with lowering, sullen looks.'

704 The Race Morning 1910

Exh. 1910 Dublin (9)
Coll. Sold to Mr. Commissioner Baily at the exhibition

705 The Circus Procession 1910

Exh. 1910 Dublin (6)

706 The Circus Chariot 1910

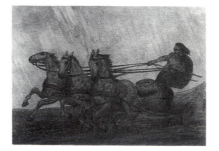

Sgd. bottom right; [also] J bottom left, and monogram
Insc. verso: A Circus Chariot (with instructions for framing)
Watercolour with crayon, 25.4 x 35.5
Exh. 1910 Dublin (5); 1967 London (1)(repro); 1967 *Bedford* (11a); 1971–2 Dublin New York (24)(repro); 1986 Dublin (11)(col. repro)
Coll. Mrs. N. Pulvertaft; purchased 1 Dec. 1967 from Victor Waddington, London, by the National Gallery of Ireland (6316)
Lit. Yeats, Jack B., *Ah Well* (1942, 1974) 12; *NGI* (1986) 22–3 (col. repro)

A chariot, drawn by three horses, driven furiously by a man in ancient British dress. There is a circus tent in the background, but the man is driving outside, in drenching rain. The colours are sombre, mainly brown and deep lilac, giving a dark, heavy effect, were it not for the carmine of the harness and the man's shield. This is a memory of a performance in London or Liverpool, perhaps, described in *Ah Well* as 'chariot races in a circus tent under a long glass roof . . .' but translated into an Irish setting, see *NGI* (op.cit.). Yeats treated the same subject in a different way in the drawing, *The Charioteer*, in *A Broadside*, September 1908.

707 A Circus Bull-Fight 1910

Sgd. bottom left
Charcoal, watercolour and gouache on paper, 26 x 36

Exh. 1910 Dublin (12); 1911 *Dublin*; 1912 London (25); 1913 *London* (181)
Coll. Sold 1912 to Miss Emily Sargent, later Mrs Ormond; F. G. Ormond; Mr. and Mrs. Conrad Ormond, Cleggan

A clown taunts some companions dressed as a bull in a circus ring. Another clown has fallen on his face and lost his hat, while two others, mounted on clown hobby horses, are coming from the rear. The audience is shadowy. Colours are dark and strong, lightened by the vivacious figure of a clown in stars and stripes.

708 Portrait of William Pollexfen* 1911

Sgd. monogram bottom right
Insc. My grandfather from memory 1911
Pencil, 15 x 11
Coll. Mr. and Mrs. F. Hess, London
Lit. Pyle , H. (1970, 1989) 4–7, 20

A sketch of Jack B. Yeats's maternal grandfather, William Pollexfen (1811–92), who ran a successful shipping business in Sligo, and with whom Yeats lived for most of his boyhood. The old bearded man is standing in a Sligo street. He holds a stick, and wears a flower in his buttonhole, and is a picture of dignity and respectability.

These memory sketches appear from time to time in Yeats's work, chiefly in the sketchbooks: and were a prelude to memory playing a more important role in Yeats's conception, eventually becoming a major element of his subjectmatter, as in *In Memory of Boucicault and Bianconi* (1937), *The Banquet Hall Deserted* (1942), *The Show Ground Revisited* (1951), and many other late oil paintings.

709 The Creek 1912

Exh. 1912 London (11); 1913 *London* (46)
Coll. Sold to the Countess of Mayo at the 1912 exhibition

710 Design for a Mountain Backcloth for 'The King's Threshold' October 1913

Sgd. monogram top right
Insc. 30 feet by 18 feet Scale ½ inch to a foot all colours to be flat

On verso: Mountain Back cloth for Kings
Threshold. October 1913. For the Abbey
Theatre
Ink, pencil and watercolour on card, squared
for transfer, 24.8 x 37.5
Exh. 1986 Dublin (17) (col. repro)
Coll. The artist's estate; Victor Waddington,
presented to the National Gallery of Ireland
in 1968 (6322)
Lit. Yeats, W. B., *Plays for an Irish Theatre: with
designs by Gordon Craig* (1911); Pyle, H.,
'"Men of Destiny"—Jack B. and W. B.
Yeats: the Background and the Symbols', in
Studies Summer/Autumn 1977, 188–213
(repro plate 5); Pyle, H. (1970, 1989) 60–7;
NGI (1986) 34–5 (col. repro)

A simple silhouette of black mountains, against
a pale blue-grey sky, with a smooth green fore-
ground broken by the intertwining lines of
black rivulets. W. B. Yeats's play, *The King's
Threshold* was originally performed by the
National Theatre Society in 1903: and W. B.
and Gordon Craig enlisted the assistance of
Jack B. Yeats for the production at the Abbey
Theatre in October 1913.

Gordon Craig had become interested in Jack
Yeats's miniature theatre when Yeats was writ-
ing juvenile plays at the beginning of the
century, and later, when creating settings for W.
B. Yeats's plays, used cut-out figures made by
Jack and Cottie in a model theatre, moving a
lighted candle about the stage to judge the
effects of shadows and masses. Jack Yeats him-
self was influenced by Craig to make his back-
cloth for his brother's play nearly abstract, with
all the emphasis on symbolic form. The design,
with its use of black ink to reinforce shapes and
outline, derives also from his own miniature
drama, and his *Broadsheet* manner, carrying the
level of abstraction in his illustration to W. B.'s
poem, 'Cathleen the Daughter of Houlihan' in
A Broadsheet (April 1903) a stage further.

The backcloth is developed from scenery that
Jack Yeats knew well, the back of the King's
Mountain, which lies between Truskmore and
Ben Eskin in the Ben Bulben range, seen at
Glenisk, near Ballintrillick, in Sligo. He has
taken a crucial image from W. B.'s play as his

theme. *The King's Threshold* describes how the
ancient poet, Seanchan, goes on hungerstrike in
order to maintain the right of poets to sit in the
king's council. He declares that by banishing the
poets from court, inspiration itself has been
banished—

'You have driven away
The images of them that weave a dance
By the four rivers in the mountain garden.'

Jack Yeats based his design on the description by
Seanchan of the mountain garden with its 'four
rivers that run there/ through well-mown level
ground'.

A 1913 unidentified presscutting in the
artist's scrapbook shows a reviewer's enthu-
siasm for the design: 'The performance of Mr.
W. B. Yeats's verse play, *The King's Threshold*
at the Abbey Theatre last week was a very
notable achievement. With the help of Mr.
Gordon Craig's design and Mr. Jack B. Yeats's
backcloth, a very beautiful scene was arranged.
It was quite simple in construction, showing
merely two sets of steps opposite each other,
and a background of mountain and sky. The
lighting, which was admirably contrived, was
of a soft and subdued nature, and anything of a
glaring effect was strictly avoided Such
work as this . . . shows us the Abbey Theatre
at its very best.'

711 **Ballycastle*** February 1915

Sgd. monogram bottom right
Insc. with notes and February 21st 1915
Pastel, 24 x 34
Exh. 1961 London (63)(repro)
Coll. Victor Waddington, London; J. H. Mount,
Kent

Yeats is not known to have been at Ballycastle,
in County Mayo, in February 1915. This pastel
landscape, taken from a terrace in the fore-
ground, may have been done from memory,
though the time of year in the drawing is win-
ter, and he visited Ballycastle, County Mayo, in
the summer of 1909, see *651–3.* Yeats seldom
used pastel on its own, and this, and *712–3*
have an experimental air. He was using coloured
crayons for his sketch notes about this time

(sketchbook 190), and continued to use it on occasion.

712 Ballycastle, Co. Mayo, Morning* 1915

Sgd. monogram bottom right
Pastel, 25 x 35
Exh. 1961 London (61)(repro)
Coll. Victor Waddington, London, Mr. and Mrs. M. Lederman, New York

A view of calm sea, taken from a grassy foreground with stunted leafless bushes. See *711*.

713 Ballycastle Co. Mayo, Evening* 1915

Sgd. monogram bottom right
Pastel, 25 x 35
Exh. 1961 London (62)(repro)
Coll. Victor Waddington, London

An unmade road with grass verge runs at a slant in the foreground. Beyond is a view looking down to the sea, which is becoming dim with twilight. See *711*.

714 Untitled: Sea* c.1915

Pastel, 25.5 x 35
Coll. Victor Waddington, London

An experimental study of sea. The soft mottled peach and green of the water and the dark shapes of rocks and boats contrast with the white circle of light reflected in the centre foreground. See *711*.

715 The Lying in State of O'Donovan Rossa* 1915

Sgd. monogram bottom left

715

Insc. on verso: done from memory August 2nd 1915 Jack B. Yeats — from memory — the Body of O Donnabain Rosa lying in State in the City Hall Dublin — 4 brown yellow candles in the black candle sticks — a crucifix — Irish Volunteer standing close to head of coffin — As soon as anyone in the line came level with Rossa face they bent and looked at it. Then the Volunteer touched them on the arm and said pass on. The Volunteer then took two paces back to his position by that time another of the line was opposite the face the Volunteer stepped forward and touched them on the arm July 29th 1915
Pencil, 25.5 x 36
Exh. 1966 *Dublin* (32); 1971–2 Dublin New York (6)(repro); 1986 Dublin (19)(repro)
Coll. The artist's estate; bought from the Dawson Gallery November 1965 by the National Gallery of Ireland (3780)
Lit. NGI (1986) 38–9 (repro)

A photograph of the lying-in-state of O'Donovan Rossa (1831–1915), the exiled patriot, taken from the *Daily Sketch* (30 July 1915) (artist's estate) was one source for this study. Yeats often worked from photographs. He also made notes from memory in *sketchbook 191* (see three ills below) of the funeral which took place on 1 August 1915, at which Pádraic Pearse made a graveside oration. This drawing of the lying-in-state was made on 2 August 1915. The open coffin rests on a bier in the City Hall, Dublin, wrapped in the tricolour, with candles in large black candlesticks at each corner and a crucifix at the

crosshatching, but mainly plain shading rubbed with a finger: and in style preempts the oil paintings of twelve years later. It is sketched freely, but conveys the solemnity of the occasion. Jeremiah O'Donovan Rossa, born in Rosscarbery, County Cork, was tried for complicity in the Fenian conspiracy of 1859. After his release, be became business manager of the *Irish People*. He was rearrested in 1865, and condemned to penal servitude for life. Later he was exiled, under amnesty, to the United States, where he edited the *United Irishman*. His funeral under the auspices of the Irish Volunteers and the Irish Republican Brotherhood was of immense significance in an Ireland on the brink of an uprising: and for Jack B. Yeats his posthumous return to the land of his birth must have been as inspiring as the return of John O'Leary, the exiled Fenian leader, to Dublin in 1885 was to his father, John Butler Yeats, who painted several portraits of O'Leary. The drawing is also interesting with regard to Jack Yeats's current preoccupation with memory, and is a prime example of his method of training it.

716 Youthful Theodore* c.1915

Insc. Youthful Theodore
 Watercolour on card, 59 x 72.5
Coll. Private collection
Lit. Gregory, A., *Me and Nu: Childhood at Coole* (1970)87

This drawing of Theodore the pirate (*573*) was sent to Lady Gregory's grandson, Richard Gregory, as a Christmas card when he was a child and living at Coole. 'I send a picture of the Youthful Theodore on a horse as a Christmas card for Richard. I thought it would amuse him pinned up on the nursery wall', Yeats wrote to Lady Gregory. The boy pirate rides a dapple grey horse on the seashore, with a fully rigged ship in the distance. He has his feet in the stirrup leathers, as the stirrups are beyond his reach.

717 A Summer Night, St. Stephen's Green
 1918

Sgd. monogram, bottom left
 Pencil, 25 x 35
Insc. on verso: A Summer Night St. Stephen's Green June 10th 1918 when 9.15 real time
Exh. 1967 London (78)(repro)
Coll. Victor Waddington, London; Dr. and Mrs. Theodore J. Edlich, Jr., New York

head. The statues in the chamber wear black drapes. Around the coffin moves a procession of men with their hats removed. Soldiers stand on each side of the open door, and a woman is looking in from outside.

On the verso side of the drawing is a sketch of the open coffin and the tricolour, which is marked 'green-white-yellow'. A further sketch with a view from above on to the bier has the following notes beside it: 'Irish Revolutionary colours', 'Volunteer', 'black cloth', 'Volunteer', 'Volunteer each side of entrance'.

The drawing is in BB pencil, with a little

A sketch from the top of a tram, with a young woman with a hat — perhaps Cottie Yeats — leaning back in one of the front seats. The drawing, which is unfinished as regards detail, shows presumably the north side of St. Stephen's Green in Dublin, with Merrion Row ahead, and the dying light brightening the Georgian buildings beyond the trees of the Green on the right. The inscription 'when 9.15 real time' refers to the change of the hour for summertime.

718 Self-Portrait *c.*1920

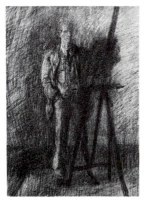

Sgd. monogram bottom right
Insc. on verso: Myself, about 1920
 Pencil with some chalk, 35.5 x 25.3
Exh. 1961 Dublin (39); 1964 Derry/Belfast (54); *1965 Dublin (73)*; 1971–2 Dublin New York (8)(repro); 1986 Dublin (22)(repro)
Coll. The artist's estate; Victor Waddington, London, presented to the National Gallery of Ireland in April 1961 (3319)
Lit. *New Knowledge* (London)(1966 April)966 (repro); Pyle, H. (1970, 1989) 133 (repro plate 9); *NGI* (1986) 44 (repro plate 22); Brater, E., *Why Beckett* (1989) 27 (repro)

The artist standing behind his easel, in the corner of a room, one hand in his pocket, the other sketching. Apart from an informal likeness of the artist, it is a study in light and shade.

Some barely perceptible light green chalk in a line down the centre of the drawing adds intensity to the drawing. The soft pencil become blunt has sometimes scraped the surface, contributing to the effect of a mobile light, coming from an unseen window on the left. Yeats's lively pencil outlines defining aspects of the figure amid the vigorous shading and cross-hatching is paralleled in oils of the late twenties and afterwards, when he draws as expressively with his paintbrush.

His portraits are few: but it is interesting that he drew this self-portrait about the time that John Butler Yeats thought he was about to complete his famous oil self-portrait, which had occupied him for years in New York. It is also of interest that about the same period Jack Yeats was making a number of self-portraits in pen and ink, perhaps for illustration, which are outside the scope of this catalogue [they are included in the forthcoming catalogue of Yeats's pen and ink drawings. See also *NGI* (op. cit.) and *Theatre and the Visual Arts* (1972), where some of the studies are reproduced]. They are more pensive and subjective in character than the pencil self-portrait, and, rather than showing the artist at his work, stress his loneliness as an observer of society, and as an introspective individual wandering apart from others. These and a few representational oils of the mid-twenties are the first indications of the late very personal paintings, where the artist blends reminiscence with emotion in metaphorical images. The figure of the artist surveys the haunts of his past, in *The Banquet Hall Deserted* (1942) and *The Show Ground Revisited* (1951), etc.

719–723 Five Sketches of Coole* 1923

In an envelope inscribed: Coole 1923
Pencil and coloured crayon, each 14 x 22.5
Coll. The artist's estate; private collection

These are brief views of the lake and woods, one with notes about the light etc.

724 Anne on Pud 1923

Coll. Sold to Lady Gregory in 1923; private collection
Lit. Reid, B. L., *The Man from New York: John Quinn and his friends* (1968) 584; Gregory, A, *Me and Nu: Childhood at Coole* (1970) 87

Lady Gregory told John Quinn in a letter (5 October 1923) that she had commissioned Jack B. Yeats to make watercolour drawings of Anne's pony and Catherine's donkey (the

mounts of her two granddaughters), "owners up". Anne Gregory, the elder daughter of Robert Gregory, who was shot down as a pilot in 1918, has described her childhood with her grandmother at Coole, and these pictures (op. cit., 87): 'Me on Pud cantering up the slope on the front lawn, with Taddy, my little terrier bouncing up at Pud's nose as he always did We were very pleased with these pictures, though I was sorry that Taddy didn't show up a bit better.'

725 Catherine on Tommy

Coll. Sold to Lady Gregory, 1923; private collection
Lit. Reid, B. L., *The Man from New York: John Quinn and his friends* (1968) 584; Gregory, A, *Me and Nu: Childhood at Coole* (1970) 87

See *724*. Catherine, known as 'Nu', was Robert Gregory's younger daughter. Anne Gregory in her reminiscences (op. cit., 87) describes the picture as 'Nu sitting very peacefully on Tommy just in front of the house . . . Nu was a bit sad that Tommy was standing still, and not galloping like Pud; but I said to her "you are lucky that Mr. Yeats didn't paint you standing on the ground just beating Tommy, trying to make him *walk*."'

726 Untitled: Horserider* 1927

Sgd. bottom left
Insc. January [?7] 1927
 Watercolour on beige paper, 10 x 15
Coll. Jeannie Reddin, Dublin

A fantasy sketch of a man on a horse galloping away across sand, with a glimpse of grass and sea beyond.

727 Cartoon for a Banner* *c.*1928

Insc. in three places with notes regarding the details of colours to be used, such as 'sea, flat green'
 Watercolour and mixed media on light brown paper, 156.5 x 106.5
Coll. Dawson Gallery, Dublin; bought by Professor George Dawson, Dublin; Sotheby's sale, 16 Mar. 1977, lot 128; James Adam (Dublin), sale 1978; Justice Barra O Briain, Dublin

A design for a banner, similar in style to the cartoons for the Loughrea banners, *447* ff . It has been carried out with great proficiency, on nearly twice the scale, and is probably much later in date, contemporary with the banners commissioned by Mrs. Oliver St. John Gogarty for Renvyle House, Co. Galway, *c.*1930 (see *450–1*). The identity of the figure in the design is uncertain. He is bearded with a halo, about four feet high, wearing a red tunic with blue collar; and he stands, holding a staff, beside the prow of a currach. Part of the design for a border, formed of intertwined ropes, has been carried out in the top left hand corner.

The figure may be St. Brendan, though in the Loughrea version he is represented wearing a brown habit and is already at sea in his coracle, as he is usually seen in pictorial versions of the legend. Alternatively it might be St. Colmcille, who was of royal blood, and might have been imagined wearing a tunic for the journey to his exile in Iona (*451*). Again, he may be some other Celtic saint.

The cartoons for the four Gogarty banners have not been traced. The subjects commissioned were St. Colmcille, St. Francis, St. Gobda or Gobnait and the Blessed Virgin (the *St. Francis* and the *Blessed Virgin* banners being seen last in the collection of Mrs. D. Williams, Tullamore, in 1968, worked in wool on silk poplin, each measuring 78.5 x 50, while the St. Colmcille is in the collection of the National Museum of Ireland (34–1936)). There is a possibility that this was a version of the S. Colmcille banner which was rejected in favour of a replica of the Loughrea banner, or, given its size, it may be quite separate from the Gogarty commission. The design is not known to have been executed.

728 A Connemara Man Leaning on his Quay
 *c.*1930

Sgd. bottom right
Insc. with title
 Watercolour, 15 x 22
Coll. Drawn by Yeats for Barbara Robertson in Dublin *c.*1930; given to Diarmuid Kennedy on his marriage in 1969; George Stacpoole, Adare, Co. Limerick

A loose watercolour sketch of the head and shoulders of a fisherman, wearing a hat, leaning his elbows on the edge of a quay. The mast of the moored boat on which he stands is all that is visible of the boat. His face is a type often met among Yeats's West of Ireland characters.

729 G. B. Shaw Playing the Spoons* 1930s

Pencil, crayon and newspaper collage, 25.5 x 20
Coll. The artist's estate; private collection

George Bernard Shaw, the Irish writer (1856–1950), is represented as a harlequin, sitting on a chair, playing the spoons in the traditional Irish manner, with a tambourine on the floor beside him. Yeats has taken a photograph of his head from a newspaper, and fitted it into the drawing, which is late, and dating from the time when he was experimenting with crayon and other media in *Lives* (*Introduction*, above, pp. 19–23).

The drawing may have been done c.1938, when Jack Yeats was writing his 'play of war's alarms', *Harlequin's Positions*, first performed in June 1939; or it may be a first thought from some time before that, when the play was still brewing in his mind (J. W. Purser, *The literary works of Jack B. Yeats* (1991) 80–1 et al.). It is interesting both as an example of the artist's constant need to experiment; and because the satirical portrait of Shaw is a rare instance of Jack Yeats's art and his late writing working in close collusion, apart from illustration.

172

EXHIBITIONS
IN WHICH JACK B. YEATS'S WATERCOLOURS
AND DRAWINGS WERE SHOWN

ONE-MAN EXHIBITIONS

1897	November	London	Clifford Gallery, *Watercolour Sketches*
1899	February	London	Walker Art Gallery, *Sketches of Life in the West of Ireland*
	May	Dublin	Leinster Hall, *Sketches of Life in the West of Ireland*
1900	March	Dublin	Leinster Hall, *Sketches of Life in the West of Ireland and elsewhere*
	24–29 October	Oxford	Clarendon Hotel, *Sketches of Life in the West of Ireland*
1901	February	London	Walker Art Gallery, *Sketches of Life in the West of Ireland and elsewhere*
	23 October– 2 November	Dublin	9 Merrion Row, *Sketches of Life in the West of Ireland*
1902	18–30 August	Dublin	Wells Central Hall, *Sketches of Life in the West of Ireland*
1903	4 February– 4 March	London	Walker Art Gallery, *Sketches of Life in the West of Ireland*
	24 August– 5 September	Dublin	Central Hall, *Sketches of Life in the West of Ireland*
1904	31 March– 16 April	New York	Clausen Galleries, *Recent Watercolours*
1905	October	Dublin	Leinster Hall, *Pictures of Life in the West of Ireland*
1906	1–20 October	Dublin	Leinster Hall, *Sketches of Life in the West of Ireland*

1908	3–29 February	London	Walker Art Gallery, *Pictures of Life in the West of Ireland*
1909	10–29 May	Dublin	Leinster Hall, *Pictures of Life in the West of Ireland*
1910	8–21 December	Dublin	Leinster Hall, *Pictures of Life in the West of Ireland*
1912	1–13 July	London	Walker Art Gallery, *Pictures of Life in the West of Ireland*
1914	29 June–18 July	London	Walker Art Gallery, *Pictures of Life in the West of Ireland*
1945	June–July	Dublin	National College of Art, *National Loan Exhibition*
1960	August–September	Sligo	County Library and Museum, *Selection of Paintings*
1961	6–29 April	London	Waddington Galleries, *Early Watercolours*
	22 April–5 May	Dublin	Dawson Gallery, *Watercolours and Pen and Ink Drawings*
	14–27 August	Sligo	Town Hall, *Loan Collection* (presented by Sligo Art Society)
1962	November–12 December	Dublin	Dawson Gallery, *Watercolours and Pen and Ink Drawings*
1963	2–20 August	Sligo	County Library and Museum *Joint Exhibition of Paintings from the Collections of the late Ernie O'Malley and the Yeats Museum, Sligo*
1964	April	Derry	Arts Council of Northern Ireland, *North West Arts Festival*
	May	Belfast	Arts Council of Northern Ireland, *May Festival*
1965	11 January–17 February	Massachussetts	Institute of Technology, Hayden Gallery, *Loan Exhibition*

1965	14–26 June	Belfast	New Gallery, *Loan Exhibition*
	26 June–10 July	Waterford	Municipal Gallery, *Loan Exhibition*
1967	27 October–18 November	London	Victor Waddington, *Early Drawings and Watercolours*
1969	12 March–5 April	Montreal	Waddington Fine Arts, *Jack B. Yeats Retrospective Exhibition*
	10–19 April	London	Victor Waddington, *Small Drawings and Watercolours from Sketchbooks*
1971	September–December	Dublin	National Gallery of Ireland, *Jack B. Yeats: a Centenary Exhibition* (shown afterwards in Belfast, Ulster Museum, in part; and in New York Cultural Center, April-June 1972)
	October–December	Sligo	County Library and Museum, *Jack B. Yeats and his Family* (in association with Rosc 71) (shown afterwards in Dublin, Municipal Gallery of Modern Art, April-May 1972)
	22–29 November	Dublin	Peacock Theatre, *Theatrical Pictures* (mounted to coincide with *That Gift of the Gab: a Selection from the Writings of Jack B. Yeats*, a rehearsed reading compiled by Hilary Pyle and directed by Edward Golden, 22 November 1971, at the Peacock Theatre)
1973	8–31 March	London	Waddington Galleries III, *Watercolours and Drawings*
1976	April	Galway	Kenny Art Gallery, *Paintings and Drawings*

1978	2–14 October	Dublin	Oriel Gallery, *Miniature Watercolours and Drawings*
1980	14 February–15 March	London	Theo Waddington, *Drawings and Watercolours* (as part of *A Sense of Ireland*)
	15 March–30 April	Birmingham (Alabama)	Alabama Museum of Art, *Jack Yeats: Irish Expressionist*
1986	26 March–20 April	Dublin	National Gallery of Ireland, *Jack B. Yeats in the National Gallery of Ireland*
1988	26 June–15 October	Dublin	Hugh Lane Municipal Gallery, *Yeats at the Hugh Lane Municipal Gallery of Modern Art*
1989	16 August–9 September	Sligo	County Library and Museum and Sligo Art Gallery, *Jack B. Yeats, 1871–1957, and Contemporaries*
1990	11–16 June	Monaco	Centre de Congres, *Images in Yeats*
	9–31 July	Dublin	National Gallery of Ireland, *Images in Yeats* (the Monaco Exhibition with the National Gallery Collection of Watercolours and Drawings)

GROUP EXHIBITIONS IN WHICH YEATS'S WORK WAS SHOWN

1895		Dublin	Royal Hibernian Academy, *66th Annual Exhibition* (contributed annually after this until 1900, after which he did not appear until 1911)
1902	May ff.	Cork	*International Exhibition*
1903		Dublin	Irish Literary Society, *Exhibition*

1903	April	London	Whitechapel Art Gallery, *Shipping Exhibition*
1904	April	St. Louis	*Exposition*
	31 May–23 July	London	Guildhall, *Loan Exhibition of Irish Artists*
	November	Dublin	Royal Hibernian Academy, *Exhibition of Pictures presented to the City of Dublin to form the nucleus of a Gallery of Modern Art*
1905	February – March	London	Baillie's Gallery, *Paintings, Drawings and Sketches by J. H. Donaldson, Jack B. Yeats, Elinor Monsell and Mrs. Norman*
		Dublin	Rotunda Rooms, *Gaelic League Exhibition*
1906		Limerick	*Industrial Exhibition*
		Dublin	An tOireachtas, *Taispeántas Ealadhan* (Yeats contributed at intervals to the annual art exhibition of the Oireachtas)
	December	London	*Exhibition* (arranged by Lady Dudley)
1909		Dublin	Aonach, *Exhibition of Paintings*
	July	London	Albert Hall, *Allied Artists' Association*
	October	Belfast	Art Society, *28th Annual Exhibition*
1910		New York	Macbeth Gallery, *Group Exhibition*
	July	London	*Allied Artists' Association*

1910	12 October–20 November	London	Whitechapel Art Society, *Shakespeare Memorial Theatrical Exhibition*
1911		Belfast	Industrial Association, *Exhibition*
	July	London	*Allied Artists' Association*
		Dublin	Royal Hibernian Academy, *82nd Annual Exhibition* (contributed regularly after this date)
	July	Dublin	Rotunda Rink, *Taispeántas Ealadhan an Oireachtais*
		Dublin	Aonach, *Exhibition*
1912		Paris	*Salon des Indépendents*
		London	Art Companions, *Second Exhibition*
1913	21 May–29 June	London	Whitechapel Art Gallery, *Summer Exhibition of Irish Art*
	December	Dublin	Rotunda Gardens, *Aonach na Nodlag*
1918	New York	Penguin Club	*Contemporary Art*
1920	August	Dublin	Society of Dublin Painters, *First Exhibition*
1934	December	London	Leger Galleries, *Exhibition*
1948	28–31 March	Tuam	St. Jarlath's College, *Tuam Art Club 6th Annual Exhibition*
1962		London	Waddington Galleries, *Watercolours: Yeats, Hayden, Feininger*
1965	14 February–16 March	Greater Victoria (B.C.)	University of Victoria, *W. B. Yeats Centenary Festival*

1965	November	Dublin	National Gallery of Ireland, *W. B. Yeats: a Centenary Exhibition*
1967	10–18 June	Bedford	St. Michael's Vicarage, *Artists and Architecture of Bedford Park 1875–1900* (Bedford Festival Week)
	July	Dublin	Peacock Theatre, *Stage Design at the Abbey Theatre*
1969		Mayo/Donegal	*Travelling Exhibition of Irish Art*
1970	May–June	Dublin	Watercolour Society of Ireland, *Centenary Exhibition*
1971	May–July	Reading	University Library, *Samuel Beckett: an Exhibition* (afterwards to ICA and National Book League; University of East Anglia; Dublin University Library)
	31 October–29 December	Cork	Crawford Municipal Art Gallery, *Irish Art in the 19th Century* (Rosc Chorcaí '71)
1972	April–May	Lund	Konsthall, *From Yeats to Ballagh*
1975–6	1 December–31 January	Cork	Crawford Municipal Art Gallery, *Irish Art 1900–1950* (Rosc Chorcaí '75)
1978		Washington	Smithsonian Institution, *'The Noble Buyer': John Quinn, Patron of the Avant-Garde*
1985	24 April–25 May	London	Pyms Gallery, *Celtic Splendour: Irish Paintings and Drawings 1850–1950*
1987	4 November–5 December	London	Pyms Gallery, *Orpen and the Edwardian Era*
1988	March–April	London	Royal College of Art, *Painters at the Royal College of Art*

1988	22 April–	Dublin	Gorry Gallery, *An Exhibition*
	5 May		*of 18th, 19th and 20th Century*
			Irish Paintings
	25 November–	Dublin	Gorry Gallery, *An Exhibition*
	8 December		*of 18th, 19th and 20th Century*
			Irish Paintings
1989	28 April–	Dublin	Gorry Gallery, *An Exhibition*
	11 May		*of 18th, 19th and 20th Century*
			Irish Paintings
	24 November–	Dublin	Gorry Gallery, *An Exhibition*
	7 December		*of 18th, 19th and 20th Century*
			Irish Paintings
1990	25 May–	Dublin	Gorry Gallery, *An Exhibition*
	7 June		*of 18th, 19th and 20th Century*
			Irish Paintings

PUBLIC COLLECTIONS

IN WHICH JACK B. YEATS'S WATERCOLOURS ARE REPRESENTED

Europe

National Gallery of Ireland, Dublin
Hugh Lane Municipal Gallery of Modern Art, Dublin
Aras an Uachtaráin, Dublin
Abbey Theatre, Dublin
Sligo County Library and Museum
Ulster Museum, Belfast

Victoria and Albert Museum, London
Windsor Castle, the Royal Library
Cecil Higgins Art Gallery, Bedford

United States

Smithsonian Institute, Washington, DC
New York Public Library, Berg Collection
Boston Museum of Fine Arts
Boston College, Bapst Library
University of Wisconsin

JACK B. YEATS'S SKETCHBOOKS

A list of sketchbooks in the form of diaries, to which Yeats returned for inspiration during the course of his painting, follows here. These are mainly in the artist's collection, and since he sold or gave away some, includes only those which have been located and which have not been broken up. The list includes only sketchbooks which might be regarded as visual diaries, containing notes of what the artist saw and wished to remember.

The list is in rough chronological order. The numbers in square brackets, for example [X164], [A7] or [33], indicate sketchbooks in the artist's collection. The entry titles are the words written by Yeats on each sketchbook cover for identification purposes.

For these diaries, Yeats generally worked with Rowney Ringback sketchbooks, measuring 9 x 13 centimetres (3½ x 5 ins.), or other small sketchbooks, which he carried around with him. He sketched in pencil, and added a watercolour wash and perhaps an ink outline afterwards. On a rare occasion he used pastel. He sketched at sporting events, in the theatre, in the street, and on the quays—wherever he went: noting incidents and characters that interested him, and using the sketchbooks to practice his powers of observation, and to train his memory.

Through these sketchbooks it has been possible to ascertain the date of certain works. As well as this, the diaries record experiences which the artist afterwards developed into oil paintings, and this is noted in relevant entries. Yeats continued to consult the sketchbooks in later years, and drew on them for subject-matter in his late compositions.

1. [A20] *Notebook.* 1895–6. [With some sketches pasted in. Light pencil drawings of characters seen in Chertsey, Honiton and Dublin, some cut from a lined notebook.]

2. [X168] *Circus Chertsey.* March 1897

3. [A19] *Large Sketchbook.* 1897. [Sketches at Snails Castle, etc., May, June, December 1897, some pasted in.]

4. [153] *Italy Venice.* [Undated, probably 1898.]

5. [151] *Untitled Italy Como.* [Undated, probably 1898.]

6. [A1] *Untitled.* May–June 1898. Begun in May ended in June like the Promise.

7.	[X164]	*Strete Circus.* 1898 [mainly. Started 9 May 1895, but most of the sketches date to 1898].
8.	[X167]	*Strete Circus.* 1898. Begun last day of June 1898.
9.	[A3]	*Galway Races Sligo.* July, August 1898.
10.	[X165]	*Sligo and Killybegs.* August 1898. 98 Aug in Ireland. Finished Aug 17th.
11.	[X166]	*Donegal (and Sligo).* August, September 1898. Commenced in Burton Port in the Rosses, Aug. 17th 1898. Finished Sept. 3, Sligo.
12.	[X162]	*Cork Strete Sligo London.* 1898, 1899. Commenced Sept. 3rd, 1898. [Includes the '98 Carricknagat celebrations.]
13.	[X163]	*Strete.* 1899. Commenced January 5, 1899.
14.		*Kensal Rise Wrestling.* 1899
15–17.		*Co. Galway* 1899; *Co. Galway Isle of Aran* 1899; *Co. Galway Galway Dublin* 1899. [Three sketchbooks in the Ernie O'Malley collection.]
18.	[X174]	*Co. Galway (2) Gort Ennis Kinvara.* April 1899. [Sketchbook 15 must be Co. Galway (1) 1899. Includes sketches made at Kinvara and Gort in April of 1899.]
19.	[X175]	*Circus Co. Galway Loughrea Gort.* April 1899
20.	[A15]	*Rooms.* 1899. [Drawings of Sligo interiors, in pen, ink and watercolour, the last one dated 1899.]
21.	[X171]	*Circus Paris Strete Barnums.* June 1899.
22.	[X170]	*Strete Kingsbridge Great Fair etc.* July 1899. Commenced, July 18th, 99.
23.		*The Broads and Yarmouth.* July 1899. [Listed in the Ernie O'Malley collection.]
24.	[X172]	*Strete.* August 1899. Aug 2 to Aug 10.
25.		*Strete.* September–October 1899. [Listed in the Ernie O'Malley collection.]
26.	[X173]	*Strete Cider Press.* December 1899.
27.	[X161]	*The Book of the Castle and the Orchard and sometimes the Valley and the Village.* 1899–1900–1901.

28.	[1]	*London.* January 1900. [Boxing &c.]
29.		*Dublin Plays.* February–March 1900. [New York Public Library Berg Collection, ex coll. W. T. H. Howe, who purchased it from the artist in January 1933, according to Yeats's Record Book.]
30.		*Sligo Dublin.* February–March 1900. [Dr. E. MacCarvill collection.]
31.	[2]	*London and Strete/Dublin.* March & April 1900. Timber Measure.
32.	[3]	*Strete London.* April and May 1900.
33.		*London Epsom Street.* May–June 1900. [Exhibited as an item from the Ernie O'Malley collection, 1963 Sligo.]
34.		*Galway.* August 1900. [Includes a programme for Galway Races, 1 August 1900. Sligo County Library and Museum. Ex.coll: Ernie O'Malley.]
35.		*Ireland Ennis Races Kinvara.* 1900. [Listed in the Ernie O'Malley collection.]
36.		*Sketchbook.* 1900. [Consists mainly of cricket scenes, one with WBY and AE at play at Coole. Dr. George Furlong collection, London.]
37.		*Galway.* 1900. [Scenes at Coole and Kinvara. New York Public Library Berg Collection, ex coll. W.T.H. Howe.]
38.	[5]	*Strete London.* 1900–1. [Contains drawing of Queen's funeral: Entry of King and Queen into Westminster.]
39.	[6]	*London Docks Boxing.* January–February 1901.
40.	[A17]	*London London Hippodrome.* February 1901.
41.	[4]	*Strete London.* May 1901.
42.	[7]	*Strete.* Summer 1901.
43.	[8]	*London.* July 1901. Loi Fuller Japanese Play.
44.	[9]	*London & Coole.* September 1901. Kate Carney Dan Leno AE.
45.	[3a]	*Coole.* c.September 1901.
46.	[11]	*London Ireland.* 1901.

47.	[10]	*London and Strete.* 1901. Herbert Campbell.
48.	[X178]	*Gort and Dublin.* 1901. Dr Hyde. W. G. Fay. [Ballinasloe, 2 Oct 1901.]
49.		*Dublin Diarmid and Grania.* October 1901. [Includes a sketch of the interior of the Mechanics Theatre, Abbey Street. An inserted programme is dated 21, 22, 23 October 1901. New York Public Library Berg Collection, ex.coll. W. T. H. Howe.]
50.	[20]	*London.* January 1902. The Gourmet.
51.	[12]	*Strete Dartmouth.* Spring 1902.
52.	[18]	*Strete.* April and May 1902. [Contains 'the Missus' and many drawings of Low.]
53.	[19]	*London.* May 1902. Pollocks Paper Theatre Shop.
54.	[12a]	*Strete.* July 1902.
55.	[17]	*London.* August 1902.
56.	[13]	*Coole.* August 1902.
57.	[21]	*Dublin.* August 1902. AE Arthur Roberts.
58.	[14]	*Dublin.* August–September 1902. Quinn The Governor Arthur Griffiths.
59.	[A6]	*Dublin and the Point.* September 1902.
60.	[15]	*London.* October 1902.
61.	[16]	*Strete.* October 1902–January 1903.
62.	[22]	*London.* February 1903.
63.	[24]	*London.* February 1903.
64.	[23]	*London.* March 1903.
65.	[152]	*London Strete.* 1903 or 1904. [Includes a sketch, 'Head of the Gara', with probably Masefield.]
66.	[25]	*Strete.* April 1903. [Several sketches of Masefield.]
67.	[26]	*Haul Sands Strete Totnes.* May 1903
68.	[27]	*Newton Races.* May 1903
69.	[28]	*Strete.* July–August 1903

70. [29] *Dublin Croker James Starkey W.G.Fay.* August 1903.

71. [35] *Dublin Bos Croker.* August 1903.

72. [34] *Sligo and Dublin.* 1903.

73. [33] *The Point.* 1903.

74. [31] *Coole.* 1903. [Includes sketches of 'Feish' (i.e. 'féis').]

75. *Galway Feish.* 1903. [Leo Smith collection.]

76. [30] *London.* Autumn 1903.

77. [32] *London Strete.* November 1903. [Portrait of 'Burke the Buff Bill orator'.]

78. [36] *Strete.* January, February, June 1904

79. *Atlantic and New York.* March 1904. [Exhibited as an item from the Ernie O'Malley collection, 1963 Sligo.]

80. [42] *New York.* March–April 1904.

81. [43] *New York.* March–April 1904.

82. [X176] *New York The Great Lafayette.* March–April 1904.

82a. *New York Wiseman and the Fool.* 1904. [Sketches of drama. Private collection, Ireland (Coll. James Adam, Dublin).]

83. [X180] *New York.* March–April 1904. [Includes a sketch of John Quinn.]

84. [A2] *New York and Passage Home on Celtic.* May 1904.

85. [40] *Atlantic Ocean Dartmouth Regatta.* March and August 1904.

86. [44] *New York Strete.* March, August, September 1904.

87. [41] *Atlantic and London Bill Baily.* March and ?Autumn 1904.

88. [37] *Strete Brixam [Brixham].* August 1904.

89. [38] *Strete London.* September–October 1904. [Includes sketches of 'Parson T.A. Harvey'.]

90. [39] *Strete London.* 1904.

91. [47] *London Masefield.* February 1905. [Includes sketches of Masefield.]

92. [55] *London Strete.* February 1905.

93. [46] *Strete Masefield.* Spring 1905.

94. [45] *London Hackensmith.* May 1905.

95–6. *Two sketchbooks.* 1905. [Sketches in the West of Ireland. Mrs. Sally Cooke-Smith, London.]

97. [A4] *Synge.* 1905. [Coast scenes, some certainly done in the West of Ireland at Clifden. Pen and ink sketches of Synge's head.]

98. *Ireland with Synge.* 1905. [New York Public Library Berg Collection, ex coll. W.T.H. Howe, who bought this and item 100 from Yeats in February 1932, according to Record Book.]

99. *Connemara.* 1905. [Includes first sketches for Synge's articles on the Congested Districts. Dr. Maurice Craig, Dublin.]

100. [A13] *Belmullet.* Undated, prob. 1905.

101. *Belmullet.* 1905. [Leo Smith collection, Sligo Museum.]

102. *Swinford.* 1905. [New York Public Library, Berg Collection, ex coll. W.T.H. Howe.]

103. [50] *Swinford and London.* July 1905. [Masefield, Synge.]

104. [51] *London and Ireland.* 1905.

105. [53] *Brixam* [Brixham] *Coole.* 1905. [Scenes at Coole, in Dublin, and Brixham Regatta.]

106. [52] *Dublin Gort.* September 1905. [Waxworks, T. A. Harvey, Variety Artists, John Dillon. Visited Tivoli Music Hall, Dublin, in the week of September 25, 1905.]

107. [A12] *Killybegs.* Undated, *c.*1905.

108. [54] *Dublin Killabegs Manchester.* October 1905.

109. [48] *Manchester.* October 1905.

110. [49] *Manchester.* October 1905.

111. [56] *Strete.* 1905 and 1906. [Masefield.]

112. [57] *Strete.* June 1906.

113. [58] *Strete.* ?July 1906.

114. [59] *Dublin Strete.* 1906.

115. [60] *Ireland.* 1906. [Includes Kinvara, Greystones, Bray, Stepaside, Gort and Dublin.]

116. [61] *Galway.* 1906. [Views at Clifden and Coole.]

117. [62] *London and Clifden.* 1906.

118. [A7] *Dublin Sligo.* 1906. [Includes scenes from Lady Gregory's play *The Jail Gate.*]

119. [63] *London.* 1906

120. [64] *Strete.* 1906–7. [Includes a visit to London to see Masefield's play, *The Campden Wonder.*]

121. [65] *Strete.* April 1907. [Visit of Lily Yeats to Strete.]

122. [66] *Strete.* 1907

123. *London.* June 1907. [Including a scene from *The Playboy* in London. Private collection, London.]

124. [67] *Strete and Coole.* 1907

125. *Clifden.* 1907. [With Ardbear Bay. Sligo County Library and Museum, ex. coll. Ernie O'Malley.]

126. *Clifden.* 1907. [Exhibited 1963, Sligo, as a second Clifden sketch book in the collection of Ernie O'Malley.]

127. [X179] *Rhine.* 1907. [Rotterdam, Dordrecht, Dusseldorf and 'Bridge of boats just before Cologne'. In a special presentation cover to Mrs. Jack B. Yeats.]

128. *Rhine.* 1907. [Private collection, Montreal.]

129. [X169] *London.* End of 1907 and 1908.

130. [69] *London.* February 1908.

131. [68] *London Follies.* February 1908.

132. [70] *London Burns and Palmer Fight.* February 1908.

133. [71] *London Bantham.* March 1908. [Sincavali. Arthur Roberts.]

134. [72] *London Sculling Championship.* 1908.

135. [73] *London Yvette Gilbert.* 1908.

136. [74] *London.* 1908. [Includes Hippodrome scenes.]

137. [76a] *Strete.* 1908

138. [75] *At Harvey's.* 1908. [A visit to his friend, the Reverend T.A. Harvey, at his rectory at Lissadell, County Sligo.]

139.		*Harvey's and the Point.* 1908. [Sligo County Library and Museum, ex coll. Ernie O'Malley.]
140.		*Dublin.* 1908. [New York Public Library Berg Collection, ex coll. W. T. H. Howe.]
141.	[76]	*Dublin Sinclair Abbey Play.* c.1908. [Includes scenes at the Abbey Theatre, with Sinclair rehearsing *The Country Dressmaker.* Notes 'A Unionist' and 'A Gael' at a meeting.]
142.		*Ireland.* 1908. [Exhibited 1963 Sligo, in the collection of Ernie O'Malley.]
143.		*Ireland.* 1909. [Views of Dublin and Co. Dublin, of Ballycastle and Downpatrick Head.Private collection, Dublin.]
144.	[A9]	*Ireland.* 1909. [Drawings include mission stalls.]
145.	[A10]	*Ireland.* 1909. [Views of a fair and a funeral.]
146.	[A11]	*Ireland.* 1909. [Characters at fair, view through chapel door.]
147.	[77]	*Ireland.* 1909. [Sligo, Downpatrick Head, Ballycastle.]
148.	[A8]	*SS Tartar.* undated [1909]. [Drawings on board ship.]
149.	[78]	*Ireland.* 1909. [Race course near Coole.]
150.	[79]	*Ireland T. A. Harvey.* 1909.
151.		*Co. Mayo.* 1909. [Bruce Flegg collection.]
152.	[80]	*Ireland and London.* 1909. [Dr. Sigerson.]
153.	[81]	*London Strete September.* 1909.
154.	[82]	*Strete.* 1909.
155.	[83]	*Strete Circus.* 1910. [Fossett's Circus.]
156.	[X177]	*Circus Dublin and Wicklow.* 1910.
157.	[A14]	*Dublin and Wicklow.* 1910.
158.		*Greystones.* Spring 1911. [Listed in the Ernie O'Malley collection.]
159.	[85]	*Greystones Napoleon.* Spring 1911.
160.	[84]	*London Pavlova.* Spring 1911.
161.	[86]	*Roundstone.* 1911.

162. [87] *Roundstone.* 1911.

163. [89] *Roundstone and Greystones.* 1911.

164. [88] *Greystones Arklow.* 1911.

165. [90] *Greystones.* 1911–12.

166. [91] *Greystones.* 1911–12.

167. [92] *Greystones.* 1912.

168. [93] *Greystones Martin Harvey.* 1912.

169. [94] *Greystones Mallaranny Donegal.* 1912.

170. [95] *Dunbeg Dunfanaghy.* 1912.

171. [96] *Donegal and Greystones.* 1912.

172. [97] *London and Greystones.* 1912.

173. [99] *Greystones Enniscorthy Metropolitan Regatta.* 1913.

174. [100] *Greystones Pantomime Dublin.* 1913.

175. [101] *Greystones.* 1913.

176. [102] *Greystones.* 1913. [Includes a sketch of Endymion.]

177. [103] *Kerry and Greystones.* 1913.

178. [98] *Kerry.* 1913.

179. [104] *Kerry.* 1913. [The Pattern Day, Early Morning.]

180. [105] *Dublin and Kerry.* 1913.

181. [106] *Greystones Circus Donkey Show in Dublin.* 1913.

182. [107] *London.* 1914.

183. [108] *London Ethel Levy Dublin Boat. Skeffington 2.* 1914.

184. [109] *Clifden Dublin Kerry and Wexford Hurley Final. Face at Window.* 1914.

185. [110] *Dublin and Greystones.* 1914. [Includes a sketch of Pearse, speaking at a Volunteer meeting at Dundrum.]

186. [111] *Clifden.* 1914.

187. [112] *Shannon and Clifden.* 1914.

188.	[113]	*Greystones Dublin Trotting Calary Races.* 1914.
189.	[114]	*Dublin Greystones Circus Clay Pipe Making.* 1914. [Off Greystones, looking for guns, 27 July 1914.]
190.	[115]	*Schull Greystones.* 1915.
191.	[116]	*Arklow Greystones Circus Schull.* 1915. [Funeral of O Donnabháin Rosa, Dublin, 1 August 1915.]
192.	[117]	*Greystones WBY.* 1915.
193.	[119]	*Greystones Half Memory House and Inn.* 1916.
194.	[118]	*Greystones Roundstone.* 1916.
195.	[120]	*Greystones Dublin.* 1917.
196.	[121]	*Dublin Lennox Robinson Ian MacNiel.* 1918. [Presumably Eoin MacNeill.]
197.	[122]	*Courttown.* 1918.
198.	[123]	*Skibbereen and Schull.* 1919.
199.	[124]	*Dublin Blaikie Murdoch Donkey Racing.* 1919.
200.	[125]	*Skibbereen Dublin Half Memory Scandanavian Market.* 1919, 1920.
201.	[126]	*Dublin Circus Skerries Tawin.* 1920.
202.	[127]	*Tawin Half Memory House.* 1920.
203.	[128]	*Dublin Tawin.* 1920.
204.	[129]	*Cahirsiveen.* 1921.
205.	[130]	*Cahirsiveen and Dublin.* 1921, 1922.
206.	[131]	*Dublin The Irish Jew.* 1922.
207.	[132]	*Dublin.* 1923, 1924.
208.	[133]	*Coole 1923 Kinsale1924.* 1923, 1924.
209.	[135]	*Dublin Kinsale Dungarvan.* 1924.
210.	[134]	*Kinsale.* 1924.
211.	[136]	*Dublin Burren Coole Valencia Darrynane.* 1925.

212. [X181] *Darrynane.* Undated, probably 1925. [Sketches of Kenmare and Derrynane, presumably dating from the 1925 visit.]

213. [137] *Dublin Kenmare.* 1925.

214. [138] *Dublin 1925 and some Greystones 1916.* 1925 (and 1916).

215. [139] *Dublin Lennox Robinson and Cyclops.* 1925, 1926.

216. [140] *Glengarriff and Dublin.* 1926.

217. [141] *Gort and Glenbeigh.* 1927.

218. [142] *Dublin.* 1927, 1928.

219. [143] *Parknasilla.* 1928.

220. [A16] *Bantry.* October 1933.

221. [144] *Sketchbook.* 1942, 1943.

222. [145] *Dublin.* 1943.

223. [146] *Dublin Lucan.* 1944.

224. [147] *Dublin.* 1944, 1945.

225. [148] *Sketchbook.* 1946.

226. [149] *Sketchbook.* 194–

227. [154] *Sketchbook.* Undated, probably 1940s. [Includes sketch of harper and fiddle player in Baggot Street, Dublin.]

228. [160] *Sketchbook.* 1947.

229. [159] *Sketchbook.* 1948.

230. [155] *Sketchbook.* Undated, March–April 1949. [Sketches of the rehearsals for *In Sand.*]

231. [158] *Sketchbook.* 1953. Stephen's Green, 11 June 1953.

232. [157] *Sketchbook.* ?1953. [Sketches of different kinds of legs and eyes.]

233. [156] *Sketchbook.* ?1953. [One sketch only, in pen and ink, of the heads of a man and a woman in some scene.] .

SELECT BIBLIOGRAPHY

BOOKS

Kennedy, B. P., *Jack B. Yeats*. Dublin, 1991.

MacGreevy, T., *Jack B. Yeats: an appreciation and an interpretation*. Dublin, 1945.

McHugh, R., ed., *Jack B. Yeats: a centenary gathering* (Tower Press series of Anglo-Irish studies III). Dublin, 1971.

Marriott, E., *Jack B. Yeats: being a true and impartial view of his pictorial and dramatic art*. London, 1911.

O'Driscoll, R., and Reynolds, L., ed., *Theatre and the Visual Arts: a centenary celebration of Jack Yeats and John Synge* (*Yeats Studies: an International Journal – 2*). Shannon/Toronto, 1972.

Pyle, H., *Jack B. Yeats: a Biography*. London, 1970; revised 1989.

———, *Jack B. Yeats in the National Gallery of Ireland*. Dublin, 1986.

———, *Yeats at the Municipal Gallery*. Dublin, 1988.

———, *Images in Yeats*. Monaco, Dublin, 1990.

Rose, M. G., *Jack B. Yeats: Painter and Poet* (European University Papers Series XVIII, vol. 3). Berne/Frankfurt M., 1972.

Rosenthal, T. G., *Jack Yeats, 1871–1957 (The Masters – 40)*. London, 1966.

White, J., and Pyle, H., *Jack B. Yeats: Drawings and Paintings*. London, 1971.

ARTICLES

Beckett, S., 'Homage à Jack B. Yeats'. *Les Lettres Nouvelles* (avril 1954).

Carric, A., 'Captain Jack B. Yeats. A pirate of the old school'. *The Mask,* 5, no. 1 (July 1912).

Colum, P., 'The art of Jack B. Yeats: the artist brother of the poet Yeats'. *TP's Weekly* (18 July 1914).

Dunlop, I., 'Jack B. Yeats: his drawings and illustrations'. *Dubliner*, 2, no. 2 (Summer 1963).

Harvey, A., 'Memories of Coole'. *Irish Times* (23-4 November 1959)

———, 'Sketches from the letters of Jack B. Yeats'. *Irish Times* (23-4 August 1960).

Hogan, R., 'John Synge and Jack Yeats'. *Journal of Modern Literature* 3 (April 1974).

'Jack B. Yeats 1871–1957'. *Eire-Ireland* 364 (29 April 1957).

Marriott, E., 'Jack B. Yeats: pictorial and dramatic artist'. *Manchester Quarterly* (July 1911).

Newton, E., 'Master of observation'. *Time and Tide* (6 April 1961).

'Poster recruits no. VII: Jack B. Yeats'. *Poster* (London) (April 1900).

Potterton, H., 'Jack B. Yeats and John Quinn', *Irish Arts Review*, Yearbook (1992–1993).

Pyle, H., ' "About to write a letter" '. *Irish Arts Review*, 2, no. 1 (Spring 1985).

———, '"Many Ferries"—J. M. Synge and realism'. *Eire-Ireland*, 18, no. 2 (Summer 1983).

'Raconteur in drawings'. *The Times* (10 April 1961).

Russell, G. (AE), 'Jack B. Yeats'. *Booklover's Magazine*, 8 (1909).

Schneider, P., 'Homage'. *Les Lettres Nouvelles* (1954 avril).

Skelton, R., ' "Unarrangeable reality": the paintings and writings of Jack B. Yeats', in *The World of W. B. Yeats: essays in perspective*, ed. R. Skelton and A. Saddlemyer. Dublin, 1965.

Sutton, D., 'Yeats and others'. *Financial Times* (April 1961).

Symons, A., 'Watercolours and toys'. *Outlook* (18 February 1905).

Yeats, E. C., 'Passages from a diary of E. C. Yeats'. *Wind and the Rain*, 3, no. 3 (Autumn 1946).

Yeats, J. B., 'The education of Jack B. Yeats'. *Christian Science Monitor* (2 November 1920).

LIST OF COLOUR PLATES

N. Bernstein: plate 13; Cecil Higgins Art Gallery, Bedford: 3; Hirshhorn Museum and Sculpture Garden, Smithsonian Institute, gift of Joseph Hirshhorn, 1966; 17 (photographer: Lee Stalsworth); Hugh Lane Municipal Gallery of Modern Art, Dublin: 4, 14, 15, 18; National Gallery of Ireland: 6; Pyms Gallery, London: 19; Sligo County Library and Museum: 8, 9, 16; Dr. Michael Smurfit, Dublin: 1; Miss Anne Yeats: 21, 22, 24. All other pictures reproduced by permission of the various private collectors to whom they belong.

INDEX

Note: numbers in brackets are catalogue entry numbers;
numbers in bold face are colour plate numbers.

205